Master Drawings
from Titian to Picasso
The Curtis O. Baer Collection

Exhibition Schedule

National Gallery of Art
4th Street & Constitution Ave.
Washington, D.C.
July 28 – October 6, 1985

Indianapolis Museum of Art
1200 West 38th Street
Indianapolis, Indiana
January 14 – May 2, 1986

The John and Mable Ringling Museum of Art
5401 Bayshore Road
Sarasota, Florida
March 27 – May 11, 1986

High Museum of Art
1280 Peachtree Street
Atlanta, Georgia
May 31 – August 24, 1986

The Walters Art Gallery
600 North Charles Street
Baltimore, Maryland
September 17 – November 2, 1986

Frederick Wight Gallery
University of California at Los Angeles
Los Angeles, California
November 30, 1986 – January 11, 1987

Master Drawings
from Titian to Picasso
The Curtis O. Baer Collection

Eric M. Zafran

High Museum of Art, Atlanta

Edited by Kelly Morris
Designed by Jim Zambounis, Atlanta
Type set by Typo-Repro Service, Atlanta
Printed by Balding + Mansell, Wisbech, England

Library of Congress Catalogue No. 85-60504
ISBN 0-939802-23-6

Cover: Attributed to Titian, *Two Satyrs in a Landscape*

Director's Preface

The High Museum is very proud to have organized this exhibition of one of America's few remaining outstanding private collections of drawings. We are deeply indebted to George Baer and his family for making a selection of the finest works from the collection formed by his father, the late Curtis O. Baer, available to the public of Atlanta and other cities. A small group of these works was shown in Atlanta in 1981 as part of the exhibition *Drawings from Georgia Collections*, organized by our curators Eric Zafran and Peter Morrin. Out of the close working relationship established by Dr. Zafran with the Baer family grew the possibility of organizing the present exhibition. We are fortunate that it could be carried out even after Dr. Zafran had left the High Museum to become the James A. Murnaghan Curator of Renaissance and Baroque Art at the Walters Art Gallery in Baltimore, and we thank him for his dedication.

We are especially pleased that this exhibition will have its American premiere at the National Gallery of Art in Washington. We express our thanks to J. Carter Brown, the Gallery's Director, and Andrew C. Robison, Senior Curator and Curator of Prints and Drawings, and the Board of Trustees. For making the presentation of the exhibition possible in their respective museums we also wish to thank Robert A. Yassin, Director, and Martin F. Krause, Assistant Curator of Prints and Drawings, at the Indianapolis Museum of Art; Anthony F. Janson, Chief Curator, the John and Mable Ringling Museum of Art; Robert P. Bergman, Director, The Walters Art Gallery; and Edith A. Tonelli, Director, The Frederick S. Wight Art Gallery of the University of California at Los Angeles.

Collectors, both private and institutional, have an almost parental concern for their treasures, and we are therefore especially grateful to Dr. Baer and his family for allowing their collection of master drawings, for which they care so deeply, to be shown so widely. We hope that the rare opportunity to see such a varied and interesting collection will be both an educational and an enjoyable experience for the viewers and will perhaps inspire some future collectors.

Gudmund Vigtel
Director, High Museum

Foreword and Acknowledgements

In the spring of 1974 I had the good fortune to be invited by Curtis Baer to visit him and see a portion of his collection at his home in New Rochelle, New York. We spent the afternoon in that favorite pastime of collectors and art historians, first attempting to attribute each drawing and then analyzing its individual qualities. Mr. Baer impressed me as being the most unpretentious and least possessive of collectors. He was a connoisseur who loved his cherished treasures and enjoyed sharing them even with a graduate student. He had, in fact, been teaching seminars on drawing for some time, so that his ability to subtly convey fine distinctions of style and meaning came easily. Over the next few years I was able to chat with him at chance meetings in New York galleries and museums. His keen perception and somewhat deprecating observations of the current "art scene" always made for stimulating sessions.

I was later afforded the opportunity to study the collection in depth, and this effort has culminated in the present exhibition and catalogue. We can but hope that Curtis Baer's memory and taste are well served.

In fact, Curtis Baer left quite explicit directions about the preparation of this catalogue, which he felt should include more than the sixty-one works selected by Agnes Mongan and shown at the Fogg Art Museum in 1958. We have followed his prescription for the format, but in order to make as much of the collection available as possible, we have devised a two-tiered catalogue. The first one hundred drawings, which are considered the outstanding works, are illustrated in large format, with full entries, and will travel in the exhibition. An additional seventy-five works are reproduced in small format, with just the relevant factual data; these will be shown only in Atlanta and Baltimore.

As Curtis Baer wrote in his statement on collecting, he set no preconceived bounds on his collection, and thus it spans the fifteenth to the twentieth centuries, with examples from all the major schools. While there are outstanding sheets by some of the world's most famous artists — Titian, Rembrandt, Ruisdael, Delacroix, and Picasso — the collection is also notable for the little pockets of related drawings, such as the Venetian group of Tiepolos and Piazzetta, the Dutch landscapes, the surprising group of works by artists working in Prague (van Vianen, Stevens, and Savery), the cache of four early Degas drawings, and the vigorous works by mid-20th century masters Klee, Kandinsky, Kokoschka, and Beckmann. Looking at the collection as a whole, one is struck not only by the range, but also by the refinement of taste. A distinctive sensibility was at work in the formation of this collection and it is no mere assemblage of names or price tags. Generally characterized, the taste was for delicate and subtle works with a special fondness for landscapes and animals. There are few scenes of violent action, few *modelli* for large-scale projects. Instead, the works often show the artist at his most personal, working on a small scale.

Over the years, Curtis Baer sold, traded, and donated some fine works, and he was always in the process of refining his collection. The works which remain present, as all such collections do, a bit of the history of art and collecting. The collection includes sheets which once belonged to such notable collectors as Mariette, Sir Joshua Reynolds, Thomas Lawrence, William Esdaile, and Richard von Kuehlmann. In one of the great coups every collector hopes for, Curtis Baer had the opportunity to acquire a group of drawings from the collection of the Prince of Liechtenstein; in this way, he added some of the most impressive pieces now on view, such as the Rembrandt and the Savery. The Baer family, inspired by his example, have continued the process of refinement and growth.

For the past five years I have had both the encouragement and the friendship of the Baer family in pursuing this project. They have made the drawings available for study and supplied whatever documentation had been gathered by Curtis. I wish to thank them for their many kindnesses, and I hope they feel the results have justified their faith and patience.

Also crucial for bringing this exhibition to fruition was Andrew Robison, Senior Curator and Curator of Prints and Drawings at the National Gallery of Art in Washington. He and I, working in conjunction with the Baer family, made the selection of the one hundred choice drawings. He has provided much helpful information and arranged for the exhibition at the National Gallery.

Only with the assistance of a great many individual scholars, connoisseurs, collectors, and curators was it possible to arrive at the present state of knowledge, which Curtis Baer — more than many — recognized was always in a process of evolution. The contribution of many of these individuals are noted in the entries, but I would like to acknowledge and thank the following, who gave of their time to review either the drawings or photographs of them: Keith Andrews, Roseline Bacou, Diane de Grazia Bohlin, James Byam Shaw, Jean Cailleaux, Marco Chiarini, Jacques Foucard, Heinrich Geissler, Mario de Gianpaolo, Guy Grieten, Carlos von Hasselt, Egbert Haverkamp-Begemann, L. J. van der Klooster, Christopher Lloyd, Börje Mugnusson, Bernard Meijer, J.-F. Mejanes, Hans Mielke, Peter Morrin, Anne Percy, Annamaria Petrioli Tofani, Mathias Polakovits, Philip Pouncey, Roger Rearick, Marianne Roland-Michel, Pierre Rosenberg, John Rowlands, Peter Schatborn, Arlette Calvet-Sérrulaz, Julien Stock, Werner Sumowski, Nicholas Turner, Carl von Tuyl, Françoise Viatte, Eliane de Wilde, and An Zwollo.

The facilities of libraries and archives in both this country and Europe were essential, and I should like to thank the staffs of the following for being so helpful: The Institute of Fine Arts; The New York Public Library; The Frick Art Reference Library; Knoedler and Co., New York; The National Gallery of Art, Washington; The Witt Library, London; The Rijksbureau, The Hague; Département de Doc-

umentation du Louvre, Paris; Kunsthistorisches Institut, Florence; and the Rubenianum, Antwerp.

At the High Museum, this project has had the long-standing support of the Director, Gudmund Vigtel. At the Walters Art Gallery, the enthusiastic willingness of the Director, Robert Bergman, to add the exhibition to the Gallery's schedule allowed me the time necessary to carry out the research and writing.

The preparation of the drawings for exhibition was facilitated by the outstanding efforts of the High Museum's Registrar, Marjorie Harvey, and members of her staff: Frances Francis, Carol Graham, and Nancy Roberts. The manuscript was prepared through the combined efforts of Liz Lane, Catalina E. Davis, and Kathleen Sweeney. Additional proof-reading was done by Muriel Toppan. As always, the High Museum's Editor, Kelly Morris, and his assistant, Amanda Woods, did a masterful job of smoothing the prose. Jim Zambounis solved the more than ordinary design problems with his accustomed aplomb. The representatives of Balding + Mansell, Guy Dawson and Michael Wojtowycz, cooperated to the utmost to see that their fine product appeared on schedule.

Eric Zafran

On Collecting

Curtis O. Baer

A collector is often asked "What do you collect?" and "How do you collect?" The more philosophical question "Why do you collect?" is seldom asked. Even in the books on collecting that I know, it is taken for granted that collecting is a natural, pleasant, commendable occupation, and needs no justification. As to the "What" of collecting, I have no fixed system whatever. I think that no over-all planning is necessary; that the less planned a collection is, the better it will be. In present times, the supply from which to select is small anyway, and if a rigid plan has to be followed — if we collect only certain periods or schools — our choices will be still more limited, or the quality of the purchases lowered. Our collection will be a clearer reflection of our taste if we do not have a program, but take advantage of whatever objects we find, as long as they meet our taste and standard. In this, the private collector is more fortunate than the public institution, whose collecting needs a system and a purpose.

To describe the "How" of collecting means talking about the most exciting and enjoyable part of a collector's activities: the act of acquisition. To find a desirable object, to consider buying it, to buy it, to take it home: these are the times of acute enjoyment. The excitement of falling in love with an individual work of art, of discussing with ourselves whether we should follow its beckoning, of saying finally and enthusiastically "Yes!": these moments are, we feel rather immodestly, the dramatic and proud moments in our careers as collectors. However, in this activity our part is less active than we are inclined to believe. Our role is usually restricted to saying "Yes" or "No." Most collectors have little time to go hunting. The choice of material is not large, and we do not go to an art dealer as we go into a store to pick out a dress amongst many dresses. It is always the individual object which speaks out amongst less eloquent ones, and says "Buy me!" We do not make a selection: we answer a call.

The collector with a taste of his own — and which collector is not proud of his personal taste? — should rely on it, and should ask for advice from experts only for problems of authenticity. To decide for himself is his privilege and his duty. He listens to the dealer, to his wife, to his friends; but finally, he has to make up his own mind. If he has not the courage to do so, the standard and the unity of his collection will suffer. In this respect also, the private collector is more fortunate than the curator, who has to take into account the taste of each member of a committee. The private collector has to converse only with himself and, alas, with his pocketbook.

When I meet a new object, my first impression is all-important. At the sight of a drawing which I really want, a bell rings at once; and I know that the decision is virtually made. But experience has taught me that such first impressions can be treacherous; I also know that when a succession of new attractive drawings has been shown me, I am under a synergistic and slightly intoxicating effect which impairs my sober judgment. Therefore, I try to stifle my impulse to buy at

once. It is wiser to give myself time for discussion with the object which urges me so strongly, and I am thankful to the dealer who allows me to take it home for a few days and gives me a chance to let the first lightning experience settle down to a more permanent glow. The ring of the bell often proves to be false. A pretender may have spoken whose virtues fade away after a while. It also may happen that I do not recognize the true virtues of an object which at the first meeting is less outspoken, or which talks indistinctly. In such cases, staring at it for a prolonged time will not be helpful, because soon the reaction will become blunted. Then it is better to interrupt; to wait till tomorrow, and start with a fresh and more detached eye. By that time, the answer is usually ready and clear.

Most of my drawings were "love at first sight." But whether our decision has been fast or slow, we cannot truthfully say that it was made with a detached mind; for that very attachment was the strongest factor in our decision. Each acquisition is accompanied by tribulations similar to those of the young man who wants to make up his mind whether to marry a certain girl, and finds it impossible to do so in a detached way: his own feelings are involved and he cannot keep his heart from taking part in his reasoning. I think that the reaction which I have described is fairly typical, and that most collectors will recognize their experience in mine.

I find that I want to know two things about every new object: first, "How important is it; what is its quality?" Second, "Of which school and by which master is it?" In interpreting these two apparently different approaches, I used to think of the second one — the question of identity and authenticity — as the domain of the expert, who is able to make a correct attribution based on the wealth of his specialized knowledge. The answer to the question of quality, and, let us say, beauty, I assumed to be within reach of the sensitive and cultivated layman. I was therefore quite puzzled that my enthusiasm for a drawing by Rubens was not at all shared by a certain neighbor who nevertheless shows a discriminating taste in the decoration of her home. If my response had been so spontaneous and prompt, why not hers? Then I remembered that I myself had been blind to van Gogh for many years. I realized that it was naive to expect a work of art to appeal to every person with good taste, and I understood that the two questions, the one of quality and the one of identity, converge into one; that quality in art is of necessity set in the matrix of the historical development of style. My response to the Rubens drawing may have been spontaneous, but it was not unprepared. My previous experience with the 17th century and with Rubens had opened my eyes before I saw this drawing. I already possessed the standard by which I would measure this new specimen in a region of art which was familiar to me.

Experiencing art in this sense means that we develop in our minds a historical landscape, in which schools and artists have their well-defined places. The clearer we see this topography in its specific

contours, the better we are able to place a new work where it belongs and to evaluate its relative importance. To appreciate it is, at the same time, to identify it by placing the new piece of the puzzle in its proper context. This is what makes fussing with anonymous drawings such a fascinating pastime: we try to fit them into our landscape, to find the exact spot where they belong.

Whether an amateur will know many artists and styles intimately will depend on his alertness and the amount of his leisure time. Any single life is short for the big task, and the territory which he can hope to know well will be small, not only because art is such a vast field, but also because our capacity to assimilate the styles of different nations and times is quite limited. I cannot imagine that anybody can have an equally deep understanding of Dutch painting, Greek sculpture, and Japanese pottery. It is more natural and rewarding to keep within limits and to aim rather at deepening than at widening our understanding. It is a great satisfaction to grasp, for example, the meaning of a Ruisdael landscape after we know the meaning of a Rembrandt landscape, to weigh their differences and their similarities, and with this knowledge to widen our view of other landscapes of the 17th century.

Experience of art — the insight into the essential qualities of a master, a style, a period — cannot be acquired without looking at many representative examples, and this in the original. For this we need museums. We train our understanding better in a museum. The material is more ample, and usually offers a more complete and representative historical survey. In the museum, our attention is usually more concentrated; and, most important, we are more detached than when we look at our own collection.

Then, why collect? If "possession," in art, means essentially spiritual possession, the drawings in the museum can be ours as much as those at home; in that case, physical ownership is no more than a satisfaction to our acquisitive crave, like collecting postage stamps. There is truth in this, but only part of the truth. Every collector knows also the better part: the peculiar and intimate relation between the individual work of art and its buyer. In the museum we are less intent on a single work as such, and more on the general concept of a master and a style. In collecting, the evaluation of the one piece is all-important; we have to clarify its exact position within an œuvre and a style. In the museum, when we try to establish such a mark for an individual object, it means the evaluation of somebody else's choice; and this does not engage us in the same way and to the same degree as the decisions we have to make ourselves. Every such decision has its trials and satisfaction and — though it may sound pretentious — we feel that our honor is involved.

A collection is the aggregate result of such decisions, but its whole is more than its single components. Already in its early stages, and more so as it grows, it becomes an organism with its own face and power. The concept of the "historical landscape" becomes clearer as it is

transformed into reality, piece by piece. The collection begins to know into which direction it wants to expand; which new members it requires; which old members have become expendable. How many stakes can be set out in the "landscape" depends on luck, skill, and financial resources. Do not judge a collection by what it does not contain. What counts is whether the concept was sound in the beginning and how it has been amplified and clarified during its realization.

To the collector, the pattern of his collection is less visible than to others. To him, collecting is a sequence of isolated decisions. Only later, when his collection has grown in size, and on rare occasions (such as the return from a long absence) does he become aware of the pattern. He realizes that he has been instrumental in carrying out a job, and that this job was his opportunity to contribute to the world of art.

No doubt, a good private collection is a cultural factor, not so much for any educational value in the training of students and the public, but as a means of communication between amateurs, professionals, and collectors, as a challenge, as an object of approval and of criticism. This operates in two ways: first, with respect to the quality and importance of the single specimens; and second, as an expression of faith in a style. Those collectors who have eyes to discern what is essential in today's art are active co-workers in the history of art. But the collector of traditional styles also participates in the subtle and continuous change of taste.

The collector is the best pupil of his collection. Formerly I thought that, the chase over and the new possession triumphantly brought home, the collector had done his work, that his excitement was over and that a peaceful affection would set in. But just as a love story does not end, but rather begins, with marriage, so our relationship with the things we collected is never final. Our standards develop and a different hierarchy of values emerges. It is a great experience to return to our own collection after having looked at some large public ones. All of which means that we have to do our own share to remain the real owner of our possessions. If the works in our collection, or, for that matter, all works of art, remain the same to us, then something is wrong — with us, not with them.

"Why do you buy drawings?" I think I have given some valid reasons. But one motive has not been mentioned, a motive which may be stronger and more basic than all the others: that is the longing to live with what we can only call the miracle of art — the strange unity between something eternal and a fragile piece of paper. To harbor such guests, who ennoble our home with their silent and eloquent presence, who bring us so much happiness: what man would not count this a privilege and a deep satisfaction?

October 1957

My Father: Curtis O. Baer

Mr. Curtis O. Baer

My father was born in 1898 in Strasbourg (now French, then German). As a boy he was an avid reader and was first attracted to the visual arts through the German romantics. His first visit to a museum was at the age of fourteen, when his parents took him to the Munich Pinakothek, but he mentioned that it meant nothing to him (or them) at the time. His strongest impulse came from reading Richard Muther's dramatically written *History of Painting,* which popularized ideas of Taine and Nietzsche. By the end of high school — a humanistic Lutheran *gymnasium* with a rigorous curriculum of Latin for nine years, and Greek for six — he had acquired a superficial knowledge of the culture of the Italian Renaissance.

In 1917, after the First World War, he entered the University of Freiburg, and studied with the archaeologist Ludwig Curtius, the philosophers Husserl and Heidegger, and the art historians Walter Friedländer and Hans Jantzen. He also met a tall, serious-looking student (whom he at first mistook for a professor) named Helmut Lütjens (see cat. no. 99). Studying art history together, they began a friendship and an exchange of views on art that lasted all their lives. He wrote in his memoirs:

> Lütjens and I frequently discussed our common aim of how to appreciate works of art adequately. We both knew that the professional literature did not offer a solution to us, that there must be a better way to catch specific quality. He was ahead of me in this search. Being older than I, he had studied in Munich before the War and told me about the method used by Rudolf Britsch in his school at Starnberg. Britsch disregarded art history's preoccupation with questions of style or subject matter; he focussed upon the single work of art and attempted to determine what it tells about the artist's seeing. "Seeing" in a particular sense: not what he factually observes, but what he fashions into shape.

These studies were unfortunately interrupted by a severe illness of my grandfather's, and my father left Freiburg to be with his family in Basel, Switzerland, where he studied art history under Friderich Rintelen. Those studies came to an end, too, when my grandfather died and inflation came; in 1921 my father entered the business world in Frankfurt to support his family. He married my mother, Dr. Kathi Meyer, a musicologist, in 1934, and they left Germany for the United States in 1940.

My father began collecting in Frankfurt, at the urging of Edmund Schilling, the curator of the Städelsches Museum, and his first purchase was the drawing by Hackaert (cat. no. 148). But most of the drawings are acquisitions of the 1950s and 1960s, when my father was a partner in an import-export firm in New York. The drawings came through auctions, personal contacts, and travels, from New York, Paris, Amsterdam, London, Berlin, and other cities. He wrote: "The collection grew out of single hand-to-mouth decisions; at no time has its course been charted, neither in its historical scope nor financially.

Therefore I was often beguiled by minor opportunities, instead of conserving my funds for rarer and more important ones."

His years steeped in art history helped him in a pragmatic way in 1961, when he left the business world to be a visiting scholar in the connoisseurship of drawings at Vassar College and to conduct graduate seminars at New York University and Manhattanville. During those years he often said that he had the advantage of starting late in life, with the enthusiasm of a beginner yet with a lifelong acquaintance with his subject. This combination also led him in 1970 to publish *Landscape Drawings*, a book which emphasizes the way of looking at art that he and Lütjens developed. During the years at Vassar he continued to collect, and the collection grew to the more than one hundred drawings now being exhibited.

I especially remember his joy as each drawing came to our home and (when I visited from college) seeing it with him for the first time in his studio. After having looked at it for a few minutes, he would ask "Do you like it?"; or "Doesn't it look very much like the drawing at the Morgan Library?"; or "I got it in London, for a very high price." He was always happy when museum curators, collectors, dealers, graduate students, professors, and others came to see the collection.

His views on collecting are stated in the short essay reprinted herein. In his memoirs, he adds:

> Today I would express my point more strongly. With every decision, the buyer shows his mettle; in its aggregate, his collection gives his personality and taste away. Without much exaggeration, it can be said *"La collection est l'homme même"* (paraphrasing Buffon). Each time when I had to make up my mind on yes or no, it has been a challenge, both harrowing and delicious; I was conscious not only of an aesthetic, but also of a moral responsibility. And this feeling does not cease completely after the drawing is a possession, and has been stored away; to a measure, the question "how good is it? how does it stand the test of longer acquaintance?" remains. However, the aspect has changed. After a short while, the page is no longer a newcomer but a friend. It has become a component of the collection, a member of the family, as it were, and also a part of myself. No other kind of material possession engenders a similar relationship. For there is a spiritual presence in the sheet — not unlike the genius in Aladdin's lamp — that cannot be "owned" in the common sense of the word; one rather has to think of it as something which exists independently yet has deigned to be our guest. Here lies the unique nature of what is called, superficially enough, the "visual arts." While also in a piece of music, or in a poem, we comprehend a spiritual entity, it has no corporeal form. The artifact exists both materially and immaterially — the little square of paper contains a sort of magic.

It is some of that magic that we have the joy of seeing today.

George Baer
January 1985

Catalogue of the Collection

Works are in loose chronological order within national groupings. Dimensions are given height before width.

Italian & Spanish

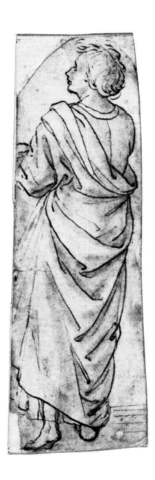

FLORENTINE SCHOOL
ca. 1460-70

1. *A Standing Man (St. John the Evangelist?)*
 Pen and bistre wash, 4½ × 1⅜ inches
 (113 × 35 mm)

 Exhibition: Cambridge, 1958, no. 2.

 Bibliography: Degenhart and Schmitt, 1968, I-2, pp. 606, 617, 621, ill. 925.

This is one of many similar single or multiple figure drawings known as "The Finiguerra Group." Maso Finiguerra, a fifteenth century Florentine craftsman trained both as a goldsmith and as an engraver, was credited by Vasari with developing the technique of making prints from silver plaques called *nielli*. His compositions usually included tightly packed groups of small figures. It is likely that his studio, following the general practice of the day, used a set of exemplars which apprentices could copy and incorporate into appropriate compositions.[1] The pose of this standing man suggests to Degenhart and Schmitt a St. John in a Crucifixion scene. They offer evidence for the existence of a workshop prototype, reproducing a nearly identical figure found on a sheet in the Louvre.[2] Whether the workshop that produced these delicate drawings was Maso's or that of another mid-century Florentine artist, such as Pollaiuolo, they attest to the Renaissance concern with the human figure.

[1] See Ames-Lewis and Wright, 1983, esp. pp. 62-63.
[2] Degenhart and Schmitt, 1968, I-2, p. 665, ill. 925 a.

BACCIO DELLA PORTA,
CALLED FRA BARTOLOMMEO
Florence, ca. 1474-1517

2. *A View of Fiesole*
 Pen and brown ink, 8⁷⁄₁₆ × 11³⁄₁₆ inches
 (214 × 284 mm)

Provenance: Fra Paolino da Pistoia, Florence;
Suor Plautilla Nelli, Convent of St. Catherine,
Florence; Cavaliere Francesco Maria Nicolò
Gabburri, Florence; Mr. Kent; Private
collection, Ireland; Sale, Sotheby's, London,
Nov. 20, 1957, no. 14.

Exhibition: New York, 1965, no. 32.

Bibliography: Gronau, 1957, p.v; Jeudwine,
1957, p. 135; Kennedy, 1959, p. 10; Joachim and
McCullagh, 1979, p. 24.

The Florentine painter Baccio della Porta was per-
suaded by the Dominican preacher Savonarola to
devote himself solely to religious art. Two years
after Savonarola was burned at the stake in 1498,
Baccio himself entered the Dominican order, but
even after becoming Fra Bartolommeo, the artist
continued to study the world around him. In the
tradition of Leonardo, he was a keen observer of
nature, and when he died, more than one hundred
landscape drawings were recorded in his studio
inventory by Lorenzo da Credi.[1] Many of these
disappeared or were attributed to other artists, but
fortunately a group of drawings was preserved in
two large albums that belonged to the artist's heir,
Fra Paolino da Pistoia, who in turn left them to a
nun of the Convent of St. Catherine in Florence.
They were purchased from the convent about 1725
by the collector and art historian Cavaliere Fran-
cesco Maria Nicolò Gabburri (1675-1742). He
removed the landscape studies to make a smaller
album comprising forty-one examples by Fra Bar-
tolommeo (Gabburri believed them to be by
Andrea del Sarto) and two by another hand. That
album was purchased from Gabburri's heirs by an
English dealer named Kent[2] and apparently
remained in English private collections until it was
broken up and sold at Sotheby's in 1957.

The Baer drawing is one of the most beautiful of
the forty-one studies and one of the few in which
the setting has been identified. Although pre-
viously described as a view of Fiesole from the
Mugnone Valley, Chris Fischer notes (in a letter of
Feb. 15, 1985) that the view is taken from the main
square (Piazza Mino da Fiesole) and shows the
"Colle di San Francesco," with the facade of San
Francesco at the upper right and the choir of San
Alessandro at the left. Fra Bartolommeo may have
made it and some of the others in the course of a
journey from Florence to Venice in 1504. Several of
the drawings served as the source of landscape
backgrounds for his paintings,[3] but there is no
doubt that they can also stand as independent
works of art. All the drawings display the same
severe delicacy of mellow brown ink on cream-
colored paper. In the Baer landscape, as Berenson
has written of Fra Bartolommeo's figure drawings,
"we find him, one can scarcely say drawing — the
word seems too ponderous — but rather breathing
onto the paper."[4]

[1]Marchese, 1879, II, p. 185.
[2]See Fleming, 1958, p. 227.
[3]See Härth, 1959, pp. 125-126, and Richards, 1962, p. 172.
[4]Berenson, 1938, I, p. 156.

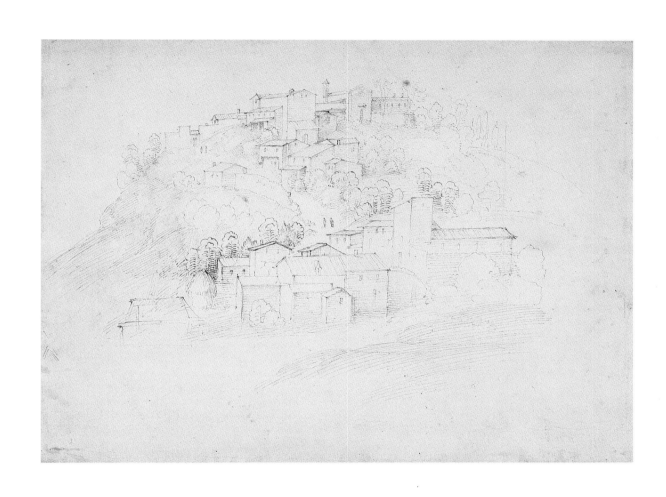

ATTRIBUTED TO TITIAN
Pieve di Cadore, 1477 - Venice, 1576

3. *Two Satyrs in a Landscape*
Pen and bistre ink on paper with a watermark of crossed arrows with a star above, 8½ × 5¹⁵⁄₁₆ inches (216 × 152 mm)

Inscribed in pen at the lower right: *Lovini Milanesi*

Provenance: The Earls of Pembroke; Sale, Sotheby's, London, July 5-10, 1917, no. 318; Henry Oppenheimer; Sale, Christie's, London, July 10-14, 1936, no. 42; E. & A. Silberman, New York.

Exhibitions: Montreal, 1953, no. 51; Middletown, 1955; Cambridge, 1958, no. 1; Newark, 1960, no. 21; New York, 1965, no. 59; Washington, D.C., etc., 1974-75, no. 8; Venice, 1976, no. 13.

Bibliography: Strong, 1900, VI, no. 54; Tietze, 1936, I, pp. 156 and 239; II, p. 319; Tietze and Tietze-Conrat, 1936, p. 169; Mayer, 1937, p. 310; Pallucchini, 1937, p. 33; Pallucchini, 1944, p. 80; Tietze, 1944, no. 1948, pl. LIX; Tietze, 1950, pp. 31 and 405, pl. 7; Brendel, 1955, p. 118; Bauch, 1965, p. 38; Panofsky, 1969, pp. 192-193; Koschatzky et al., 1971, under no. 61; National Gallery, 1973, p. 415, fig. 20-2; Wethey, 1969-75, III, p. 56; Rearick, 1976, pp. 40-43; Pignatti, 1976, p. 268; Rearick, 1977, pp. 182 and 185; Gould, 1977, p. 46; Pignatti, 1977, p. 168; Oberhuber, 1978, pp. 112-113; Rearick, 1978, p. 27; Pignatti, 1979, p. 7, no. VII.

Given the rarity and importance of universally accepted Titian drawings, it seems worthwhile to recapitulate the critical history of this drawing.

An inscription identifies the drawing as the work of the Milanese painter Luini. This is highly unlikely, and about 1900 the work was more properly ascribed to the Venetian school. When it was sold at the Oppenheimer sale (1936), the drawing was attributed by K.T. Parker (with some hesitation) to Domenico Campagnola, but he acknowledged its affinity to Dosso Dossi, an idea which Brendel later adopted. Pallucchini preferred to think of Sebastiano del Piombo, as did Agnes Mongan in the 1958 Cambridge catalogue. It was the Tietzes who first made the attribution to Titian, pointing out the similarity of the satyr at the right to a figure in Titian's *Pardo Venus* at the Louvre (fig. 1), which is believed to be an early painting completed at a later date by the artist. Mayer and Panofsky, considering the work a copy, both rejected the Titian attribution, but more recently Oberhuber, Rearick, and Pignatti have wholeheartedly endorsed the attribution. A dissenting opinion has been voiced (in conversation) by Charles Hope, who felt that not only was the handwriting on the sphere not Titian's, but also that the work was too crude and the connection to the *Pardo Venus* too tenuous to be considered positive evidence, as a similar pose also appears in Dosso Dossi's *Bacchanal*.[1]

The interpretation of the drawing is as problematic as its attribution. The juxtaposition of the "satyrs" with the celestial sphere and the meaning of its astrological markings have never been fully explicated. Panofsky, basing his explanation on the composition's relationship to the *Pardo Venus*, wrote that the "satyr" group represents the contemplative life and the figures are actually Pan "disclosing the movement of the universe to another sylvan divinity — perhaps Silvanus."[2]

The pastoral setting with charming buildings set amidst gentle hills and the short abrupt strokes used to compose the field remind one of a number of the other drawings considered early works by Titian.[3] Other figures with a similar mass of curly hair are the *St. Eustace* (British Museum) and *Sleeping Shepherd* (Louvre).[4] In these works also occur the heavier outlines on the bodies, which in the case of the Baer drawing have sometimes been thought to be later reinforcements. What, however, is more problematic is a certain confusion in the depiction of the anatomy, and it is this which still leads to hesitation in assigning the drawing to Titian.

[1] National Gallery, London. See Gibbons, 1968, pl. 19.
[2] Panofsky, 1969, p. 193.
[3] Pignatti, 1979, pls. III-V.
[4] Ibid., pls. XVII and XXXII.

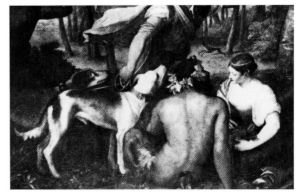

Fig. 1: Titian, *The Pardo Venus* (detail), The Louvre, Paris.

BATTISTA FRANCO
Venice, ca. 1510–1580

4. Recto: *Study of a Woman*
 Black chalk

 Verso: *Standing Man* (*Samson?*)
 Pen and ink, 15⅜ × 5⅛ inches
 (390 × 130 mm)

 Provenance: Jonathan Richardson, Jr., London
 (L. 2170); Colnaghi's, London, 1962.

Although a Venetian by birth, Battista Franco formed his style in Rome, where he arrived about 1530.[1] Franco was greatly influenced by the work of Michelangelo, whose style he aped effectively in drawings. But, according to Vasari, he met with little success when he attempted to incorporate this style into his large-scale paintings in Florence and Rome. He found a haven in the more provincial setting of Urbino, where, beginning in 1545, he worked for Duke Guidobaldo, designing majolica vases and festival decorations as well as painting frescoes. By 1554 Franco had returned to his native city and his work took on a more painterly Venetian manner.

 This double-sided sheet is fascinating because it reveals two aspects of Franco's draftsmanship clearly indebted to Michelangelo. The highly finished black chalk study of a monumental female figure is reminiscent of allegorical figures in drawings by Michelangelo[2] as well as in his sculpture and paintings.[3] The pose of this figure seems to have been adapted by Battista Franco for Strength in a fresco (ca. 1560) at the Grimani Chapel.[4] The elongated male nude on the verso looks like a hybrid of a Michelangelesque pen drawing and a ruined antique sculpture. The figure may be holding a jawbone, in which case the drawing may represent Samson, although there is nothing heroic about the man, who resembles some of the spectral allegorical figures in other drawings by Franco.[5] Franco is not known as an architect, but he is so intent on imitating Michelangelo that he includes fragments of architectural designs such as occur on many sheets by Michelangelo.

[1]Rearick, 1959, p. 107.
[2]See Wilde, 1978, p. 152.
[3]See especially the figure of Night at San Lorenzo and the Magdalen in the *Noli me tangere* that Franco copied after Michelangelo. See Proccaci, 1965, pl. 108.
[4]Rearick, 1959, pp. 126-127, fig. 10 m.
[5]Examples are in the Ashmolean, the Ambrosiana, and the Uffizi.

LUCA CAMBIASO
Moneglia, 1527 - Madrid, 1585

5. *Christ and the Apostles Going to Emmaus*
 Pen and ink on paper with a watermark of
 a mermaid, 12⅛ × 9⅛ inches
 (308 × 234 mm)

6. *Christ and the Apostles Going to Emmaus —
 Back View*
 Pen and ink on paper, 13¼ × 9¾ inches
 (355 × 248 mm)

 Provenance: Mrs. S. Maison, London, 1956.

 Exhibition: Cambridge, 1958, nos. 7 and 8.

The opulent frescoes of Luca Cambiaso, the most
important painter of sixteenth century Genoa, dec-
orate many of the city's palazzos and churches. In
1583 Cambiaso was invited by Philip II of Spain to
be his court painter, and he worked at the Escorial
for the rest of his life.

An amazingly prolific draftsman, Cambiaso
developed a distinctive rapid style of pen drawing.
His at times almost abstract approach is the result of
his method of working after geometric dolls
arranged to form his composition. Apparently
both Cambiaso and his students made drawings of
these figures from various angles, or else the stu-
dents copied Cambiaso's originals, for in many
cases there are versions of varying quality. This
practice of working from three-dimensional mod-
els is certainly responsible for this pair of drawings,
especially the unusual depiction of the pilgrims
seen in back view. Christ and the two apostles on
the road to Emmaus was the subject of a lost fresco
by Cambiaso in the cloister of the monastery of San
Lorenzo at the Escorial, and these two drawings
and several others[1] are probably related to that
project. In this case the crisp line and direct applica-
tion suggest the hand of the master himself. There
are copies of both compositions with wash added:
the depiction of the figures in front view is in the
Uffizi,[2] and the drawing in back view is in the
museum of Besançon.[3]

[1]Bremen and Zurich, 1967, no. 81; Sale, Sotheby's,
London, Dec. 7-10, 1920, no. 18.
[2]Inv. no. 1614. See Suida-Manning and Suida, 1956, fig.
435.
[3]Inv. no. 1458 (Gernsheim no. 8358).

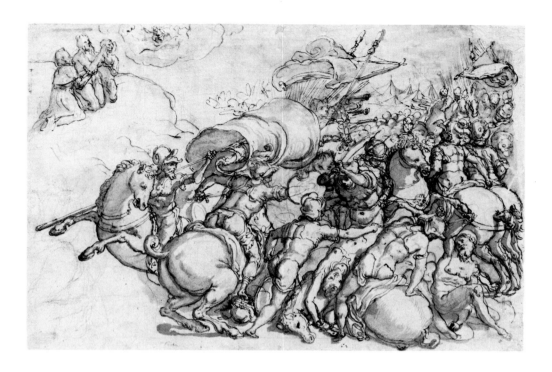

NICCOLO MARTINELLI,
CALLED IL TROMETTA
Pesaro, ca. 1540 – Rome, 1611

7. *Moses at the Battle of Israel and Amalek*
Brown ink and wash with pen and brush
over black chalk, 10¹³⁄₁₆ × 16 inches
(274 × 405 mm)

Provenance: Victor Spark, New York, 1955.

Exhibition: Indianapolis, 1954, no. 36;
Cambridge, 1958, no. 4.

Bibliography: Gere, 1963, p. 394; Gere, *MD*,
1963, p. 17, no. 32.

Niccolò Martinelli, known as Niccolo da Pesaro or
Il Trometta, was established in Rome by early 1565,
when he received a commission for one of his many
fresco decorations. His frescoes are so much in the
style of Taddeo Zuccaro that it is assumed he
worked as an assistant to that master. His most
important project was the decoration of the vault of
the choir of S. Maria in Aracoeli, completed in
1568.

Among the forty-two drawings identified by
Gere as the work of Trometta, this is one of only

two with an Old Testament subject. Unlike most of
the other drawings, it is not on blue paper. The
subject here is taken from Exodus 17:8-16, which
describes how the Israelites, commanded by
Joshua, were successful in battle against the forces
of Amalek only so long as Moses held up his hands
in prayer. To assure victory, Aaron and Hur, who
were with Moses on a nearby hilltop, each held up
one of his hands until the sun set. The contrast in
scale between the figures of Aaron, Moses, and
Hur at the left and the intertwined mass of warriors
in the foreground is typically mannerist. Such com-
plex battle scenes were found in the work of Vasari
and the Zuccari. Federico Zuccaro had devoted two
fresco series to the story of Moses, and the
printmaker Antonio Tempesta created two engrav-
ings of this subject that are somewhat similar in
composition to the drawing.[1] As Gere has observed
of Trometta, "the thick, tremulously undulating
contour with which he circumscribes his forms is
something which he derives from Taddeo Zuccaro,
but in Trometta's hands it conveys a particularly
intense, and unmistakably characteristic, illusion of
massiveness and weight."[2]

[1]Bartsch-Buffa, 1984, nos. 60, 70.
[2]Gere, *MD*, 1963, p. 11.

ULISSE SEVERINO DA CINGOLI,
CALLED MESSER ULISSE
Cingoli, ca. 1540 - ca. 1600

8a. *Farm Buildings in a Landscape*, 1567
Pen and brown ink, 6⅛ × 8⅝ inches
(155 × 220 mm)

Inscribed at the top edge: *casa gia d[i]
Gioso sotto la romita Sto Gir[oni]mo
R[icarate] dal suo boschetto d[i]. ♀ .30 d[i]
Maggio, 1567*

8b. *Rock with Trees*, 1567
Pen and brown ink, 5⅞ × 8½ inches
(150 × 215 mm)

Inscribed at the top edge: *scoglio sotto sto
Angelo, qu[ello] se vi alla romita allongo,
ricavato d[i]. ☾ li. 16 d[i] giugno. 1567*

Provenance: P. Cassirer, Amsterdam, 1962.

Bibliography: Bolten, 1969, p. 142, nos. 111 and 112.

J. Bolten identified a group of more than one hundred and fifty landscape studies, including these two drawings, as the work of Ulisse Severino da Cingoli, a cultivated amateur artist. The drawings range in date from 1560 to 1597. Some are studies after nature in The Marches; others were inspired by paintings and prints of such artists as Lavinia Fontana and Hieronymous Cock. On many of the sheets Messer Ulisse noted both the place and the date, and even specified the day of the week by using a planetary symbol. In the inscriptions seen here, the symbol ♀ indicates Venus or Thursday, and ☾ represents Luna or Monday.

Although Messer Ulisse is not a major figure in the history of art, his spirited drawings, inspired by the Flemish tradition, possess a lively charm.

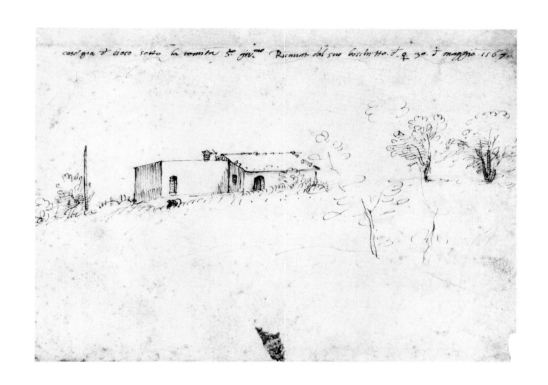

casa già d cioso sotto la romita S. giu.me Ricauar dal suo boschetto. d. q. 30. d maggio .1567.

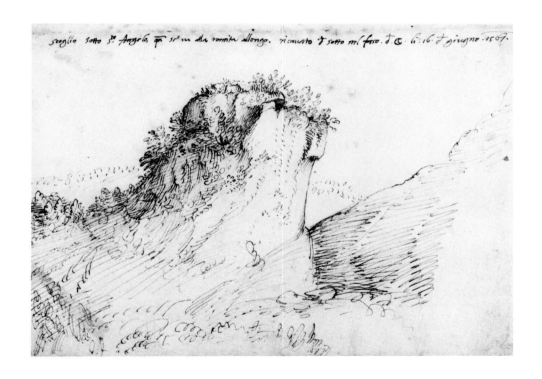

scoglio sotto S. Angelo, qui se u alla romita allongo. ricauato d sotto ml foro. d. C. li. 16. d giugno .1567.

BARTOLOMEO PASSAROTTI
Bologna, 1529-1592

9. Recto: *Study of a Left Arm, a Bending
Woman, a Madonna and Child, a Torso of a
Bearded Man, and a Rearing Horse*
Inscribed at right: *lo che paegr ... / di tal
vast no / saglio* (?)

Verso: *A Seated Male Nude in Back View
and Various Anatomical Studies*
Inscribed at right: *questa / parte / un / posta
adosso...*
Pen and ink on paper with a watermark of
an angel, 11⁷/₁₆ × 7⅞ inches
(290 × 200 mm)

Provenance: Dr. L. Pollak (L. 7886).

Exhibition: Cambridge, 1958, no. 3; Ottawa,
1982, no. 11.

Passarotti studied architecture with Jacopo Vignola
and by 1551 had gone with his teacher to Rome.
After working as a printmaker with Taddeo Zuc-
caro, he settled in his native Bologna, becoming
famous as a portraitist and painter of still lifes and
genre scenes. Inspired by the drawings of
Michelangelo and Bandinelli, Passarotti developed
a singular style of tight cross-hatching that he used
particularly for his many anatomical subjects.
Studies such as this one, which considers a left arm
from various angles, may have been made for an
instructive album, for he conducted a school where
Agostino Carracci, among others, received his
training.

Passarotti's drawings combine anatomical stud-
ies with a wide variety of other themes. The bend-
ing woman on the recto of this sheet, who appears
to be sewing or plucking a chicken, may be related
to some of the artist's genre paintings. On the same
side are a Virgin and Child and the torso of an old
man, possibly St. Jerome. The sculptural torso on
the verso is based on the famous Belvedere torso.

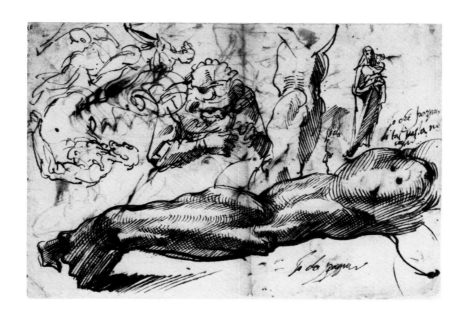

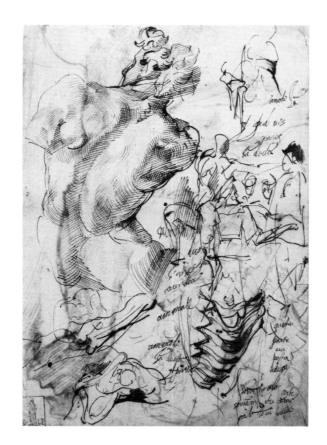

AGOSTINO CARRACCI
Bologna, 1557 - Parma, 1602

10. *Head of a Woman*
Red chalk with traces of black chalk on
buff paper, 13⅝ × 9¾ inches
(347 × 249 mm)

Provenance: Jonathan Richardson, London
(L. 2170); John Skippe; to his descendants the
Martin family, including Mrs. A. D. Rayner-
Wood; Edward Holland Martin; Sale,
Christie's, London, Nov. 20-21, 1958, no. 63.

Exhibitions: London, 1938, no. 372; New
York, 1962, no. 7; New York, 1967, no. 5;
Indiana University, 1983-84, no. 15.

Bibliography: Gealt, 1984, pp. 106-107.

Agostino Carracci, the older brother of the more
famous Annibale, first studied with Passarotti and
then worked as a printmaker with Domenico
Tibaldi. He collaborated with Annibale and their
cousin Ludovico on the fresco decorations of the
Palazzo Fava (1584) and the Palazzo Magnani (1592)
in Bologna, and then worked with Annibale in
Rome on the Palazzo Farnese from 1597 until 1600,
when they supposedly quarreled. Agostino then
went to Parma to work for Duke Rannuccio Far-
nese, for whose palace he painted a fresco cycle.

A poet, a musician, and a master of printmaking
as well as painting, Agostino was probably chiefly
responsible for the founding of the celebrated Car-
racci academy in Bologna. His fame as an artist was
great — especially for his altarpiece *The Last Com-
munion of Saint Jerome* (Pinacoteca Nazionale,
Bologna) — and he was given an elaborate funeral.[1]

Although he adopted a more mannered style in
his late work, Agostino for the most part seems to
have shared Annibale's concern for a direct, natural
observation of people and events. This red chalk
drawing, which the collector John Skippe
attributed to Agostino about 1800, is one of several
forthright head studies now assigned to the mas-
ter.[2] The clearest evidence of Agostino's authorship
is the similarity of this drawing to the signed and
dated 1598 portrait of Giovanna Parolini-Guicciar-

dini now in the Staatliche Museen, Berlin-Dahlem
(fig. 2).[3] In both works an older woman is shown in
rigid frontal pose. The broad planes of the face are
emphasized and the features — large eyes, heavy
nose, and tightly drawn lips — are similar, as is the
use of the wide collar to frame the head. In the
drawing, which dispenses with further indications
of costume, the compelling intensity of the model-
ing endows the head with a timeless quality remi-
niscent of antique portrait busts. A few sprigs of
leaves offset the severity of the face.

[1]See Enggass, trans. 1968, pp. 104-122.
[2]Examples are reproduced in the exhibition catalogue,
Bologna, *Disegni*, 1963, pls. 36 and 37. See also Witt-
kower, 1952, nos. 164-172; and Joachim and McCullagh,
1979, no. 46.
[3]Bologna, *Dipinti*, 1956, pl. 46.

Fig. 2: Agostino Carracci, *Portrait of Giovanna
Parolini-Guicciardini*, Dahlem Museum, Berlin.

30

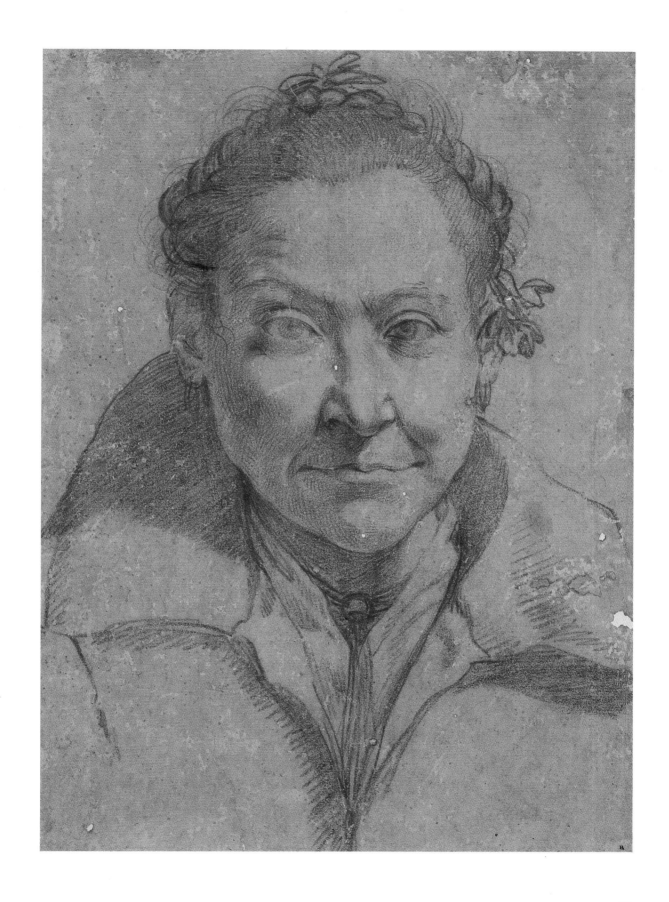

31

BOLOGNESE SCHOOL
17th century

11. *Landscape with Icarus and Daedalus*
 Pen and brown ink over black chalk,
 10⅝ × 7⅛ inches (270 × 181 mm)

 Numbered in pen and brown ink at lower
 left: *15*

 Inscribed in pen at lower right: *Icaro e
 Dedalo*; and on the verso in ink: *Tintoretti /
 130*, and in pencil: *Caracci / 23/5/2*

 Provenance: H. M. Calmann, London, 1960.

 Exhibitions: New York, 1962, no. 9; New
 York, 1967, no. 7 (as Agostino Carracci).

This fine and unusual drawing has never been satis-
factorily attributed. It was formerly ascribed to
Agostino Carracci, but it is quite different from his
work. The pen style, especially in the landscape and
the fisherman, is more reminiscent of Annibale
Carracci's, whose plans for the Farnese Gallery
included a representation of this subject. However,
not only is the pen work less felicitous than Anni-
bale's, but also the design of the Farnese Gallery
fresco painted by his assistants is very different,
with the boatmen dominating the scene and the
tiny figures of Daedalus and Icarus seen in the
distance. That design follows a long-standing tra-
dition (exemplified by Pieter Bruegel's famous
work in Brussels) of contrasting the fate of the
falling boy with the everyday routine of other mor-
tals. In this drawing, on the other hand, the empha-
sis is on the drama of the two flying figures.
According to the myth, Icarus flew too close to the
sun (here rather naively made a participant in the
action by the addition of a face) and his wax wings
melted. As depicted here, he began to lose feathers,
and his father, the master inventor Daedalus, could
do nothing but look on in despair. The literary
treatment of the theme, as well as the pen style,
suggests an artist working in Bologna.

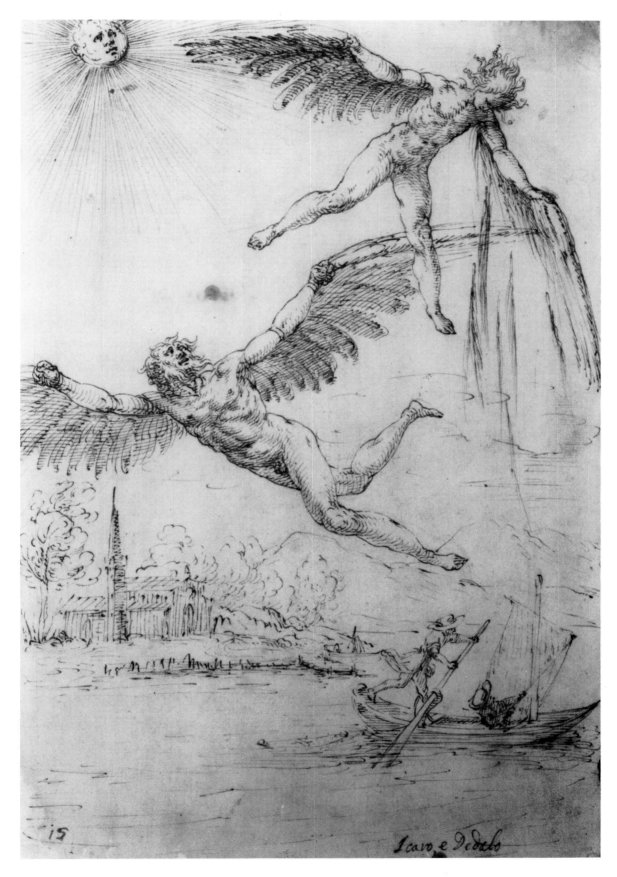

Icaro e Dedalo

33

GIOVANNI FRANCESCO BARBIERI,
CALLED IL GUERCINO
Cento, 1591 - Bologna, 1666

12. *Esther and Ahasuerus*, ca. 1637
Pen and brown ink, 7³/₁₆ × 9¼ inches
(180 × 235 mm)

Provenance: Jan Pietersz. Zoomer (L. 1511);
Mrs. Ralph Booth, Detroit.

Exhibition: Cambridge, 1958, no. 5.

Bibliography: Horton, 1960, p. 16.

After he returned to Cento from his exciting
Roman sojourn of 1621-23, Guercino established
himself as one of the most successful and conscien-
tious seventeenth century Italian artists. For his
many commissions for religious subjects, he
employed a distinctive oblong format with the fig-
ures shown up close in half or three-quarter length.
To arrive at his final composition, he made innu-
merable pen studies. This sheet represents an early
phase of his thinking on the subject of Queen
Esther and King Ahasuerus, which was commis-
sioned by Cardinal Magalotti in 1637. When the
painting was completed two years later, it passed to
Cardinal di Sant'Onofrio, who presented it to his
brother the Barberini Pope, Urban VIII.[1] The
painting, which is now in the University of Michi-
gan Museum of Art at Ann Arbor (fig. 3),[2] depicts
Esther fainting before the King, an Apocryphal
episode long popular with artists.[3] The Baer draw-
ing shows one of the other meetings between the
King and his Queen; judging from her determined
pose and his surprise, it could be the moment in
chapter 7 of the Book of Esther when she tells him,
"I and my people have been sold to be destroyed, to
be slain, and to perish."[4] Studies of the imperious

king alone include one of him facing right (sold at
Christie's, London, Nov. 23, 1971, no. 106) and one
facing left (sold at Christie's, London, April 11,
1978, no. 49). Preliminary studies for the final com-
position with the fainting Queen supported by two
women include one sold at Sotheby's, London
(March 23, 1978, no. 157), and one — possibly a
studio copy — at Windsor Castle (no. 2517).

The Baer drawing is an excellent example of the
shorthand style Guercino evolved when he was
working rapidly — the looping swirls to indicate
draperies, the claw-like hand of the king, and the
series of dots and short strokes to indicate the shad-
ing on Esther's face. As in many cases the *première
pensée* is more exciting and lively than the rather
bland finished product.

[1] See Vivian, 1971, p. 23.
[2] Detroit, 1965, no. 102.
[3] Pigler, 1956, I, pp. 198-199.
[4] *The Apocrypha*, trans. Goodspeed, 1959, p. 171.

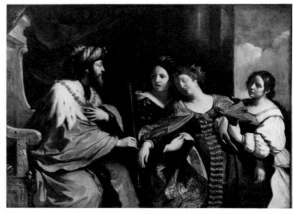

Fig. 3: Guercino, *Esther before Ahasuerus*, 1639, The
University of Michigan Museum of Art.

34

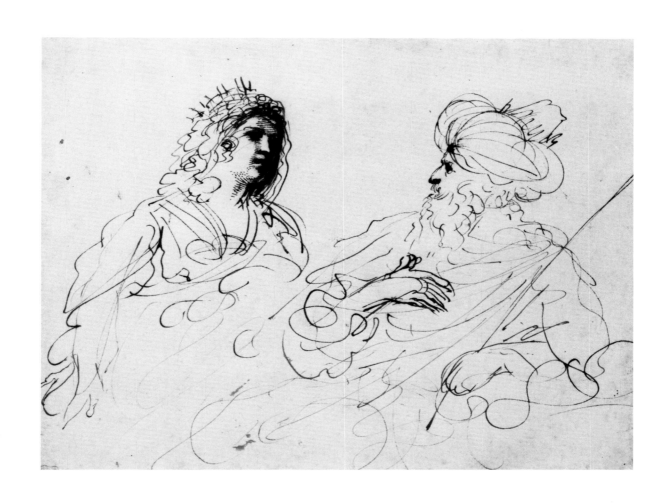

GUIDO RENI
Bologna, 1575-1642

13. *Study of Hands*
 Black chalk on blue paper with white
 highlighting, 8¼ × 11¼ inches
 (210 × 285 mm)

One of the greatest Italian Baroque artists, Reni perfected a tender "ideal" manner that was well suited to the many religious commissions he received. His training began in Bologna with the Flemish painter Denys Calvaert, who passed on to him an elegant mannerist style derived from Parmigianino. Reni entered the Carracci academy about 1595, the year of Annibale Carracci's departure for Rome; he no doubt learned the school's drawing methods from Annibale's cousin Ludovico. Reni himself went to Rome in about 1600 and remained there for fourteen years, absorbing the influences of Caravaggio and the new classicism, and painting such major works as the *Aurora* ceiling in the Casino Rospigliosi (1613-14). After returning to Bologna, he shifted away from fresco painting to oil painting, developing a lighter and freer treatment.

The hands of the figures in Reni's compositions convey more emotion than the passive, idealized faces. This sensitive drawing, which has been accepted as Reni's work by both Denis Mahon and Stephen Pepper (in conversation) exemplifies the care he took in the planning of such poetic effects. The attention to detail and the three-dimensional modeling reveal his debt to the Carracci school. A similar study of hands attributed to Annibale Carracci is in Besançon.[1] Another chalk study of folded hands by Reni which is in the Scholz collection has been identified as a study for San Carlo Borromeo in the *Pietà dei mendicanti* of 1614 in Bologna.[2]

The delicate handling of the black chalk on blue paper seen here is characteristic of Reni's mature work. A similar pose was employed by Reni for the Virgin in the *Immaculate Conception* in the Church of San Biagio, Forlì,[3] and a *Virgin in Contemplation* in a private collection, Rome.[4]

[1]Bologna, *Disegni*, 1963, no. 96, fig. 50.
[2]Vienna, 1981, no. 56, and Detroit, 1965, no. 85.
[3]Baccheschi, 1971, p. 104, no. 136; Hibbard, 1969, fig. 6.
[4]Pepper, 1984, pl. 226.

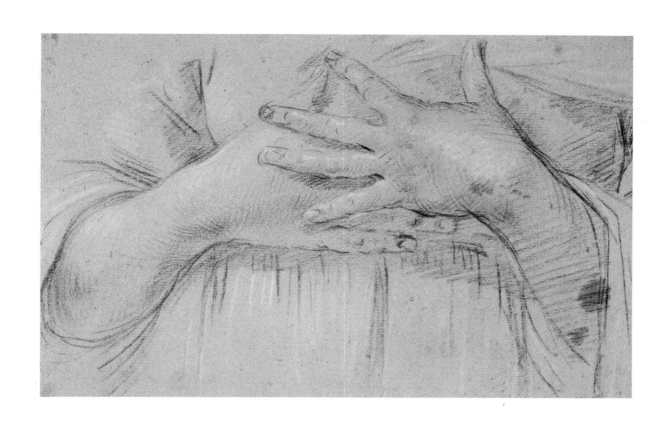

SALVATOR ROSA
Naples, 1615 - Rome, 1673

14. *Two Men Gesticulating over the Body of a Third*
Pen and brown ink with brown wash,
7¾ × 7⁷⁄₁₆ inches (197 × 189 mm)

Provenance: Sir Thomas Lawrence (L. 2445); Miss MacIntosh; Sale, Sotheby's, London Nov. 10, 1954, no. 5; Cassirer, Amsterdam, 1957.

Exhibition: Cambridge, 1958, no. 10.

Bibliography: Mahoney, 1977, I, p. 218, no. 12.5.

Rosa, a poet, playwright, and musician as well as a painter, received his earliest training in Naples. The local Spanish-inspired taste influenced his early choice of subject matter — battle pictures, landscapes, and low-life genre scenes. In 1635 he went to Rome. He was in Florence from 1641 to 1649, and then returned to Rome, where he remained for the rest of his life. Although he continued to paint large romantic landscapes after his return to Rome, classical and historical subjects, often with philosophical or moralizing intentions, became more frequent.

Rosa was known for his impetuous, even violent, temperament, and this element of his personality is evident in the verve of his drawings. This example is one of a small group of studies dating from the 1640s which Michael Mahoney characterizes as drawings "of very high quality in which transparent washes give body to the fluently rendered pen figures."[1] These drawings have not been related to any painting or print by the artist, and they may be simply extemporaneous, freely improvised sketches. The Baer drawing and one in the Uffizi (Mahoney, 12.4) depict the discovery of a body. Here the force of the dramatic diagonals seems to explode the small sheet, and we marvel at Rosa's brilliant rendering of the difficult perspective of the prone figure.

[1]Mahoney, 1977, I, p. 215.

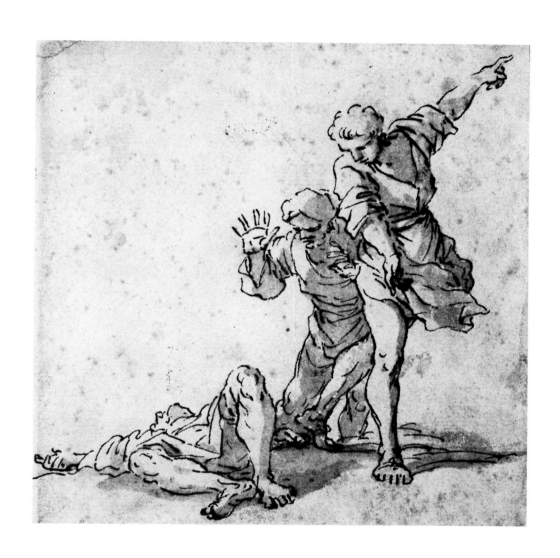

BACCIO DEL BIANCO
Florence, 1604 - Madrid, 1656

15. *Study for Sigismondo Buonaroti Ordering the Reinforcement of the Fortifications at Modigliana*
Pen and ink, 15⅞ × 10⅞ inches (403 × 276 mm)

Inscribed upside down in pen at the right center above the fold: *Di Baccio del Bianco*; and below the fold: *Modigliana fortificata da Gismondo Buonaroti*

Baccio del Bianco was a talented Florentine stage and costume designer as well as a painter. He studied with Giulio Parigi and Bilverti and collaborated with Stefano della Bella. From 1620 to about 1630 Baccio worked with the architect and military engineer Giovanni Battista Pieroni in the service of Emperor Ferdinand II in Vienna. Returning to Florence, he assisted Alfonso Parigi with festival designs for the Medici wedding of 1637.[1] In 1651, he went to Madrid to work for Philip IV.[2]

This drawing was first identified as a Baccio del Bianco by Annamaria Petrioli Tofani (in a letter of May 3, 1982). As the inscription indicates, the drawing has the same subject as one of the artist's frescoes in the Casa Buonarroti in Florence, painted in 1637-38.[3] That fresco in the *stanza della notte e del dì* depicts "Gismondo Buonarroti [Michelangelo's youngest brother], podestà and commander at Modigliana, ordering the reinforcement of the fortifications in preparation for the attack of the French forces of Maréchal Lautrec in 1528" (fig. 4).[4]

The drawing, done in Baccio's sprightly style on a sheet of paper filled with calculations, shows the elements of the finished painting — Gismondo accompanied by a soldier and a page, the workers with their tools, and the distinctive fortified tower behind. Baccio himself, according to his biographer Baldinucci, worked in Modigliana,[5] so the fortification is probably an actual study rather than imaginary. In the fresco the composition has been further refined to make Gismondo more prominent. It is evident that Baccio drew with greater facility than he painted; the whirling lines and schematized faces indicate how easily he could turn his talents to satirical caricatures.[6]

[1] Dartmouth, 1980, no. 86.
[2] Masser, 1977, pp. 365-75.
[3] Baccio's involvement with the Casa Buonarroti went back at least a decade, as evidenced by his 1628 preliminary drawing and fresco of *The Astronomers*. See Thiem, 1973, pl. 178 and fig. 300.
[4] Procacci, 1965, p. 180, pl. 52.
[5] Baldinucci, 1812 ed., 12, p. 422.
[6] See Gregori, 1961, pp. 410-415.

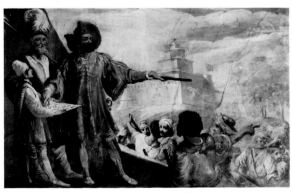

Fig. 4: Baccio del Bianco, *Gismondo Buonarroti at Modigliana*, fresco at the Casa Buonarroti, Florence, 1637-38; courtesy Gabinetto Fotografico, Soprintendenza beni artistica-storia dell'Arte, Florence.

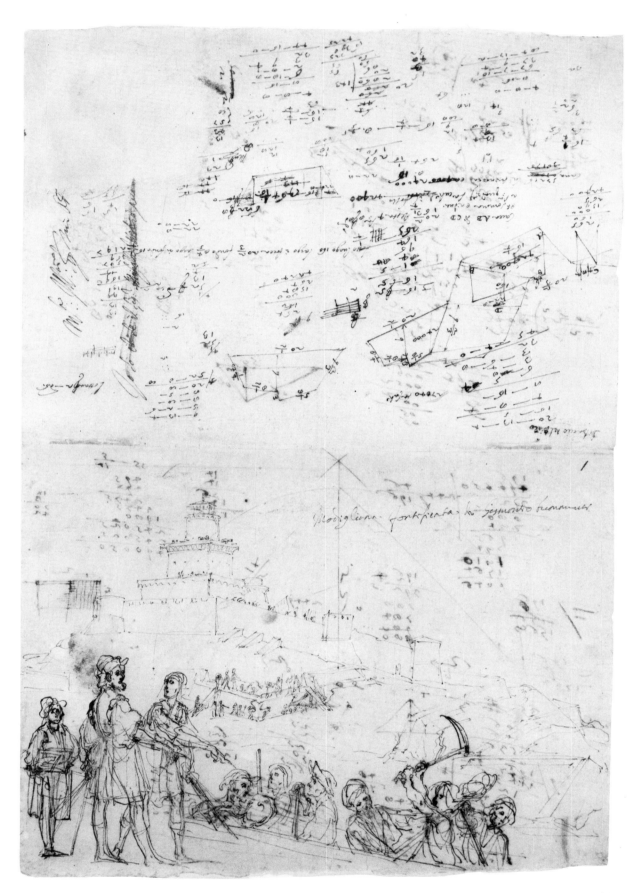

STEFANO DELLA BELLA
Florence, 1610-1664

16. *Study of an Eagle*, ca. 1651
Brown ink and wash, 4¼ × 4⅞ inches
(106 × 123 mm)

Provenance: Library of Kinnaird Castle; Lord
Gainsborough; Earl of Southesk; Arcade
Gallery, London, 1946.

Exhibition: London, 1946, no. 48 (?).

Active in both Italy and France, della Bella was one
of the most popular seventeenth century
printmakers, designers, and scenographers. He
received his earliest training from goldsmiths and
studied printmaking in the workshop of Cesare
Dandini, but the chief influence on him was the
work of Callot, who was in Florence until 1621.
Like Callot, della Bella became court artist for
Lorenzo de' Medici (brother of the Grand Duke
Cosimo II), who sent him to further his studies in
Rome from 1633 to 1636. After a short return to
Florence to help with the festivities for the marriage
of Ferdinando II and Vittoria della Rovere, della
Bella went to Paris, where he worked until 1650.
Through the patronage of Anne of Austria and
Cardinal Richelieu, he received many important
commissions such as the *Siege of Arras*, and he
collaborated with French printmakers and pub-
lishers on a wide range of engraved series. In 1647
he made a trip to the Netherlands and probably met
Rembrandt. After his return to Italy, he stayed in
Rome and in Florence, where he was employed by
Prince Mattia de' Medici.

Della Bella was fascinated by the wonders of
nature. Cornelius de Bie, writing in 1661, noted
that in his landscapes "birds are singing, waters are
rushing and leaves are trembling."[1] Among his
prints and drawings are many devoted to birds and
other animals. About 1651 he produced a series of
seven etched prints of eagles,[2] and the present work
is one of many drawings apparently made in prepa-
ration for that project. This and two similar studies
formerly in the Leverton Harris collection[3] are
related to two plates from the Eagle series (figs. 5
and 6). Another eagle sheet is in the Louvre,[4] and
one with three studies was sold at Sotheby's in
London (April 9, 1981, no. 91).

The Baer drawing came from an album of della
Bella drawings that had been at Kinnaird Castle and
contained several other studies of eagles. In this
example, though della Bella adheres to the delicate,
small format with touches of wash that he favored,
he convincingly depicts the bird's cold, piercing
glance, the harsh line of its beak, and the powerful
talons.

[1] Quoted in Koschatzky, et al., 1971, under no. 81.
[2] Masser-de Vesme, 1971, I, p. 113, nos. 720-725, II, p.
137.
[3] Sale, Sotheby's, London, May 22, 1928, no. 29B; sold
again at Christie's, London, March 18, 1975, no. 7; and
exhibited Milan, 1976, nos. 51 and 52.
[4] Viatte, 1974, no. 261.

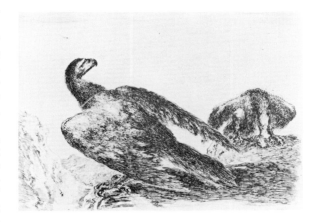

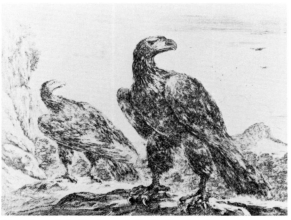

Figs. 5 and 6: Stefano della Bella, *Eagles*, etchings.

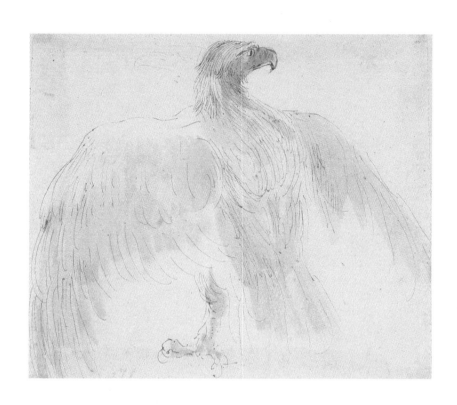

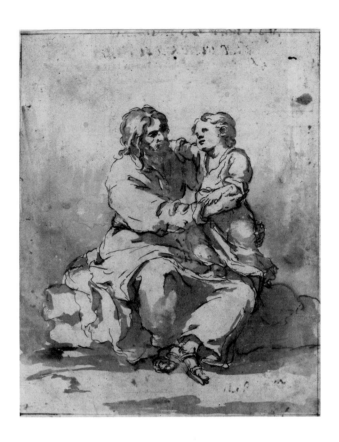

BARTOLOME ESTEBAN MURILLO
Seville, 1617-1682

17. *St. Joseph and the Christ Child*
Pen and brown ink with brown wash on
white paper with the watermark *MCGG*,
9⁷⁄₁₆ × 7³⁄₁₆ inches
(250 × 192 mm)

Inscribed in pen on the remains of an old
mount: *bartolome murillo f.*

Provenance: C. Morse; Sale, Sotheby's,
London, July 4, 1873, no. 153(?).

Exhibitions: Cambridge, 1958, no. 12;
Princeton, 1976, no. 36; Madrid and London,
1982-83, no. D.9.

Bibliography: Brown, 1973, p. 33.

Although Murillo was one of the leading Spanish
artists of the seventeenth century and had a long
and prolific career, including a term as co-president
of the Drawing Academy which flourished in
Seville from 1660 to 1674, only a few of his draw-
ings survive. This seems due in part to the indif-
ference of Spanish painters and collectors to
drawings as anything but preparatory studies or
teaching tools.

Murillo's most characteristic drawing style,
employing pen and wash with strong contrasts of
light and dark, was probably learned from the ear-
lier Sevillean painter Francisco de Herrera. Murillo
perfected this technique to achieve the delicate
sfumato effects suitable for sweet religious subjects
such as this one.

A revived devotion to the image of St. Joseph
was a prominent aspect of Counter-Reformation
iconography.[1] Angulo Iñiguez has attributed to
Murillo a number of paintings of St. Joseph hold-
ing the Christ Child.[2] None of these is specifically
based upon the Baer drawing, although the poses in
one (no. 326) are quite close and the figure types in
another (no. 328) are similar. The composition is
obviously derived from the traditional Virgin and
Child theme. In the drawing neither figure has a
halo, but a devotional tone is established by the
expression of the two figures. The Christ Child
looks with rapt countenance up and into the dis-
tance, and the humble, saintly Joseph regards the
boy with a mixture of awe and sadness. It is little
wonder that such a splendidly pathetic composi-
tion was repeatedly copied.[3]

[1]See Knipping, 1974, I, pp. 117-119.
[2]Angulo Iñiguez, 1981, III, pls. 402-405 and 593-600.
Another wash drawing by Murillo shows the Saint and
Child walking together. See Madrid and London, 1982-
83, fig. 60.
[3]Two were illustrated in Princeton, 1976, figs. 14 and 15,
and a third was noted as having been in the collection of
Louis Philippe that was sold in 1852.

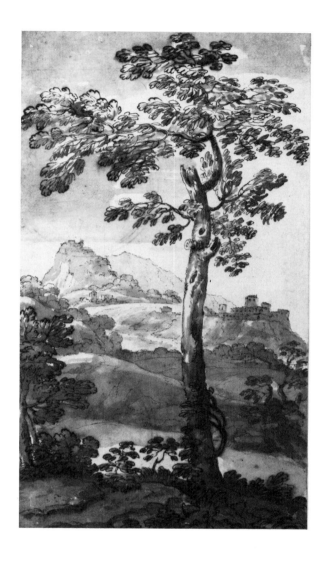

GIOVANNI FRANCESCO GRIMALDI
Bologna, 1606-Rome, 1680

18. *Mountain Landscape with Castle*
Brown ink and wash, 10⅞ × 5⅜ inches
(264 × 148 mm)

Provenance: Thos. Agnew and Sons, London,
1962.

Bibliography: Chiarini, 1972, p. 42, ill. 75.

Grimaldi, who is sometimes referred to as Il Bolognese, received his training in the Carracci tradition of his native city. From this source he seems to have absorbed both his interest in landscape and the schematic pen style he sometimes employed. By 1635 he was in Rome, where he was recorded as a member of the Accademia di S. Luca; he became president of the Accademia in 1666. Grimaldi had a highly successful career in Rome as a painter of fresco decorations and was even called to Paris in 1648 to assist Romanelli in the decor of the Galerie Mazarine.[1] Although he prepared architectural, theatrical, and commemorative projects, he was best known for his landscapes, which were influenced not only by Carracci and Domenichino, but also by Claude and Gaspard Dughet, his contemporaries in Rome.

Grimaldi was a prolific draftsman. Many of his drawings, as in this case, are independent, highly finished studies in pen and wash of idyllic landscapes. Similar drawings of a single noble tree contrasted with a distant vista of a castle are in the Royal Collection, Windsor Castle,[2] and at Holkham Hall.[3] They may be related to some of his decorative landscape paintings, such as the series at the Borghese.[4]

[1]See Batorska, 1972, pp. 145ff.
[2]Kurz, 1955, no. 311, pl. 46.
[3]London, Agnew's, 1977, no. 62.
[4]See della Pergola, 1955, I, nos. 75-78.

GIOVANNI BATTISTA PIAZZETTA
Venice, 1682-1754

19. *A Young Man Embracing a Girl*, ca. 1743
 Black chalk heightened with white on
 faded blue paper with the watermark
 H P or H R, with a strip added at the right,
 15⅝ × 12½ inches (396 × 315 mm)

 Provenance: H. A. Vivian Smith; Sale,
 Christie's, London, May 20, 1955, no. 43.

 Exhibitions: Cambridge, 1958, no. 11; New
 York, 1971, no. 38; Washington, D.C., 1983,
 no. 45.

 Bibliography: Mariuz, 1982, pp. 132-133, no.
 D15.

Piazzetta was one of the outstanding artists of eigh-
teenth century Venice, where he established an aca-
demic training program on the lines of what he had
observed during his studies in Bologna. Drawing
played a primary role in this system, and it was for
his book illustrations and his highly finished pre-
sentation drawings, rather than for his religious or
genre paintings, that Piazzetta was chiefly
renowned. His large, airy chalk drawings — and
the engravings made from them — were ideal deco-
rations for Venetian rooms.

In 1743, fourteen of Piazzetta's head studies, pri-
marily of youthful couples and exotic figures, and
all apparently commissioned by the English collec-
tor Consul Joseph Smith, were engraved by
Giovanni Cattini for a publication entitled *Icones ad
vivum expressae*. The present drawing appeared as
plate six (fig. 7). For many of his presentation
drawings Piazzetta studied members of his own
family, and the girl here is probably his fourteen-
year-old daughter Barbara Agiola. The boy appears
in other drawings, such as those at Windsor Castle.

While some of the *Icones* drawings seem to have
erotic implications, this one is extremely tender.
The figures appear as if caught in a moment of
private reverie. Piazzetta's technical mastery of
chalk and white heightening is evident in the fig-
ures' animated expressions and the subtle grada-
tions of tone which suggest the textures of skin and
garments.

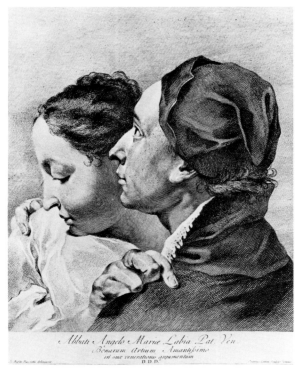

Fig. 7: Cattini after Piazzetta, *A Young Man Embracing
a Girl*, engraving, 1743.

46

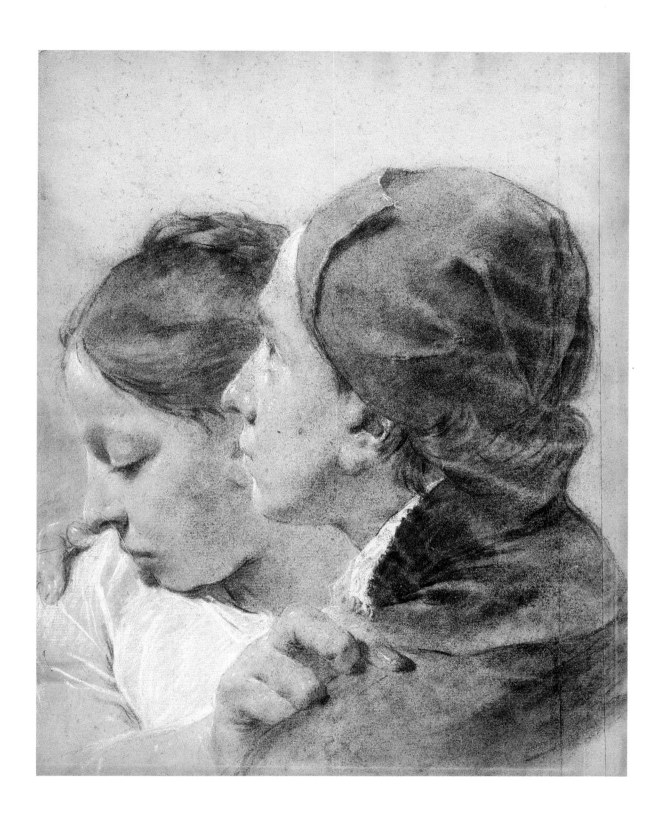

GIOVANNI BATTISTA TIEPOLO
Venice, 1696 – Madrid, 1770

20. *Figure of a Man Seen from Below*
 Pen and bistre wash on paper with a
 flower watermark, 9⅜ × 7⅞ inches
 (238 × 199 mm)

 Numbered *127* at the lower right corner,
 and *50* at the middle of the lower edge

 Provenance: S. Thalheimer.

 Exhibition: Cambridge, 1958, no. 9.

This drawing is quite close in style and subject to
the many sheets once found in an album of Tiepolo
drawings entitled *Sole Figure per Soffitti*, probably
executed in the 1740s[1] and now dispersed among
many collections. One of the most similar of these
drawings is the *Male Figure Carrying a Bowl* in the
Yale University Art Gallery.[2] The steep perspective
of these drawings suggests that the figures were
intended for a ceiling, but very few have been spe-
cifically identified as studies for a known project.[3]
They seem rather to be brilliant exercises which
Tiepolo compiled into what Jacob Bean has
described as "a kind of pattern book" with a reper-
tory of poses that could be "drawn upon when a
ceiling decoration was undertaken by the studio."[4]
Each sheet, however, remains an immaculate gem
of spontaneous creation.

[1]Knox, 1964, p. 8.
[2]Yale, 1970, no. 309, pl. 167.
[3]Mras, 1956, pp. 50-51.
[4]Princeton, 1966, p. 54.

48

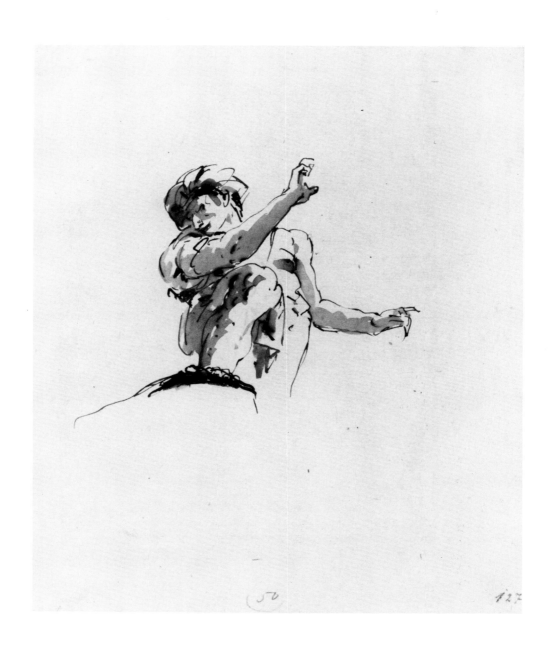

GIOVANNI DOMENICO TIEPOLO
Venice, 1727-1804

21. *St. Lawrence Carried Up to Heaven by Angels*
Pen and grey ink, with grey wash,
10¾ × 7¾ inches (274 × 197 mm)

Signed at the lower left: *Dom. Tiepolo f.*

Provenance: Francesco Guardi; Horace Walpole; The Earl of Beauchamp; Sale, Christie's, London, June 15, 1965, no. 41.

Giandomenico was very much his father's son, having been trained by Giovanni Battista and having assisted him in the fresco decoration of the Würzburg Residenz (1750), at Udine (1759), at Strà (1761), and finally in the Royal Palace in Madrid and the Church of Aranjuez (1762-1770). After his return to Venice, although he continued to paint large-scale religious works, he increasingly devoted himself to smaller paintings and drawings of landscapes, costumes, mythological subjects, and humorous genre.

Giandomenico developed a distinctive style of drawing, using jagged lines overlaid with wash, that is filled with vitality and is particularly appropriate for scenes of rapturous emotion such as this St. Lawrence. He produced twenty-two etchings of the Flight into Egypt, and seems to have made a point of demonstrating that he could create count-less variations on such themes as God the Father in the Clouds supported by angels and cherubs, Christ Received into Heaven, the Assumption of the Virgin, and the apotheosis of various saints.[1] Compositions by his father certainly helped to inspire these airborne figures,[2] but Giandomenico derived from them every conceivable variant, so that each sheet becomes a tour de force of his *invenzione*. St. Lawrence, as George Knox points out (in a letter of November 1984) appears in paintings by Giandomenico in Strasbourg and one formerly in Milan.[3]

This drawing of *St. Lawrence Carried Up to Heaven* was one of five treatments of the subject in an album that was probably assembled between 1783 and 1797. The album was apparently sold by Giandomenico's uncle, the painter Francesco Guardi, to the English writer and collector Horace Walpole. In this now dispersed series Giandomenico varied the position of the saint's arms and head and the placement of his attribute, the grill. The Baer drawing is the only one in which St. Lawrence is given a halo. The signatures are in a different ink from the drawings, suggesting that they were added by the artist at a later date.

[1]See Byam Shaw, 1962, pp. 32-33.
[2]See Morassi, 1962, pls. 87-90, 93, and 226; and Mariuz, 1971, pls. 312-327.
[3]Mariuz, 1971, pls. 263 and 328.

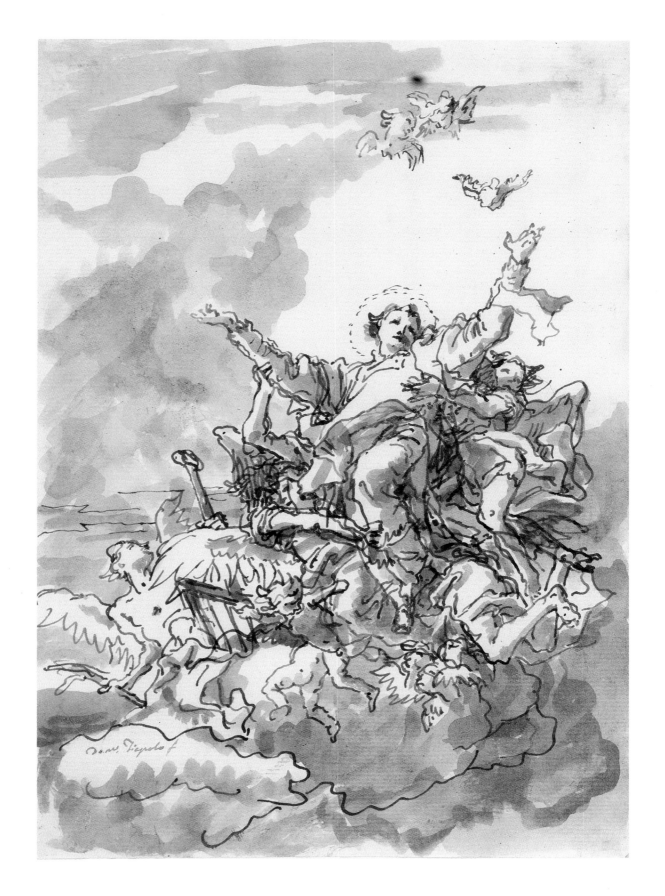

51

Dutch, Flemish, & German

MASTER OF THE STORY OF TOBIT
Netherlandish, ca. 1475-1500

22. *Jacob's Dream*
 Pen and ink on brown paper,
 8³⁄₁₆ × 7¼ inches (210 × 184 mm)

 Exhibition: Cambridge, 1958, no. 13.

The sorting out of the different hands of the few surviving Early Netherlandish drawings is a difficult task, especially as the works of the greatest masters were frequently copied by lesser artists. The anonymous draftsman of this drawing was inspired by the example of Hugo van der Goes. The figures of Jacob and Rachel in the right background derive from the central figures in Hugo's extraordinary drawing at Christ Church, Oxford.[1] Perhaps the motif of Jacob's dream also occurred in a lost drawing by Hugo. If the composition of the figures is similar to Hugo's work, the lack of intensity and the disunity of foreground and background are not.

The Baer work stylistically resembles a drawing at Windsor Castle and one at Dresden which illustrate scenes from the apocryphal Book of Tobit. A. E. Popham called the artist the "Master of the Story of Tobit"[2] and related the two drawings to a series of glass roundels illustrating the Tobit story, one of which — *Tobias Opening the Fish* — is in the Musée de Cinquantenaire, Brussels.[3] It seems likely that the Baer drawing was part of another series devoted to the stories of Joseph and Jacob, for roundel designs for *Benjamin Taking Leave of His Father* in the Ashmolean[4] and *Joseph Interpreting Pharaoh's Dreams*, Stuttgart,[5] are attributed to the same hand, as is a scene of feasting in the British Museum.[6]

[1]See Friedländer, 1967, IV, pl. 102.
[2]See Popham, 1928, p. 177. The Windsor Castle drawing, *Tobias and the Fish*, is no. 12952, and the Dresden drawing represents *The Angel Leaving Tobit and Tobias*.
[3]Ibid., p. 176.
[4]Parker, 1938, I, p. 4, no. 8.
[5]Inv. no. 1735. Photo in RKD no. 2018.
[6]Inv. no. 1961-2-11-1. See London, 1964, no. 44.

CIRCLE OF JAN GOSSAERT,
CALLED MABUSE
Netherlandish, early 16th century

23. *King Solomon* (?)
Pen and black ink on paper with a
fragment of watermark of a figure 4
suspended from a circle, 7⅜ × 3½
inches (185 × 90 mm)

Inscribed on the plinth of the pilaster:
1521

Provenance: Marquis de Valori; Sale, Nov.
25-26, 1902, no. 2 (as A. Altdorfer); E.
Rodrigues; Sale, Frederik Muller & Cie,
Amsterdam, July 12-13, 1921, no. 31.

Exhibitions: Cambridge, 1958, no. 19;
Rotterdam and Bruges, 1965, no. 50.

Bibliography: Van der Osten, 1961, p. 454;
Winkler, 1962, p. 145, ill. 8; Haverkamp-
Begemann, 1965, p. 404; Herzog, 1968, II,
pp. 412-13; III, pl. 109.

Following a trip to Italy in 1508–09, Gossaert was
one of the chief artists to introduce a Renaissance
style into the Netherlands. His paintings of the
period immediately after his return, such as the
Malvagna triptych in Palermo, show a blend of
Italianate decorative forms with a Gothic over-
abundance of detail. The same fantastic quality is
evident in the design of this small drawing. Boon
(in a letter of December 9, 1984) reiterates the idea
that the date 1521 is a later addition, and stylistically
the work is similar to earlier Gossaert drawings
such as the *Mystic Marriage of St. Catherine* in
Copenhagen,[1] the *Virgin and Child with Saints*,
Amsterdam,[2] and the *Emperor and Sibyl* in Berlin.[3]
Both Haverkamp-Begemann and Jacqueline Folie
(in conversation) have expressed doubt that the
drawing is by Gossaert, and suggest instead that it
is by one of his many followers.

The subject of the drawing is not clear. An Old
Testament scene, it was identified as "King Sol-
omon in his Palace" in the 1902 sale catalogue. The
elaborate garb and the scepter held by the man in
the foreground suggest a potentate, and Solomon is
a possibility since the figure seems to be worship-
ping idols.

[1]Rotterdam and Bruges, 1965, no. 43.
[2]Washington, etc., 1958-59, no. 12.
[3]Folie, 1951, p. 79, fig. 1.

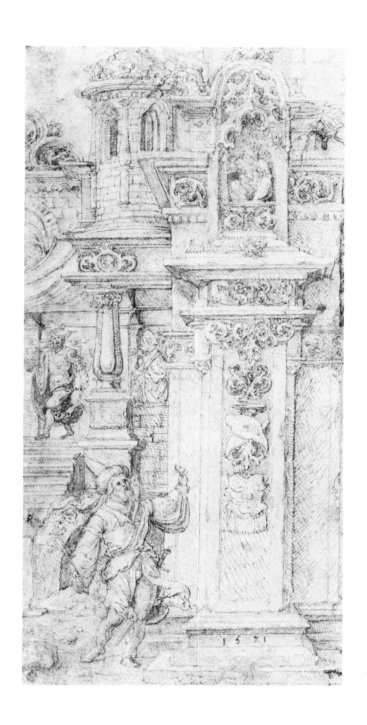

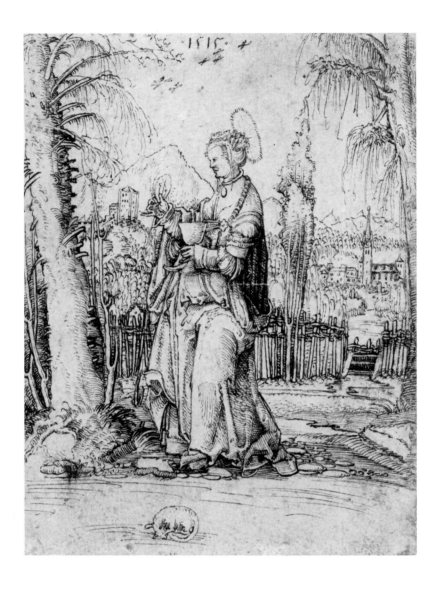

DANUBE SCHOOL
German, early 16th century

24. *St. Barbara in a Landscape*
Pen and black ink, 5¹³⁄₁₆ × 4³⁄₁₆ inches
(147 × 107 mm)

Inscribed at the top center: *1515*; and at
the lower left: *GV*

On the verso, a black chalk sketch of a
nude woman with flying drapery.

Provenance: Prince Liechtenstein.

Exhibition: Cambridge, 1958, no. 56 (as
school of Niklaus Manuel Deutsch).

The name Danube School is used to designate the
artists active in South Germany and Austria
(especially in river cities such as Regensburg and
Passau) in the first half of the sixteenth century. The
most outstanding artists of the Danube School
were Albrecht Altdorfer and Wolf Huber, whose
works are characterized by a dynamic proto-
Romantic style and the overwhelming importance
of landscape. Particularly in the drawings, the pres-
ence of divine or miraculous forces in nature is
conveyed by pulsating lines. The impact of the
Danube School style was felt in Switzerland, par-
ticularly in the works of Niklaus Manuel Deutsch.
In the Baer drawing the landscape, as Alan Shestack
(in a letter of Jan. 28, 1985) has confirmed, is related
to the work of Huber,[1] but the figure and her
costume are much closer to Deutsch,[2] to whom
Agnes Mongan attributed the drawing in the Fogg
exhibition of 1958. The figure of the saint and the
exuberant vegetation complement each other, a

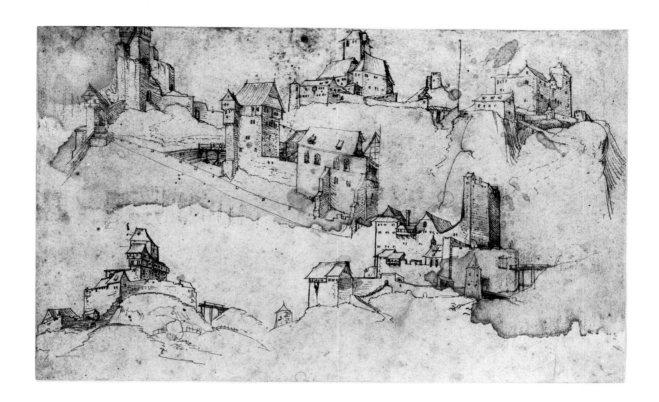

typical effect of Danube School works.

The third century St. Barbara was extremely popular in the imagery of the Danube School. Secluded by her father in a tower to discourage suitors, she turned to Christianity, resisted all efforts to break her faith, and was finally decapitated. In Germany her traditional attribute, the tower, was either supplemented or replaced by a chalice surmounted by a consecrated Host, for she was commonly invoked for protection against death without benefit of the Holy Sacraments.[3] This drawing shows the saint with a halo, dressed in billowing robes and carrying the chalice and Host. She is similarly depicted in drawings by Albrecht[4] and Erhard[5] Altdorfer and Urs Graf,[6] among others. The curious and rather poorly drawn dog in the foreground is an unusual addition.

[1] Winzinger, 1979, pls. 12 and 38.
[2] See von Mandach, etc., Basel, pls. 72 and 73.
[3] Washington and New Haven, 1981, p. 78.
[4] Winzinger, 1952, pls. 62 and 63.
[5] Oettinger, 1959, fig. 20.
[6] A drawing of 1515 in Basel.

GERMAN
Early 16th century

25. *Studies of Castles*
Pen and black ink on paper with a watermark of a high crown,
7⅛ × 11⁷⁄₁₆ inches (181 × 291 mm)

Provenance: Prince Liechtenstein.

Exhibition: Cambridge, 1958, no. 55.

These lively studies of medieval castles and town gates observed from various angles have been related by both Winkler and Geissler (in correspondence) to the Karlsruhe sketchbook of Hans Baldung Grien.[1] But in the Karlsruhe drawings and Grien's other sketches of castles,[2] there are usually more elaborate landscape settings. This sheet was probably drawn by a contemporary Augsburg artist — perhaps Jörg Breu, who depicted very similar buildings in the backgrounds of his paintings.[3]

[1] See Martin, 1959.
[2] See Karlsruhe, 1959, no. 137, and Bernhard, 1978, pp. 166 and 167.
[3] See especially Benesch and Buchner, p. 353., pl. 255.

NETHERLANDISH
First quarter of the 16th century

26. *Five Nude Soldiers and Three Nude Women*
Brush drawing heightened with white on
a prepared green ground,
11⁵⁄₁₆ x 8⁷⁄₁₆ inches (287 × 214 mm)

Inscribed at the upper center: *1522*

Provenance: Prince Liechtenstein, Feldsberg.

Exhibition: Cambridge, 1958, no. 14 (as
Swiss).

Bibliography: Schönbrunner and Meder, IV,
no. 432.

Although authorities such as Stechow and Geissler
have recently expressed the opinion that this
unusual drawing is German, the original attribu-
tion by Schönbrunner and Meder to the early
Netherlandish School seems more convincing and
has been supported (in correspondence) by Eisler
and Falk. The date of 1522 inscribed on the sheet
appears to be authentic, and the drawing is consis-
tent in style — particularly in the use of the colored
ground and the treatment of the women — with a
drawing of the *Judgement of Paris* in the National
Gallery of Scotland that has been identified as a
work of the Flemish School, ca. 1520.[1] Panofsky,
who believed that the drawing was German, sug-
gested that since the standards held by the men
seemed to have been inspired by Colonna's *Hyp-
nerotomachia Poliphili*,[2] it might be a fragment of a
design for a triumph.[3] The presence of three female
nudes makes one think of the many representations
during this period of the Judgement of Paris, but in
this case the women appear to be prisoners. Possi-
bly the subject is related to the theme of witchcraft
and enchantment.

[1] Vasari Society, VII, pl. 7.
[2] See Calvesi, 1980, ill. 39-40.
[3] In Cambridge, 1958, p. 27.

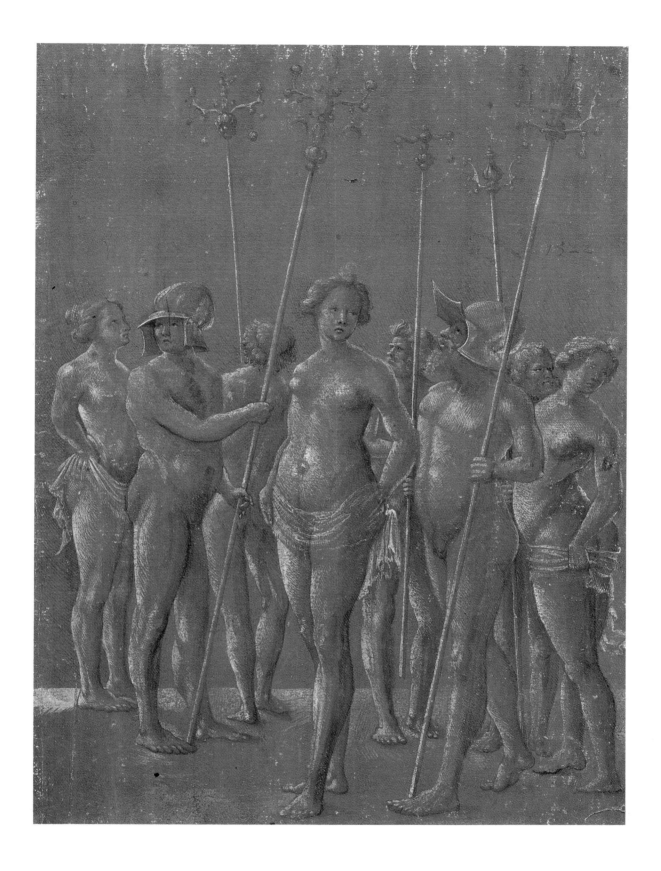

MAARTEN VAN HEEMSKERCK
Heemskerck, 1498 - Haarlem, 1574

27. *The Triumph of Job*, 1559
Pen and brown ink, 7⅛ × 10⅜ inches
(182 × 262 mm)

Signed and dated at the lower right: *M. vã Haemskerch / 1559 inventor*

Provenance: Freiherr Richard von Kuehlmann.

Exhibitions: Middletown, 1955; Cambridge, 1958, no. 15.

Bibliography: Hoetink, 1961, p. 15; Veldman, 1977, p. 62; Oberhuber, ed., 1977, p. 124; W. Robinson in Providence, 1983, p. 173.

Heemskerck received his early training in Haarlem and Delft; his most important master was Jan van Scorel. Following this painter's example he went to Italy. He was in Rome by 1632, according to Vasari; there he studied the works of Michelangelo and filled notebooks with drawings of antiquities and the Roman countryside. After his return to Haarlem, by 1637, he immediately began receiving commissions for major altarpieces. He achieved important social rank by marrying a wealthy woman. Heemskerck was an artist of tremendous industry, and in addition to his paintings, he made many designs for prints. Van Mander wrote that Heemskerck "had a very nice way of drawing with the pen, his hatchings were very neat, his touch loose and fine."[1]

The impetus for Heemskerck's activity as a designer of prints may have come from the poet-philosopher Dirck Volkertsz. Coornhert (1522-90), who conceived the complex allegorical subjects of the prints, engraved them, and published them. This drawing is for the fifth plate in the 1559 Heemskerck-Coornhert series *The Triumph of Patience* (fig. 8). As Veldman has observed, this series can be "read from the first print to the last as a succession of stages through which man passes on his way to the ultimate goal of divine mercy . . . the artist elected to use the scheme of the allegorical triumph which was so popular in the fifteenth and sixteenth centuries and was based on the *triumphus* of classical time."[2]

The opening image of Patience seated in a chariot drawn by Hope and Longing is followed by six prints of figures from the Bible, five from the Old Testament and one from the New Testament. Each figure rides a beast and is shown with incidents from his life, emblems, and Latin verses recounting his triumph. The series concludes with an image of the triumphant Christ.[3] In addition to the Baer drawing, other preliminary drawings, all dated 1559, are known. The drawings for the triumphs of Isaac, Joseph, and St. Stephen (plates 2, 3, and 7) were formerly in the Koenigs collection and are now in the Boymans-van Beuningen Museum.[4] The drawing for the fourth plate, *The Triumph of David*, is in the Museum of Art, Rhode Island School of Design,[5] that for the triumph of Tobias (plate 6) is in the H.R. Bijl collection, The Hague, and *The Triumph of Christ* drawing is in the Steiner collection.[6]

Fig. 8: Coornhert after Heemskerck, *The Triumph of Job*, engraving, 1559.

Job, also the subject of a 1562 series of Heemskerck engravings,[7] displayed astonishing patience in the face of adversity. The inscription on the engraving of his triumph helps to explicate the drawing:

> When Job had lost all his possessions after trial without number, after so many difficulties and so many torments of every kind by which he was tested by the hostile devil, and by his friends and deceitful wife, his faith yet enabled him to endure all those trials steadfastly, and he remained as strong as a tortoise, whose shell no one can break.[8]

Thus Job is riding on a tortoise, pulling along Satan, Job's wife, and his three false friends. In the background are episodes of his afflictions, the destruction of his possessions, the loss of his children and livestock, and the scene of the dung heap. On his banner are a winged heart (a symbol of hope), a balanced scale (emblem of even temperament), and a flaming sword and the orb of the world, signifying Christ's power to turn man's desires away from worldly things. The drawings for this series, all of which were incised and successfully transferred into engravings, were widely admired, and Vasari commented that they were "designed by Maarten with a bold and practiced hand, the manner being very like that of the Italians."[9]

[1] Stechow, 1964, p. 37.
[2] Veldman, 1977, p. 63.
[3] Hollstein, VIII, p. 240, nos. 120-127.
[4] See Hoetink, 1961, pp. 16-18, figs. 9-11.
[5] Providence, 1983, no. 58.
[6] Oberhuber, ed., 1977, no. 481.
[7] See Hoetink, 1961, pp. 12-15, and Andrews, 1967, p. 381, pl. 13.
[8] Translated in Veldman, p. 66.
[9] Vasari, 1851 ed., III, p. 520.

Hans Bol
Mechlin, 1534 – Amsterdam 1593

28. *Landscape Vista*, 1587
 Pen and grey wash on white paper,
 6⅝ × 9¹⁵⁄₁₆ inches (168 × 237 mm)

 Signed and dated at lower right edge:
 Hans Bol 1587

 Provenance: Prince Liechtenstein.

 Exhibition: Cambridge, 1958, no. 27.

 Bibliography: Franz, I, 1965, pp. 54, 58, 64,
 ill. 124.

Hans Bol was one of the most important landscape
artists of the generation after Pieter Bruegel the
Elder. He came from a family of artists and worked
in Heidelberg, Antwerp, and Amsterdam. Bol's
drawings and paintings typically present a pan-
oramic landscape view, usually, as in this case, of a
village tucked into a mountain valley. Bol dated
many of his works, so it is possible to understand
his chronological development. This drawing from
the later part of his career shows his increasing use
of dramatic contrasts of light and dark. There may
even be elements of fantasy in the depiction of this
scene. Many of Bol's landscapes are peopled with
Biblical figures, and Franz has pointed out that the
Baer drawing is somewhat similar to a landscape
drawing with the prophet Elisha (ca. 1588) in
Frankfurt.[1]

[1] Franz, 1965, p. 54.

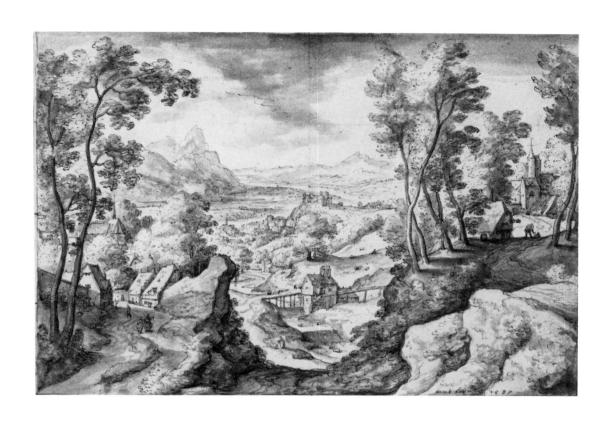

ROELANDT SAVERY
Courtrai, 1576 – Utrecht, 1639

29. Recto: *Seated Peasant and Standing Peasant Woman with Back Basket*
Pen and light brown ink over black chalk

Annotated in brown ink at the lower left: *R. Savery* (disfigured by a later effort to transform it into *Bruegel*)

Inscribed near the figures with the color notations: *grisse mus / omberre / rock / witte koūsen / swartte mus / wit / swartte mantel / swartte rock / nar het le . . . /*

Verso: *Peasant in Profile and Woman Seen From the Rear*
Black chalk on paper with a letter "W" watermark, 3¹⁵/₁₆ × 5½ inches
(100 × 140 mm)

Provenance: Prince Liechtenstein.

Exhibitions: Montreal, 1952, no. 7; Cambridge, 1958, nos. 17, 18.

Bibliography: Kurz, 1936, p. 5, fig. 2; de Tolnay, 1952, recto, no. 82, pl. LIV-top, verso, addendum no. 2; van Gelder, 1960, p. 33; Munz, 1961, nos. 77, 78; New York, etc., 1969, p. 30; van Leeuwen, 1970, p. 26; Spicer, 1970, p. 23; Berlin, 1975, p. 157; Spicer-Durham, 1979, p. 627, 629-630, nos. C196, F191, C198, F193.

Savery had trained and worked in Holland, but by late 1603 he was in Prague, apparently called into the service of Emperor Rudolf II. According to Sandrart, in 1606-07 the Emperor sent Savery to make studies in the Alps. His drawings of the wild forests and mysterious mountains provided the basis for Savery's paintings of fantastic decaying buildings and landscapes filled with strange birds and plants. By 1614, the artist had returned to the Netherlands. He seems never to have returned to the court in Prague or Vienna.

This is one of about eighty drawings referred to as the "*naer het leven*" ("taken from life") group after the phrase written on many of them. Most are devoted to sketches of Bohemian peasants and are inscribed with copious color notations. For many years they were attributed to Pieter Bruegel the Elder, but recently Spicer and van Leeuwen have offered convincing arguments that the handwriting, drawing style, and nature of the subject matter are Savery's.[1] Other scholars, however, maintain that the group contains works by various artists, one of whom may be Bruegel.[2]

It seems likely that Savery produced these lively drawings as a record of the interesting people he saw in Prague during the years 1603-09. Some of the figures were later incorporated into his paintings. In this case, the seated peasant on the recto is repeated on a sheet in Stockholm[3] and in reverse in a painting of a *Rocky Landscape* in the Museum at Geneva.[4] These remarkable studies reveal Savery as an innovator in the development of realistic genre.

[1] Van Leeuwen, 1971, pp. 139-149.
[2] Brown, 1975, p. 832.
[3] New York, etc., 1969, no. 48.
[4] Ghent, 1954, pl. 6.

PAULUS VAN VIANEN
Utrecht, ca. 1570 – Prague, 1613-14

30. Recto: *Study of the Side of a Rocky Cliff*

Verso: *Dam on a Mountain Stream*
Pen and colored wash, 5⅜ × 7 inches
(137 × 178 mm)

Provenance: Rudolf Wien, New York.

Van Vianen was the son of a goldsmith who trained him in that profession. According to Sandrart, the young artisan went to Florence and Rome but left after encountering difficulties with the Inquisition. By 1596 he was in Munich, where he was accepted as a master in 1599. He next worked in Salzburg, probably in the service of the Archbishop. Emperor Rudolf II appointed van Vianen court goldsmith (*Kammergoldschmied*) to the imperial court in Prague on July 20, 1603. Aside from a visit to Utrecht and a trip through the Tyrolean Alps, he spent the rest of his life in Prague.

Although most famous for his exquisite work in silver, van Vianen also produced paintings, miniatures, and a series of remarkable landscape drawings. Many of these nature studies, like the Baer example, are double-sided, suggesting that they came from a sketchbook the artist kept on his Alpine journey. The drawings may have been made in 1606-07 in the company of Roelandt Savery, who was sent to the Alps by the Emperor to draw "the rare works of nature."[1] Van Vianen's landscape drawings reflect his primary vocation as a goldsmith and medallist. The thin pen lines are quick and lively, as if done with a needle, and the colored washes are of exceeding delicacy. Both the recto's study of an outcropping of rock and the verso's broader view of a dam and waterfall are similar to other drawings by the artist.[2] The naturalism of these charming drawings contrasts with the mannered figure style found in van Vianen's other work.

[1] Spicer-Durham, 1979; and Princeton, 1982, p.158.
[2] See Gerszi, 1982, pls. 36, 40, 42, 53, and 103.

PIETER STEVENS
Mechlin, ca. 1567 – Prague, after 1624

31. *A Landscape with a Castle*
 Pen and ink with watercolor wash in
 blue, green and red, 7⅞ × 10½ inches
 (196 × 267 mm)

 Bibliography: Zwollo, 1982, pp. 98-99, fig. 5.

Stevens is a charming landscape artist of the Prague
school who has only recently, through the research
of An Zwollo, gained just recognition. He came
from a family of artists in Mechlin but was proba-
bly trained in Antwerp, where he became a master
in 1589. The following years he spent in Italy
undoubtedly in contact with other Netherlandish
artists such as Hendrick van Cleef and Paul Brill.
Stevens's landscape views were engraved by Sadeler
and Hondius, which must have helped to spread his
fame, for in 1594 he was named a court painter
(*Kammermaler*) by Rudolf II. He remained in Prague
following the Emperor's death, probably in the
service of Prince Karl of Liechtenstein.

The artist's earlier landscapes show the influence
of Coninxloo and Brill; in Prague he came into
contact with Roelandt Savery, another court
painter, and Jan Bruegel, who visited the city in
1604. Stevens developed a vigorous style of his own
which, as can be seen especially in his many land-
scape drawings, is looser, more fanciful, and more
painterly than the styles of his colleagues. This
drawing probably dates from about the time he
arrived in Prague. The lively, somewhat splotchy
rendering of the leaves, the application of color
washes, the sketchily indicated figures, and the
composition — the trees and buildings grouped
with a panoramic view spread out on either side —
are characteristic of his works of the 1590s.[1] The
arrangement seen here of a curving road rising out
of the foreground also occurs (as Zwollo has
observed) in both a painting and other drawings,
including another in the Baer collection (cat. no.
128).[2]

[1] See the examples in Zwollo, 1968, pp. 135-144.
[2] Zwollo, 1982, pp. 97-98.

HENDRICK GOLTZIUS
Mühlbrecht, 1558 - Haarlem, 1616

32. *Head of a Young Gentleman*
 Pen and light brown ink, 3¾ × 3 inches
 (95 × 77 mm)

Signed at the upper right with the artist's
monogram: *HG*

Provenance: D. Muilman collection; Sale,
Amsterdam, March 29, 1773, no. 984; J. L.
van Dussen, Amsterdam; Sale, Amsterdam,
Oct. 31, 1774, no. 944, and March 10, 1777,
no. 48; Rudolf Wien, New York.

Exhibitions: Cambridge, 1958, no. 21;
Poughkeepsie, 1970, no. 52.

Bibliography: Bartsch, 1803, III, pp. 40-41,
no. 131, and p. 112, no. 88; Dutuit, 1881, IV, p.
520, no. 7; Reznicek, 1961, I, p. 389, no. 331;
II, p. 382, fig.384.

Goltzius, a masterful engraver and draftsman
despite a crippled hand, began painting late in his
career. At first he worked in a mannerist style
inspired by Spraenger, but after a trip to Italy in
1590–91 he turned to greater naturalism.

Goltzius's expertise as an engraver is reflected in a
drawing such as this one, in which the bold lines
flow with tremendous energy. He made drawings
of young men in the 1580s that are tighter in han-
dling and more finished.[1] The freedom of this
study led Reznicek to date it about 1600. Reznicek
also called attention to an anonymous early seven-
teenth century engraving of the drawing (fig. 9),[2]
an unusual compliment for such a small work, but
understandable in view of its liveliness.

[1] See the examples in Rotterdam, 1958, p. 39.
[2] Hollstein, VIII, p. 138, no. 565.

Fig. 9: Anonymous engraving after
Goltzius, *A Young Man.*

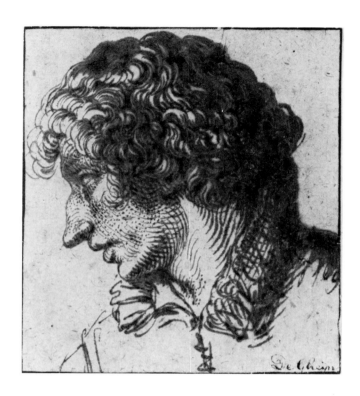

JACOB DE GHEYN II
Antwerp, 1565 - The Hague, 1629

33. *Head of a Young Man*
 Pen and brown ink on brown paper,
 3¼ × 2⅞ inches (82 × 73 mm)

Inscribed at the lower right in brown ink:
De Gheyn

Provenance: J. Werneck, Frankfurt (L. 2561); Sale, Frederik Muller & Cie., June 23-25, 1885; William Pitcairn Knowles, Rotterdam (L. 2643); Sale, Frederik Muller & Cie., June 25-26, 1895, no. 256 with two others; Charles Slatkin, New York.

Exhibition: Cambridge, 1958, no. 22.

Bibliography: Van Regteren Altena, 1983, II, p. 126, no. 781; III, p. 194, pl. 392.

According to J. Richard Judson, de Gheyn's drawings are "in their infinite variety and splendor second only and sometimes equal to the creations of Rembrandt himself."[1] Born into a family of artists in Antwerp, de Gheyn studied in Haarlem and lived in Amsterdam, Leiden, and The Hague, where he was employed by Prince Maurice and his court. He achieved greatest renown as an engraver.

The breadth of his interests is reflected in the variety of his subjects, which range from botany to armaments and from witchcraft to portraiture.

De Gheyn's drawings were made both in preparation for his engravings and occasional paintings and as independent studies. Like his master, Goltzius, he shared the Renaissance fascination with capturing human emotions and defining specific types. He often made several divergent character studies on a single piece of paper,[2] and this small drawing of a youth in profile may have been cut out from such a large sheet. As Carlos van Hasselt has pointed out, this and several other small figure drawings are all inscribed in the same hand with de Gheyn's name.[3] Van Regteren Altena speculated that this was the artist's signature, but it seems more likely that it was applied by the dealer or collector who separated the works. This group of drawings shows the influence of Goltzius and probably dates from the early part of the seventeenth century.

[1] Judson, 1973, p. 9.
[2] Ibid., pls. 80 and 81.
[3] In the entry for the forthcoming catalogue of the Lugt Collection, Paris; the other examples are one in that collection, inv. no. 2008, two in the Hessisches Landesmuseum, Darmstadt, inv. nos. AE406 and 407, and one in the Rijksprentenkabinet, Amsterdam, inv. no. 4389.

ATTRIBUTED TO WILLIEM VAN NIEULANDT
Antwerp, ca. 1584 – Amsterdam, 1635

34. *The Temple of Vesta and Santa Maria in Cosmedin*, 1603
Pen and wash, 7½ × 11 inches
(188 × 280 mm)

Inscribed in pen at the lower right: *In roma 22 april 1603*

Provenance: Sale, Paul Brandt, Amsterdam, March 17, 1959, no. 194.

The name of van Nieulandt has been retained for this drawing not as a certain attribution but to suggest the milieu of northern artists working in Rome in the early seventeenth century. It is evident from the number of versions of such picturesque scenes that these artists either worked together on the same spot or copied one another's drawings and prints.

The identical subject is found in a drawing at the Royal Museum of Fine Arts, Copenhagen (1642-43), attributed to Paul Brill. An Zwollo (in a letter of June 24, 1971) tentatively attributed the Baer drawing to Brill. Zwollo also pointed out that there was a version signed and dated "Heintz in Rome 1611" in Dresden and another in the copy sketchbook at Wolfenbüttel.[1] Another slightly different rendering of the scene, attributed to Paul Brill, was sold at the Hôtel Drouot, Paris (June 7, 1979, no. 15).

The same setting, but from different angles, had served Matthijs Brill for two drawings,[2] and it is known that after his death in 1583 his younger brother Paul enlisted several artists, including Nieulandt, to make copies of his drawings. It appears that Nieulandt employed this drawing in the composition of one of his many etchings of Roman views.[3]

[1] See Thöne, 1960, fig. 8.
[2] One at the Albertina, Vienna, and the other at the Louvre.
[3] Hollstein, XIV, no. 11.

PAUL BRILL
Antwerp, 1554 – Rome, 1626

35. *Landscape with Figures*, 1606
 Pen and bistre and grey wash on white
 paper, 8¹⁵⁄₁₆ × 7¾ inches (227 × 196 mm)

 Signed and dated at the lower left:
 PAVELS / ∞ / 1606

 Provenance: H. S. Reitlinger, London; Sale,
 Sotheby's, London, June 23, 1954, no. 757.

 Exhibition: Cambridge, 1958, no. 25.

After training in Antwerp, in 1574 Paul Brill went
to Rome, where he collaborated with his older
brother Matthijs on fresco projects. Following the
death of Matthijs in 1583, Paul continued for a time
as a fresco painter, working in the Vatican and other
Roman churches and palaces, but by 1590 he had
turned primarily to easel paintings of landscapes.
Over the years his style evolved from a mannerist
one influenced by Muziano to a more naturalistic

one. This development is especially apparent in his
drawings, which have an important position in the
history of landscape depiction, for his student
Agostino Tassi became the master of Claude Lor-
rain.

This drawing is dated 1606 and bears the artist's
device of eyeglasses (the meaning of the Dutch
word *bril*). It is an excellent example of the elaborate
forest scenes Brill created in the early part of the
seventeenth century. Following the mannerist for-
mat of Jan Bruegel and others, the massing of trees
at the left is contrasted with the expanse of open
water and sky at the right. The trees and foliage,
looking as if they had boiled up from the surface of
the earth, form a complex tangle of roots and
branches. The contrasts of light and dark are
heightened by layers of colored washes, and the
small figures are nearly obscured. In Rotterdam
there is a copy of this drawing with only minor
changes that is attributed to Abraham Genoels.[1]

[1] Photograph in the Witt Library, London.

PETER PAUL RUBENS
Siegen, 1577 - Antwerp, 1640

36. *Head of Hercules*
Pen and ink on paper with a winged
eagle watermark, 10¼ × 6⅜ inches
(261 × 162 mm)

Inscribed at the lower left: *P.P. Rubbens
delin*

Provenance: Nathan Marseilles; George Isarlo,
Paris; Shaeffer Gallery, New York City, 1952.

Exhibitions: New York and Cambridge, 1956,
no. 24; New York, 1968-69, no. 45.

Bibliography: Held, 1959, I, p. 114; Miesel,
1963, p. 326, n. 18; Jaffé, 1977, pp. 81, 116,
126, fig. 278; Vlieghe, 1978, p. 473.

When Rubens left Antwerp for Italy in May of
1600, he was an immature, if highly promising,
artist of twenty-two. The eight years he spent in
Italy — employed by the Duke of Mantua, and
working in Rome from July 1601 to April 1602 and
again in 1606 — were the formative ones for the
creation of his mature baroque style. He studied
both Renaissance and ancient art. Though probably
already familiar with engravings (such as those by
Goltzius) after many of the ancient sculptures in
Rome, Rubens made his own drawings of them,
undoubtedly, as Miesel conjectured, "to familiarize
himself with their noble physiques and their elo-
quent poses."[1] One of the most impressive works
was the colossal statue of Hercules that had been
discovered in Rome in 1540. It was housed in the
Palazzo Farnese when Rubens made several
sketches of it.[2] He also probably acquired some
form of small-scale replica, for it continues to reap-
pear in his work as the prototype for his various
Hercules compositions.[3]

The present drawing is either a free improvisa-
tion on the Farnese Hercules or is based on a
slightly different model, for the face is raised to
look straight ahead with Zeus-like grandeur. The
bold, if somewhat crude, pen work is similar to the
style Rubens often employed in this early period.[4]

The drawing was first published as a Rubens in
the 1956 Rubens exhibition at the Fogg and Pier-
pont Morgan. Jaffé has accepted it as an original,
but Vlieghe rejected it. Both Haverkamp-
Begemann (in conversation) and van der Meulen
(in a letter of Dec. 4, 1984) have expressed doubts
about the attribution. Julius Held, however, in a
letter of June 11, 1952, described the work as "a very
fine and characteristic original of Rubens" and later
asserted (in a letter of Nov. 26, 1983) that "the
overall quality is high enough to justify the attribu-
tion."

[1] Miesel, 1963, p. 314.
[2] See Held, 1959, pp. 113-114; Jaffé, 1977, figs. 279-280;
and Berlin, 1977, no. 2. The sculpture is now in Naples.
[3] See London, 1977, no. 72.
[4] See especially Jaffé, 1977, fig. 285; and also Antwerp,
1977, nos. 115 and 117.

P. P. Rubens delin.

REMBRANDT VAN RIJN
Leyden, 1606 - Amsterdam, 1669

37. *Man and Woman Seated at a Table*, ca. 1640
Pen and bistre wash on white paper,
6 × 7¼ inches (152 × 186 mm)

Inscribed on the verso: *Rembrandt van Rein f.*

Provenance: Samuel de Festetis (L. 926); J. C. Ritter van Klinkosch (L. 579); Sale, Wawra, Vienna, April 15, 1889, no. 724; The Prince of Liechtenstein, Vienna.

Exhibitions: Cambridge, 1958, no. 29; Middletown, 1959; New York and Cambridge, 1960, no. 36.

Bibliography: Schonbrunner and Meder, 1896, IV, no.418B; Hofstede de Groot, 1906, no. 1510; Lilienfeld, 1914, p. 144; Valentiner, 1934, II, no.777; Benesch, 1954, II, p. 90, no. 397; Rosenberg, 1956, p. 69.

Jakob Rosenberg has written with great insight:

> The language of Rembrandt's drawing is surely more articulate and intimate, more immediate and more expressive than anything known in the seventeenth century, though this period did not lack genius in draughtsmanship. Rembrandt employed the art of drawing not only in the usual way, as a means of studying the visual world, of storing motifs, or preparing compositions for etching and painting. To him drawing became an art for its own sake, which allowed him to express his visions more speedily, yet no less articulately than any other technique.[1]

These remarks are strikingly illustrated by this mysterious Rembrandt drawing in the Baer collection. Its subject has never been satisfactorily explained. Is it simply a genre scene, as titles like "The Declaration of Love" (proposed by Valentiner) or "The Matchmaker" (proposed by Benesch) would suggest? The psychological tension between the two figures seems too great for this to be the case. The man seems to show anguished concern and the woman calm resignation. Lilienfeld, although mistaken in attributing the drawing to Aert de Gelder, may have been on the right track when he related the subject to a painting of Esther and Ahasuerus. There is something regal about the woman, and her clothes do not seem particularly contemporary. Is she perhaps pregnant? If so, one might think of the subject as a Virgin Mary and a somewhat younger-than-usual St. Joseph. Rembrandt often showed Biblical figures with veils; Mary wears a veil in his drawing of the *Virgin and Child Adored by a Magus* in the Rijksmuseum (Benesch no. 115).

Though the subject of the drawing may never be known, this couple remains a paradigm for the vividness with which Rembrandt could capture human relationships in mere pen strokes. One marvels at the expressiveness of his draftsmanship: the thick line used for the woman's profile is framed by the delicate edge of the veil, and the foot-like folds of the tablecloth on the floor mirror the position of the woman's own feet and seem to embody in their rough shape the strain between the two people.

[1] Rosenberg, 1960, p. 336.

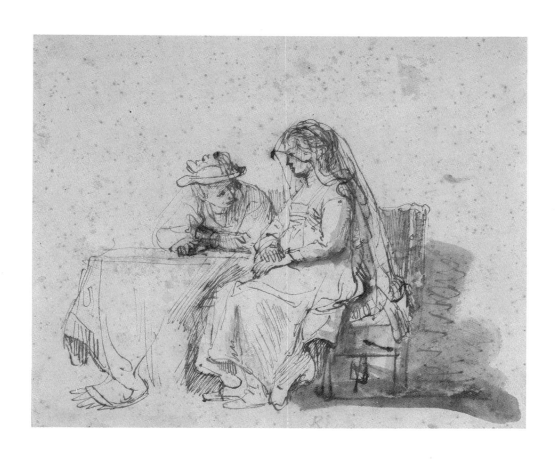

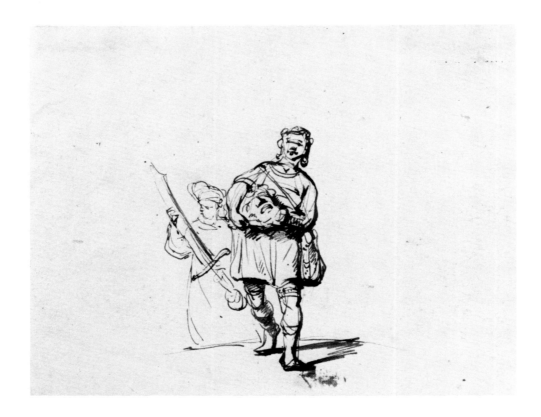

GERBRANDT VAN DEN EECKHOUT
Amsterdam 1621-1674

38. *David Carrying the Head of Goliath*
Pen and bistre ink on paper with a
watermark of three balls, 5⅛ x 6⅝ inches
(130 × 169 mm)

Provenance: Musée des Beaux-Arts,
Besançon; J. Gigoux, Besançon, by 1906.

Exhibition: Cambridge, 1958, no. 31.

Bibliography: Hofstede de Groot, 1906, p.
128, no. 547 (as Rembrandt); Sumowski,
1980, III, pp. 1618-19, no.750.

Eeckhout was one of many Amsterdam artists who
trained in Rembrandt's studio in the 1630s. Unlike
most of them, as Houbraken relates, he never
turned away from the master's style or type of
subject matter. This is evident in the present draw-
ing, which probably dates from the 1660s and is
indebted to Rembrandt's vigorous manner of using
the brush and brown ink. Similar compositions
with two isolated figures and little background
detail occur in Rembrandt drawings of the 1650s.[1]
The story of David was one of Rembrandt's favor-
ite sources, but no treatment by him of this subject
is known. Though Eeckhout does not evince a
comparable power, he does succeed in conveying
the overweening pride of the victorious young
David.

[1] See particularly Benesch, 1973, figs. 822 and 1307.

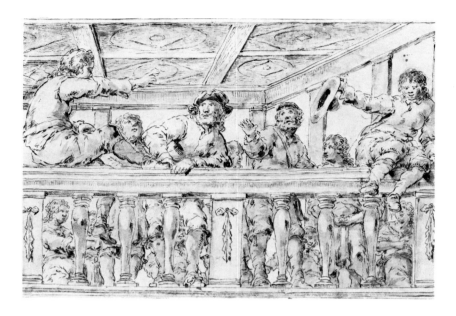

LEONARD BRAMER
Delft, 1596-1674

39. Recto: *Men on a Balcony*
 Brown and black ink with wash

 Verso: *An Old Man and a Boy Looking at a Book*
 Pen and ink, 7½ × 11¼ inches (193 × 286 mm)

 Provenance: Drey Gallery, New York.

Bramer's style was formed primarily by his extensive sojourn in Italy, where he arrived by way of France in 1614. He spent six years in Rome and seems to have been most influenced by Elsheimer and the Utrecht Caravaggisti, especially Gerrit van Honthorst. He was back in Delft by 1628 and the following year was enrolled in the local guild of St.Luke, which he served five times as governor.

Today Bramer is best known for his small-scale religious and allegorical paintings, often with nocturnal settings. They are rendered in a rough, almost caricatured manner, and suggest the influence of the Rembrandt school. But in his own time he was much celebrated as a painter of wall and ceiling frescoes. Little of his work or that of any artist in this medium has survived the damp Dutch climate.[1] Therefore this drawing, another in the Baer collection (cat. no. 140), several in the British Museum, and others in Oslo and Berlin[2] are valuable records of his lost illusionistic ceiling projects. Possibly these scenes of merrymaking and musicians relate to the decorations he executed in the palaces of Frederick Hendrik at Rijswijk and Honselaersdijk. These drawings owe a great deal to the example of Honthorst in subject matter and the illusionistic representation of figures looking over a railing; a similar painting on panel by Honthorst is in the Getty Museum.[3]

The lively figures are reminiscent of the bearded men in ragged hats who appear in many other of Bramer's drawings.[4] The sketch on the verso is probably a study for a Biblical painting, perhaps on the theme of the priest Eli instructing the young Samuel.[5]

[1] There are, however, examples on canvas, especially by Gerard de Laresse. See Snoep, 1970, pp. 159-218.
[2] A double-sided drawing of ceiling designs in the British Museum (1936-7-4-3) was sold at Sotheby's, London, June 17, 1936, no. 87; a drawing of musicians in the Kupferstichkabinett, West Berlin, was cat. no. 179; and for a double-sided drawing in Oslo, see the 1976 catalogue, no. 8.
[3] Fredericksen, 1972, p. 75, no. 92.
[4] See the example in Düsseldorf, 1968, no. 17, fig. 36.
[5] One by Lievens is in the Getty Museum. See Fredericksen, 1972, p. 77, no. 95.

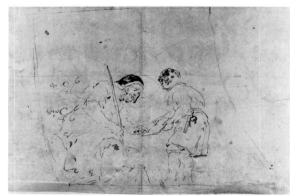

Fig. 10: Bramer, verso of no. 39.

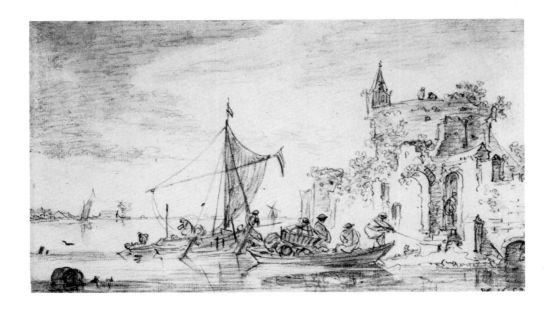

JAN VAN GOYEN
Leiden, 1596 – The Hague, 1656

40. *River Landscape with Fisherman*, 1652
Black chalk and grey wash on white
paper with the watermark of the Bishop's
Crook of Basle, 4⅜ × 7⅝ inches (111 ×
195 mm)

Signed with the monogram and dated at
the lower right: *VG 1652*

Provenance: Otto Mündler; Sale, Leipzig,
Oct. 27, 1884, no. 403; E. Habich, Kassel;
Sale, Stuttgart, April 27, 1899, no. 316; Prince
Liechtenstein, Vaduz.

Exhibitions: Cambridge, 1958, no. 30; New
York, 1960.

Bibliography: Beck, 1972, I, p. 195, no. 579A.

One of the most prolific Dutch landscape artists,
van Goyen produced about fifteen hundred paint-
ings and more than eighteen hundred drawings. He
was trained in Leiden, made a brief trip to France

about 1615, and then worked in Haarlem with the
pioneer of landscape painting, Esaias van de Velde.
He finally settled in The Hague, but continued to
travel around the lowlands, studying the everyday
activities of the inhabitants and producing sublime
landscapes and seascapes.

This drawing of a river view is one of many made
in this format in 1652-53. The arrangement of the
composition, with the buildings at the right, the
distant river vista at the left, and the figures in the
foreground, is one van Goyen often favored. The
round tower is derived, as Agnes Mongan pointed
out, from the ancient fortified wall of Nymwegen.
This drawing, like many by the artist, is interesting
not only for its immediacy of observation and skill-
ful rendering of forms in cursive black chalk strokes
but also for the atmospheric effects achieved by the
use of grey wash. The movement of the clouds,
reflections of light, and shimmering surface of the
water are all delineated. The drawing was etched by
Jan de Visscher[1] and the traces of the etching needle
are evident on the surface.

[1] See Beck, 1957, p. 195.

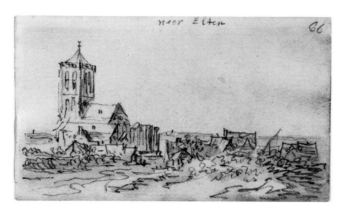 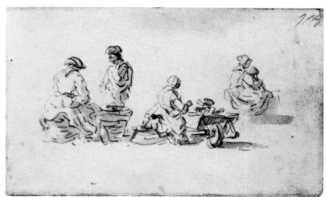

JAN VAN GOYEN
Leiden, 1596 - The Hague, 1656

41a. *Landscape at Lower Elten*
Black chalk with grey wash, 3¹³⁄₁₆ × 6¼ inches (97 × 159 mm)

Inscribed at the upper edge: *neer Elten*; and numbered at the upper right corner: *66.*

41b. *Market Women at Work*
Black chalk with grey wash, 3⅞ × 6⅛ inches (97 × 156 mm)

Inscribed at the upper right corner: *148*

Provenance: Johnson Neale, London; T. Mark Howell, London; Thomas Dinwiddy; Sale, Sotheby's, London, July 3, 1918, no. 124; P. & D. Colnaghi, London; Sale, A. W. M. Mensing, Amsterdam, April 27, 1937, no. 218; A. Mayer, The Hague and New York; Dr. Karl Lilienfeld, New York, 1957; C. F. Louis de Wild, New York; H. E. Feist, New York, 1964.

Bibliography: Dodgson, 1918, p. 234; Dattenberg, 1967, p. 174, no. 183; Beck, 1972, I, p. 296, no. 847/66, and p. 305, no. 847/148.

Both of these drawings come from a small sketchbook van Goyen kept on a journey in 1650-51 extending from the area of Haarlem and Amsterdam along the Rhine to the region around Arnhem. The sketchbook was first recorded in 1895. When published in part by Dodgson in 1918, it contained 179 leaves numbered up to 290, suggesting that some leaves had been removed and that the artist had not been consistent in numbering the pages. The sketchbook was broken up in New York in 1957 and the individual sheets sold. Another sheet is also in the Baer collection (cat. no. 142).

On many pages of this pocket-sized sketchbook, van Goyen drew prominent local landmarks, such as the view inscribed *neer Elten*, which shows the church of the town of Lower Elten towering above a few nearby cottages. Other sheets have sketches of the everyday activities of people like the market women seen here, possibly opening oysters for a waiting customer. All these drawings convey the pleasure van Goyen took in observing the Dutch landscape and the ordinary life of its inhabitants. Some of these studies, as Beck has shown, later served as the basis for more highly finished chalk drawings.[1]

[1] Beck, 1957, pp. 247-50.

JACOB VAN RUISDAEL
Haarlem, 1628-1682

42. *The Ruined Cottage*
Black chalk and grey wash on white paper with a jester's scepter watermark, 7⅞ × 10¾ inches (200 × 275 mm)

Monogrammed at the lower right corner

Provenance: S. Feitama; Sale, de Bosch, Amsterdam, Oct. 16, 1756, no. L.44; G. Hoet; Sale, Amsterdam, Aug. 25, 1760, no. 801; J. Goll von Frankenstein; Sale, de Vries, Amsterdam, July 1, 1833, no. S.9; H. van Cranenburgh; Sale, Roos, Amsterdam, Oct. 26, 1858, no. B.30; E. Galichon, Paris; Sale, Hôtel Drouot, May 10, 1875, no. 143; J. P. Heseltine (L. 1507); H. S.Reitlinger (L. 2274), London; Sale, Sotheby's, London, June 22-23, 1954, no. 699.

Exhibitions: Cambridge, 1958, no. 33; Poughkeepsie, 1976, no. 41; Washington, etc., 1977, no. 71; The Hague and Cambridge, 1981-82, no. 71.

Bibliography: Josi, 1821, II, n.p., under "Jacob Ruisdael"; De Vries, 1915, p. 39, no. 126; Huffel, 1921, p. 63, no. 144; J. Giltay, 1980, p. 160, fig. 24; Slive and Hoetink, 1982, pp. 184-185.

Of all the landscape specialists of seventeenth century Holland, Ruisdael was the most concerned with conveying the power of the forces of nature. Themes of growth, decay, mortality, and rebirth are treated repeatedly in his paintings and drawings, and the humble Dutch landscape is subtly revealed as a scene of natural conflict. In this drawing of the early 1650s, a simple dilapidated cottage becomes an emblem of the transience of life and the futility of human efforts. Ruisdael's serious concerns are well served by the strength and purity of his draftsmanship.

It is likely that Ruisdael made the drawing in preparation for a painting, though no such oil by him is known. The subject was, however, copied by several other artists, but without the dramatic impact Ruisdael gives it. A copy by Emmanuel Murant is in the Rijksmuseum, Amsterdam (fig. 11), an anonymous copy is in the Boston Museum of Fine Arts (fig.12), and other anonymous versions include one in the Musée des Beaux-Arts, Nîmes, and another formerly with the dealer Douwes in Amsterdam. A drawing after the Baer sheet by C. Ploos van Amstel was engraved by Cornelis Brouwer.

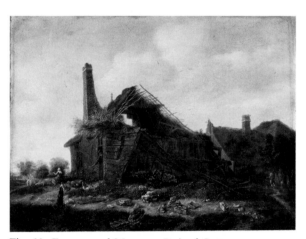
Fig. 11: Emmanuel Murant, *Ruined Cottage*, courtesy Rijksmuseum, Amsterdam.

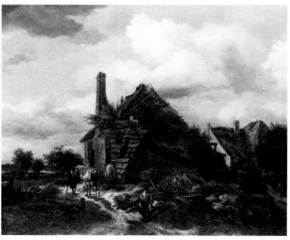
Fig. 12: Anonymous Dutch, *Ruined Cottage*, courtesy Museum of Fine Arts, Boston.

JAN DE BISSCHOP
Amsterdam, 1628 - The Hague, 1671

43. *Campagna Landscape with a Castle and
Farm Building*
Pen and brown ink, with brown wash,
4¾ × 8¼ inches (120 × 207 mm)

Provenance: Sale, Christie's, London, March
26, 1974, no. 131; Colnaghi's, London, 1977.

Exhibition: London, 1974, no. 19.

Jan de Bisschop was the most talented of a group of
amateur artists (including Constantijn Huygen the
Younger and Jacob van der Ulft) who lived pri-
marily in The Hague and were devoted to land-
scapes, especially of Italy. He was a lawyer by
profession, but began drawing at an early age and
by the end of his life was devoting himself almost
totally to art, producing handbooks with etchings
after ancient sculpture and the works of Italian
masters. He is believed to have visited Rome several
times in the 1650s.[1]

De Bisschop's finest works are serene landscape
vignettes rendered in delicate washes of brushed
ink. The golden-brown tonality of his "Bisschop's
ink," as it became known, may have been achieved

by mixing copper red with india ink.[2] Other artists
copied his works; the present drawing was one of
several which after de Bisschop's death became the
property of Jacob van der Ulft, who copied it in a
sketchbook of 1675 (fig. 13), now in the Lugt collec-
tion.[3]

[1] See van Gelder, 1971, pp. 208-210.
[2] Ibid., p. 217.
[3] Florence, 1966, pp. 20 and 72.

Fig. 13: Van der Ulft after Bisschop, *Landscape with
Buildings*, Institut Néerlandais, Paris.

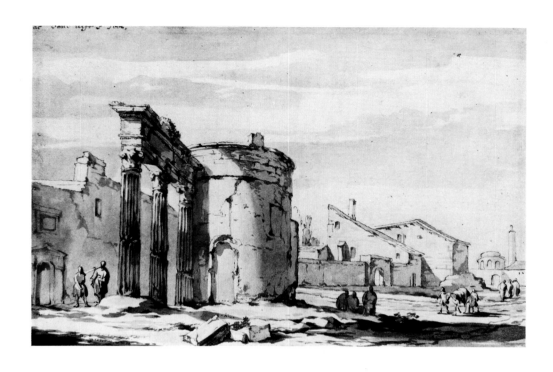

JACOB VAN DER ULFT
Gorkum, 1621 - Noordwijk, 1689

44. *Roman Ruins*
 Brown ink and wash, 5⅞ × 8⅞ inches
 (149 × 226 mm)

 Signed and dated at the upper left edge:
 van Ulft 1661

Like Jan de Bisschop, whose work he often imitated, van der Ulft was an amateur artist fascinated by Italian views. Most of his life was spent in his native Gorkum, where he served as *burgermeester* and held other official posts. Although the seventeenth century biographer Houbraken wrote that van der Ulft never visited Italy, this seems unlikely. The variety of his subjects and the specificity of their treatment suggest that they were done on the spot. It would be odd for the artist to have both signed and dated this study if it were a copy of another drawing. The artist depicted a similar round tower with three columns in a drawing in the Cleveland Museum and repeated the somewhat naive compositional device of lining up structures on a diagonal as they recede into the distance in a drawing of the Colosseum and other monuments which is in Rotterdam. The weaknesses in composition in his drawings are redeemed by his elegant use of brown wash, which he learned from de Bisschop. Here he employs it effectively to capture the play of shadows on the surface of the stone.

WENZEL HOLLAR
Prague, 1607 - London, 1677

45. *View of Orsoy*
Pen and ink over pencil, 5⅜ × 17½
inches (136 × 444 mm)

Inscribed in pen in the sky: *Orsöy 1650*
(?); and at the bottom in pencil by a later
hand: *Lautensack*

Provenance: P. H. Lankrink; Dr. H. Wellesley;
Sir Bruce Ingram; Colnaghi's, London, 1966.

Exhibition: Manchester, 1963, no. D 104.

Hollar, who was probably the most talented seven-
teenth century topographical artist, had been
trained as a map maker and miniaturist before leav-
ing Prague in 1627 to avoid religious persecution.
He went to Stuttgart and then to Strasbourg, where
in 1629 or 1630 he made his earliest panoramic city
view.[1] He may then have worked as a printmaker
with Matthias Merian in Frankfurt am Main. After

a brief journey to Holland, he settled in Cologne in
1632.

In 1635 a series of twenty-four of Hollar's land-
scape engravings were published in book form.
The book may have been seen by Thomas Howard,
Earl of Arundel, who was in Cologne the following
year as ambassador from King Charles I to the
Emperor Ferdinand II. In any case Arundel, a great
collector and art lover, decided he needed an artist
to accompany his mission and record sites along the
Rhine and Danube and in Vienna and Prague. In a
May 1636 letter to his friend and agent William
Petty, the Earl remarks that he has employed Hol-
lar, "who draws and etches prints in strong water
quickly and with a pretty spirit."[2] The expedition
lasted until December and the nearly one hundred
surviving panoramic town views by Hollar are
among the highlights of his prolific output. Some
of the vistas he later redrew and then engraved.
They may originally have been intended to illus-
trate the written account of the journey kept by the
Earl's secretary William Crowne, but when the
account was published in London in 1637, it was
not illustrated.[3]

86

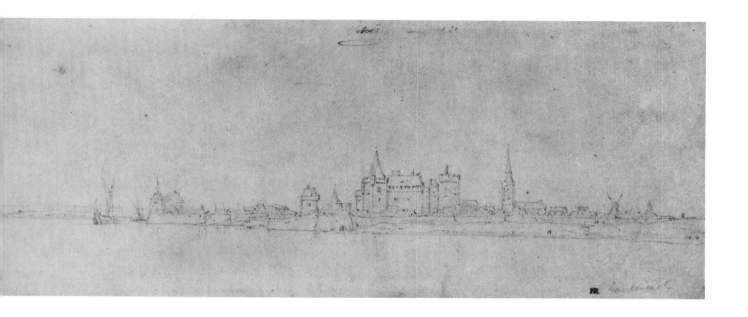

After the completion of the mission at the end of 1636, Hollar accompanied the Earl's entourage to England, where he lived the rest of his life, except for the period 1644 to 1652, which he spent in Antwerp. He engraved treasures in the Earl's collection, made views of London both before and after the Great Fire of 1666 that are valuable to historians, and in 1668-69 accompanied an expedition to recover Tangier. Despite his renown he died in poverty.

This drawing, as the inscription indicates, represents the fortress town of Orsoy (or Orsoi) on the Rhine near Düsseldorf. The Arundel expedition passed this site on the return journey during the first week of December 1636, and Crowne's account records that they had "to drop anchor until our ship had been searched," so there was undoubtedly time for Hollar to make a sketch.[4] Since the town was razed by French forces in 1672, the drawing is of historical as well as artistic significance.[5] While larger than many of the Rhine sketches made on the Arundel trip, it follows the same basic principles. The original graphite sketch done on the spot was later gone over with pen. The artist maintained an objective, almost clinical, attitude towards his subjects — never, as Dutch artists often did, reordering the composition. Viewing the town at eye level from a distance, Hollar was able to position it in the middle of his sheet and allow it to spread the full width of the paper. The result is a delicate design of supreme lightness that seems to hover upon the surface of the paper.

[1] Denkstein, 1971, p. 33.
[2] Quoted in Springell, 1963, p. 240.
[3] *A true relation of all the remarkable Places and Passages observed in the travels of . . . Thomas Lord Howard, Earl of Arundel . . . Ambassador Extraordinary to his sacred majesty Ferdinando Emperour of Germanie Anno Domini 1636.* Reprinted in Springell, 1963. See also Kratochvil, 1965, pp. 22-25.
[4] The date on this drawing is problematic. It is usually read as "1650," although it is possible to interpret it as 1636. Both the location and the date may have been copied over at a later time. Since Hollar was on the continent in 1650, it is possible that he returned to sites on the Rhine, though no such visit is documented.
[5] A somewhat different view by Hendrick Feltman is in the Berlin Kupferstichkabinett. See Dattenberg, 1967, p. 133, no. 142.

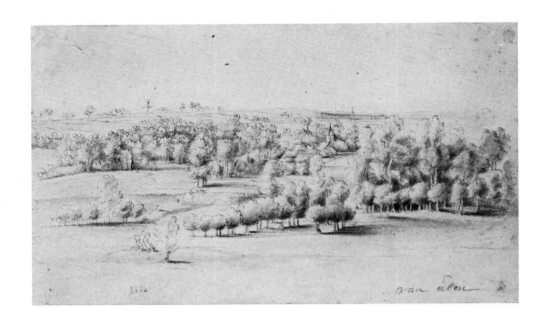

LUCAS VAN UDEN
Antwerp, 1595–1672

46. Recto: *Landscape*
Pen with grey-blue and yellow-green
wash

Inscribed at the lower right: *Van Uden*

Verso: *The Trunks and Lower Branches of
Three Trees*
Pencil on paper with the watermark *PP*,
5⅛ × 8⁹⁄₁₆ inches (128 x 218 mm)

Provenance: N. F. Haym, London (L. 1970).

Exhibition: Cambridge, 1978, no. 23.

Van Uden studied with his father and became an
independent master in 1627-28. He spent his whole
life in Antwerp, except for a trip on the Rhine in
1644. He was a specialist in landscape painting,
working in the tradition of Joos de Momper. The
figures in his paintings were sometimes executed
by other artists, such as Jordaens and Teniers, and
he painted the landscape backgrounds in some
works by Rubens and also made prints after others.

Van Uden's most appealing works are his land-
scape drawings with watercolor, dating primarily
from the 1640s. These refined drawings, such as the
recto of this sheet, present the infinite vistas of the
hilly Flemish countryside. They were probably
prepared in the artist's studio based on pen and
pencil sketches made on the spot, like the studies on
the verso.

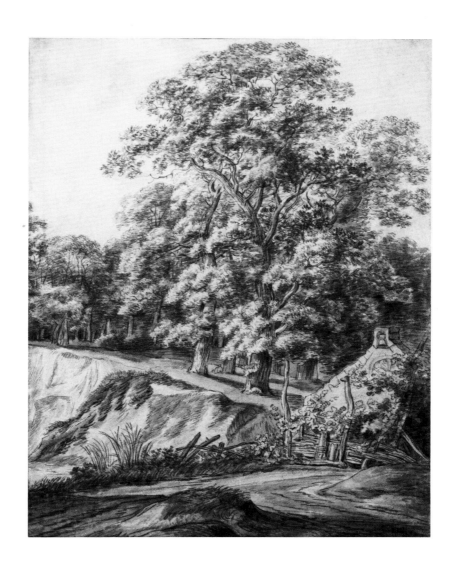

ANTHONIE WATERLOO
Lille, ca. 1610 – Utrecht, 1690

47. *Landscape*
Black chalk, 17¾ × 13¾ inches
(450 × 350 mm)

Provenance: Colnaghi's, London.

An art dealer who resided in Utrecht, Amsterdam, and Leeuwarden and travelled throughout Germany and Belgium, Waterloo was apparently a self-taught artist. He devoted himself to landscape prints and drawings and made many large black chalk studies, such as this one, that depict dense stands of monumental trees looming over little buildings and tiny figures.

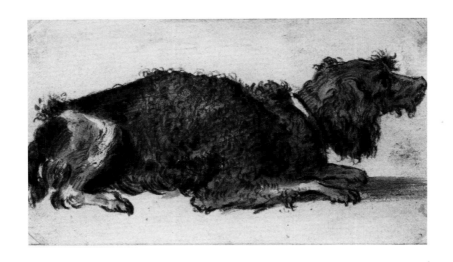

CORNELIS SAFTLEVEN
Gorkum, 1607 – Rotterdam, 1681

48. *A Dog*
Black chalk and grey wash, 3¼ × 5⁹⁄₁₆
inches (83 × 151 mm)

Provenance: Herbert Feist, New York.

The attribution of this small drawing to Cornelis Saftleven has been confirmed by Wolfgang Schulz (in correspondence). Saftleven, a painter of peasant scenes and still lifes, made many animal studies, ranging from wild beasts like camels and bears to humble domestic creatures[1] such as this amiable dog, an early variety of poodle. His approach, as Franklin Robinson has observed, always remained "fresh and childlike."[2]

[1] See Schulz, 1978, pls. 91-107.
[2] Washington, etc., 1977, p. 49.

90

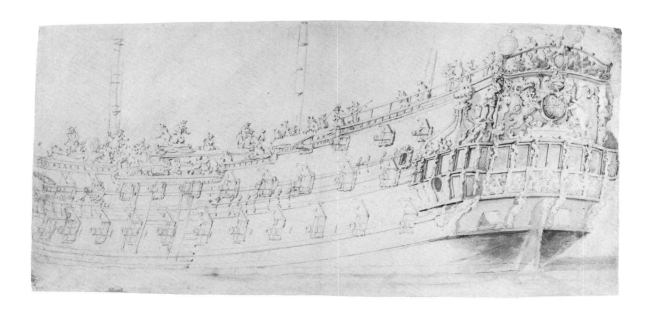

WILLEM VAN DE VELDE THE YOUNGER
Leiden, 1633 - London, 1707

49. *The Princess*, ca. 1673
Graphite with grey wash, 9½ × 20
inches (241 × 507 mm)

Bibliography: Fox, 1980, pp. 73-74, ill. 76.

Willem van de Velde the Younger has been described as "the most important marine painter and draftsman of seventeenth-century Holland."[1] His father, Willem van de Velde the Elder (1611-1693), was an established painter of ships and sea battles who had observed first-hand much action in the Anglo-Dutch wars. The younger van de Velde also studied with Simon de Vlieger.

In the winter of 1672-73, both van de Veldes, probably as a result of the French invasion of Holland, emigrated to England, taking up residence at Greenwich. The elder van de Velde may have accompanied the party of Charles II to England on the occasion of his restoration to the throne in 1660, and both father and son were now given special positions as court painters of sea fights. They designed large tapestry compositions of English naval victories and continued as chroniclers of the Anglo-Dutch wars. In 1691 they moved to London. After his father's death in 1693, van de Velde the Younger was authorized by the English Admiralty to join the fleet for a Mediterranean voyage in 1694-95.

Van de Velde's studies of the English fleet are invaluable documents for naval historians. To compose his finished "portraits" of ships he made thousands of preparatory drawings, usually in black chalk or pen and brush. Frank L. Fox (in a letter of Feb. 28, 1977) first identified the ship in this drawing as the 54-gun *Princess*, which is also represented in a drawing dated 1673 now at Greenwich.[2] As Mr. Fox noted, the ship was built in 1660 and broken up in 1680, but in its short life took part in all of the seven main fleet actions of the Second and Third Anglo-Dutch Wars and on a journey to Gothenburg in 1662 fought two remarkable actions, one against a Dutch fleet and the other against two Danish men-of-war.

[1] See New York - Paris, 1977-78, p. 167.
[2] Robinson, 1958, I, no. 441.

ATTRIBUTED TO DANIEL GRAN
Vienna, 1649 - St. Pölten, 1757

50. Recto: *Music-making Angels*
Pen, black chalk, and grey wash

Verso: *Scenes of a Saint's Life*
Black chalk, 15⅜ × 9⅞ inches
(390 × 250 mm)

Exhibition: Cambridge, 1958, no. 57 (as
German or Austrian).

Daniel Gran, one of the leading painters of eight-
eenth century Austria, studied first in Vienna and
then in Venice and Naples. His training enabled
him to adapt the manner of Solimena for both his
many large-scale altarpieces and his expansive
multi-figured frescoes. These works are dis-
tinguished by remarkable pastel rococo coloration.

Andrew Robison's attribution of this drawing to
Gran is based upon its similarity in style and tech-
nique to a sheet with six studies of angels which is
in Budapest.[1] This attribution has been seconded
by Heinrich Geissler (in a letter of November 27,
1984).

These music-making angels, like those on a sheet
by Gran which is in the Albertina,[2] are probably
preparatory drawings for figures which appear in
his enormous dome fresco at Breitenfurth of
1730-32.[3] That depiction of the Apotheosis of St.
Johannes Nepomuk includes angels playing the
instruments seen in the Baer drawing. The pre-
carious placement of the angels on protruding walls
with candelabra is typical of Gran's illusionistic
devices, which, in the tradition of Baciccio, often
overflow from the ceiling onto the walls.

[1] Knab, 1977, Z 59, pl. 147; Salzburg, 1981, no. 6.
[2] Knab, 1977, Z 27, pl. 75.
[3] Ibid., pl. 76s.

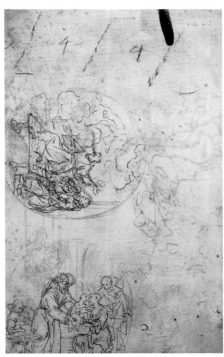

Fig. 14: Attributed to Daniel Gran, verso
of no. 50.

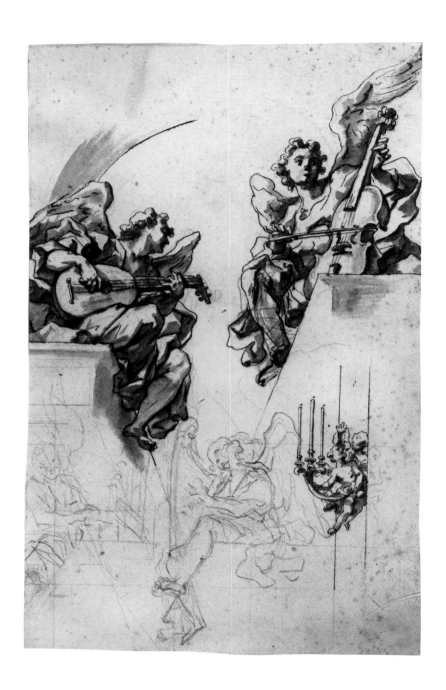

French
17th, 18th, & 19th Century

MONOGRAMIST W. W. M.
French (?), early 17th century

51. *A Paper Mill*, 1606
 Pen and brown ink with yellow and pink
 wash, 4⅝ × 8⅟₁₆ inches (117 × 250 mm)

 Inscribed and dated at the lower left:
 W.W.M. 1606

 Provenance: Buisman collection; Sale, de
 Vries, Amsterdam, Jan. 25, 1921, no. 86.

 Exhibition: Cambridge, 1958, no. 35.

 Bibliography: Hunter, 1930, no. 103.

Although this drawing was identified as German
when it was sold in 1921, Agnes Mongan in 1958
designated it as probably of the French school.
More recently Julien Stock (in conversation) has
made the observation that the style of the drawing,
with its lively strokes, quickly sketched, almost
comic figures, and use of colored washes, is close to
that of the Master of the Hermitage Sketchbook,
now identified as Louis de Caulery.[1] If the mono-
gram on the drawing were that of a collector rather
than the artist, an attribution to de Caulery would
be especially tenable. De Caulery worked pri-
marily in Antwerp, where he became a master in
1602-03 and died in 1621-22. Aside from questions
of authorship, this drawing is fascinating for its
subject, a depiction of the process of making paper
from wood fiber.

[1] See Brussels, etc., 1972-73, no. 17.

ATTRIBUTED TO ISRAEL SILVESTRE
Nancy, 1621 - Paris, 1691

52. *View of a City with a Bridge*
Pen and brown ink, 7⅝ × 15¾ inches
(193 × 400 mm)

Provenance: E. Calando collection (L. 837);
Colnaghi's, London, 1968.

Silvestre was a leading topographical artist of seventeenth century France. Trained in a family tradition of printmaking and book publishing, he was influenced by Callot and della Bella in developing his detailed but sensitive style. He travelled in France and several times to Italy in search of subjects, and eventually settled in Paris, where he was well received. He became a member of the Academy and in 1663 was appointed *Dessinateur et Graveur du roi*. His skill was employed by the state in 1665 when Colbert sent him to Lorraine and the Ardennes to engrave sites of military fortifications. Ten years later he became drawing master to the Dauphin.

Silvestre produced more than a thousand prints, and his drawings show the care with which he prepared his compositions. This scene, probably of a city in southern France, employs the wide-angle view and meticulous touch seen in other drawings he made of French towns.[1]

[1] See Latour, 1972, p. 318; and Washington, D.C., etc., 1981-82, no. 109, pl. 22.

96

ATTRIBUTED TO JACQUES FOUQUIER
Antwerp, ca. 1590 – Paris, 1659

53. *Forest Interior*
 Pen and ink over graphite with white
 heightening, 7¼ × 9⅝ inches
 (182 × 243 mm)

 Provenance: Chevalier de Damery (L. 2862);
 London Art Market, 1954; Sale, L'Art
 Ancien, Zurich, 1959, cat. 50, no. 23.

 Bibliography: Reitlinger, 1922, p. 135, pl. 26
 (as Flemish, ca. 1600).

The attribution of this fine drawing to Fouquier
dates only from its sale in 1959, but it seems reason-
able. A similar landscape drawing, with an inscrip-
tion attributing it to Fouquier, is in the National
Gallery of Canada.[1] A drawing in Budapest cata-
logued as Circle of Gillis van Coninxloo III[2] and
one shown in London as by Gillis van Coninxloo[3]
also depict thick forest interiors with fallen trees
and employ a similar technique and tonality. As
Stechow pointed out, the influences of de Momper,
Coninxloo, Bruegel, and de Keuninck all merge in
the work of Fouquier.[4]

Fouquier became a master in the guilds of Ant-
werp and Brussels in 1614 and 1616 respectively. He
then worked with Rubens, with whom he may
have travelled to Paris in 1621. In France he achieved
renown as a painter of large landscapes, working in
Toulon and Paris. This work must be an early one,
for Fouquier's later drawings, as exemplified by the
masterful *Brook Between Wooded Banks* in the
Louvre,[5] are in a looser, brighter style.

[1] Ottawa, 1965, p. 142.
[2] Gerszi, 1971, no. 54.
[3] London, 1953, no. 205.
[4] Stechow, 1948, pp. 421-22.
[5] Paris, 1984-85, no. 37.

NICOLAS POUSSIN
Les Andelys, 1594 - Rome, 1665

54. *The Feast of Pan*
Pen and wash, 5¼ × 8⅛ inches
(133 × 207 mm)

Inscribed: *Nicolò Possino in Vecchiaia*

Provenance: Sale, Sotheby's, London, Dec.
13, 1973, no. 28.

Bibliography: Friedlaender and Blunt, V,
1974, p. 107, no. 438; Wild, 1980, II, p. 67;
Edinburgh, 1981, p. 51, fig. 12.

By 1635 Nicolas Poussin, who had been living in
Rome since 1624, had established such a reputation
among French connoisseurs that Cardinal
Richelieu commissioned from him two paintings
of *Bacchanals*.[1] The subjects chosen for these, *The
Triumph of Bacchus* and *The Triumph of Pan*, and their
treatments reflected Poussin's long-standing inter-
est in both Titian (whose *Bacchanals* he had seen in
the Villa Ludovisi) and the antique.

This drawing is a preliminary study for a portion
of *The Triumph of Pan*, which was formerly at
Sudley Castle (fig. 15).[2] The inspiration for it may
have come, as Anthony Blunt has written, from an
engraving after a composition by Giulio Romano,[3]
but Poussin, following the example of classical sar-
cophagi, imbued his painting and the various pre-
liminary drawings with an appropriate robustness.
In the earliest pen studies (two in the Musée Bay-
onne, and one at the Royal Library, Windsor Cas-
tle[4]) the chief unit of the composition — the girl
riding a goat with one satyr supporting her and
another satyr proffering a tray of flowers — was
facing to the right. These studies also show details
of the Bacchic rite (such as the prominent wine jar
on a plinth) that Poussin, inspired by his reading of
the ancient writers, eventually incorporated into
his painting.

Following his usual working methods, Poussin
next produced individual drawings or, as he called
them, "pensées,"[5] such as this, after wax models, to
further define each section of the composition. As a
later full drawing at Windsor[6] and the painting (sent
to Richelieu in May 1636) reveal, he reversed the
direction of the chief group and eliminated the
youth supporting an inebriated woman.

Poussin's earliest biographer, Bellori, noted in
1672 that the artist's drawings "were not exactly
worked out with their settings, but were composed
rather of simple outlines and simple tones in wash,
which however vividly rendered all the actions and
expressions."[7] In this case one can see clearly how
Poussin was able to indicate the langorous poses,
lascivious expressions, and suggestive shadows
appropriate to his pagan revel.

[1] Blunt, 1966, pp. 95-97, nos. 136 and 137.
[2] Blunt, 1958, II, pl. 88.
[3] Ibid., I, p. 137.
[4] Friedlaender and Blunt, 1953, III, nos. 186, 187, and 189.
[5] See Blunt, 1979, p. 186.
[6] Friedlaender and Blunt, 1953, III, no. 192.
[7] Translated in Blunt, 1979, p. 1.

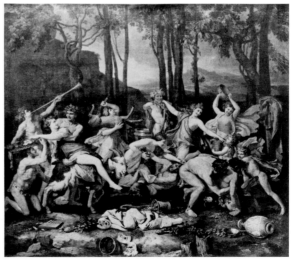

Fig. 15: Poussin, *The Triumph of Pan*, 1636, courtesy
The Witt Library.

NICOLAS POUSSIN
Les Andelys, 1594 - Rome, 1665

55. *A Landscape*
Pen and brown ink, squared in black
chalk, and with a portion of a letter on
the verso, 4¼ × 6½ inches
(107 × 165 mm)

Provenance: P. J. Mariette (L.1852); M.
Marignane.

Exhibition: Cambridge, 1958, no. 37.

Bibliography: Shearman, 1960, pp. 183 and
186; Friedlaender and Blunt, 1963, IV, p. 51,
nos. 250 and 290.

Throughout his career Poussin maintained an inter-
est in landscape, and during his later years his
feelings deepened into a profound, pantheistic
attitude that is reflected in both his paintings and
drawings. The eighteenth century connoisseur
Mariette, who once owned this drawing, wrote of
Poussin's method:

> He followed for his landscapes a method different
> from the one which he adopted for figure painting.
> The absolute need to study the scene on the spot led
> him to make a large number of very careful landscape
> drawings from nature. Not only did he on these occa-
> sions observe the forms with reverent care, but he also
> paid special attention to unusual effects of light, which
> he then incorporated into his paintings with great
> success. On the basis of these studies he composed in
> his studio those noble landscapes which make the

spectator feel that he has been transported to ancient
Greece, to those enchanted valleys described by
poets.[1]

It is tempting to think that this little drawing,
with the sparkling light of the Roman campagna
captured in rapid strokes, was made directly from
nature. Poussin is reputed to have always carried a
sketch pad with him, and he was also both com-
pulsive and parsimonious in his use of the backs of
other drawings or, as in this case, drafts of letters
for quick sketches.[2] The fact that the drawing has
been squared for transfer suggests that he may have
wished to compose a more formal version for even-
tual use in a painting. There is, however, no known
painting that employs this particular composition.

During his unhappy sojourn in Paris from
December 1640 to September 1642, Poussin was
afflicted for the first time with a malady that caused
his hands to shake. The severity of the tremor
apparently fluctuated, but it distinctly affected his
drawing style. The incorporation of the shakiness
into the aesthetic of this drawing is comparable to
that seen in a group of landscapes which
Friedlaender and Blunt dated to the 1660s.[3]

The letter on the verso has unfortunately been
cut at the sides, but it is apparently addressed to a
French patron who had sent Poussin a roll of canvas
to be used in making copies after Raphael.

[1] Translated in Blunt, 1979, p. 2.
[2] Other examples are Friedlaender-Blunt, III, 1953, no.
212, V, 1974, no. 431.
[3] Ibid., III, 1953, nos. 175 and 212.

MASTER OF THE BLUE PAPER DRAWINGS
French, 18th century

56. Recto: *Study of Clouds*
Bistre and white wash

Verso: *Ruins*
Pen on blue paper, 3¾ × 7⅞ inches
(95 × 200 mm)

Provenance: Sir Thomas Lawrence (L.2445);
W. Esdaile (L.2617); W. Benoni White
(L.2592).

Exhibitions: London, 1953, no. 380 (as
Claude Lorrain); Cambridge, 1958, no. 36 (as
Claude Lorrain).

Bibliography: Badt, 1960, pl. 2;
Roethlisberger, 1965, p. 380; Knab, 1971, pp.
368-369, fig. 2.

This is one of a group of about sixty drawings on
blue paper, all probably from a sketchbook, which
share a provenance going back to the collectors
Thomas Lawrence and William Esdaile. At one
time most of the drawings were assumed to be by
Claude Lorrain, although their authorship by
Poussin's brother-in-law, Gaspard Dughet, had also
been suggested. In 1965 Roethlisberger rejected the
Claude attribution for the entire group and
assigned the drawings to an artist of the circle of
Grimaldi, active in Rome about 1650. Knab dis-
agreed in 1971, stating that the works were by
several hands, including Dughet and Claude. Most
recently the artist has simply been referred to as
"The Master of the Blue Paper."[1]

Knab has written that the Baer drawing and a
Study of Clouds in the Kupferstichkabinett, West
Berlin, "do not correspond with the rest of the
group." He believes that "credit for both drawings
should be given back to Claude, because in their
animated and broad execution they blend in well
with his drawings of the 40s, for example with the
Edge of a Wood with a Draughtsman and an Onlooker in
the Albertina, where we find similar clouds."[2] The
blue paper *Campagna Landscape* at the Art Museum,
Princeton, is also linked to the Baer drawing, since
both have similar pen drawings of antique frag-
ments on their versos.

The case made for the attribution of the work to
Claude, who did employ blue paper for some of his
drawings in his *Liber Veritatis*, may not be totally
convincing, but we have to conclude from this
small sheet, with its picturesque use of blue
ground, fluent chalk work, and sensitive applica-
tion of white heightening, that the Master of the
Blue Paper was a highly talented artist working in
the *ambiente* of Claude.

[1] Louvre, 1984–85, p. 91, no. 116.
[2] Knab, 1971, p. 368.

102

CLAUDE GELLEE, CALLED LE LORRAIN
Chamagne, 1600 - Rome, 1682

57. *Landscape with Apollo and Mercury*, 1671
Pen and brown ink with grey wash and
white heightening, 6⅝ × 9⅝ inches (170
× 245 mm)

Inscribed at the lower left: *Claudio / inv.
fecit / Roma 1671*

Provenance: Wellesley collection; Sale,
Sotheby's, London, June 25, 1866, no. 305;
Paul Cassirer, Amsterdam, 1957.

Exhibition: Cambridge, 1958, no. 39.

Bibliography: Roethlisberger, 1961, I, pp.
450-451; Roethlisberger, 1968, I, p. 380, no.
1029; II, fig. 1029; Zwollo, 1970, p. 274.

Of the nearly twelve hundred surviving drawings
by Claude, a great many are devoted to mythologi-
cal subjects set in pastoral landscapes. This drawing
depicts the conclusion of the story of Mercury's
theft of cows from his exiled brother Apollo, who
was tending the flocks of Admetus. This unusual
subject, as Roethlisberger has pointed out, was
taken not from Ovid but from the Homeric *Hymn
to Mercury*.[1] In order to mollify Apollo after the
theft, Mercury gave him the lyre which he had just
invented, and received in exchange the caduceus.
The gods are shown with the lyre and caduceus,
which became their attributes. Mercury, the mes-
senger of the gods, is also distinguished by his
winged helmet. The amicable settlement of affairs
between the two gods is reflected in the calm of the
arcadian landscape. The highly individualized char-
acter of the cows is the result of Claude's many
careful sketches of these beasts (see cat. no. 153b).[2]
The same composition in reverse appears in a less

finished drawing in the British Museum which also
probably dates from 1671.[3] The subject reappears in
a drawing of 1672 now in the Kupferstichkabinett,
West Berlin.[4] Claude's careful working processes
are suggested by the fact that the subject did not
find its way into paint until 1679. The painting has
unfortunately disappeared but it is known to us
through the dated and annotated drawing (fig. 16)
in Claude's *Liber Veritatis*,[5] the illustrated catalogue
of his paintings which he began keeping in the
1630s, and which is now in the British Museum. In
the later versions of the subject, the poses of the
figures remain the same, but the landscape setting is
expanded to include at the right a broad river and
the remains of a classical temple.

[1] Roethlisberger, 1961, p. 450.
[2] See Roethlisberger, 1968, nos. 201, 231-241.
[3] Ibid., no. 1028.
[4] Ibid., no. 1111.
[5] Ibid., no. 1112, and Kitson, 1978, no. 192.

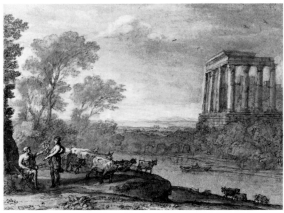

Fig. 16: Claude Lorrain, *Landscape with Mercury and
Apollo*, 1678, courtesy the British Museum.

ANTOINE WATTEAU
Valenciennes, 1684 – Paris, 1721

58. *Les Epoux Mal Assortis*, ca. 1708
Sanguine, 8⅞ × 6¾ inches
(225 × 172 mm)

Inscribed at the lower right: *Watteau*

Provenance: Emile Galichon, Paris; Sale, Paris, May 10-14, 1875, no. 173; Louis Galichon, Paris; Sale, Paris, March 4-9, 1895, no. 169; Leboeuf de Mongermont (or Lehmann), Paris; Sale, Galerie Georges Petit, Paris, June 16-19, 1919, no. 292; Gentile de Giuseppe; Sale, Sotheby's, London, June 8, 1955, no. 70.

Exhibitions: Cambridge, 1958, no. 40; Atlanta, 1983, no. 70.

Bibliography: Parker and Mathey, 1957, I, p. 20, pl. 141; Eidelberg, 1970, pp. 59 and 66, fig. 29; Eidelberg, 1981, p. 31, fig. 3.

This drawing is from early in Watteau's career when he was still under the influence of Claude Gillot. However, the boldness with which he uses the red chalk and the individuality with which he endows each figure already reveal the distinctive genius of Watteau.

Margaret Morgan Grasselli has recently observed (in conversation) that this drawing is actually drawn over a counterproof. Strokes of the original transferred image are still visible, but the most convincing evidence, as she points out, is that the guitarist is playing his instrument with the wrong hand. Watteau was generally scrupulous in his depiction of musical performance. There are other instances of Watteau's drawing over a counterproof; he may have done so in this case because he planned to create an etching of the subject along the lines of his *Figures de mode*. Neither the original drawing nor a print of the subject by Watteau himself is known, but the identical young woman and her cavalier both occur, proceeding from left to right, in the lineup of participants in the painting *The Village Bride* of ca. 1710-12 (Schloss Charlottenberg)[1]; they follow a man leaning on a cane. The same three figures proceeding in this (the original) direction are also found in a drawing by the Watteau follower Quillard.[2]

The Baer drawing was exactly copied in a drawing formerly in the Beurdeley collection,[3] and seems to have provided the inspiration for another drawing attributed alternatively to Watteau[4] or Quillard.[5] It was engraved twice — once by Jean Audran as plate 302 of the *Figures de Différents Caractères* (fig. 17), the compilation of Watteau's works made by his friend and patron Jean de Jullienne, and again by the connoisseur and collector Comte de Caylus.[6]

Parker and Mathey gave this work the title *Les*

Epoux mal Assortis. In the sales at the early part of the century both it and the copy were entitled *Le Ménage Mal Assorti*. The title, plus the obviously theatrical costumes of the characters, led to the suggestion that the subject relates to the play *Les mal Assortis*, first published in Paris in 1700.[7] But Professor Robert Tomlinson has observed (in a letter of December 26, 1984) that the action and characters of the play have nothing in common with what is seen in the drawing. Rather he writes:

> The general theme suggested by the drawing, that of the cuckolded old man, is part of a comic tradition which dates back to Plautus and Terence, and whose most illustrious French examples are Molière's *L'Ecole des Femmes* and Beaumarchais' *Le Barbier de Seville*. This time-worn theme was particularly common in *commedia dell'arte* scenarios. The Italian Comedians popular in 17th century France were banished in 1697, but Watteau could have seen their Franco-Italian successors at the Fair Theatres which flourished at the beginning of the 18th century. Even before his arrival in Paris around 1702, Watteau is known to have sketched the travelling mountebanks who used brief theatrical sketches to sell their wares in his native village of Valenciennes [Parker and Mathey, nos. 144 and 145]. The Fair companies also travelled widely in the provinces. The rustic setting suggests that a representation of one of these itinerant troops is intended. The young Watteau drew several similar compositions showing the actors parading to drum up business for

Fig. 17: Jean Audran after Watteau, *Les Epoux mal Assortis*, etching.

their play [Parker and Mathey, nos. 120 and 130].

The old man's costume is similar to that of figures in an early arabesque, *Les Enfants de Momus* [Dacier and Vuaflart, no. 120], and a late painting, *Comédiens italiens* (National Gallery, Washington) which are identifiable as Pantalon (Pantaloon) and thus he too is probably intended as this Commedia character or his Fair Theatre counterpart Cassandre. The young couple are stock stage lovers, but the next figure is problematic. His costume resembles that of Pierrot, who often carries a guitar in Watteau's paintings (cf. *L'Amour au Théâtre-Italien* and *La Partie quarrée*), but the odd fringed apron is atypical. The last figure is dressed in the short cape and floppy beret of many stage valets. Although he does not wear the usual stripes, he may represent Mezzetin, the traditionally scheming valet who takes on a lyrical character in many of Watteau's paintings. Here he carries a *vielle* or hurdy-gurdy.

Watteau invests these stock characters with life, establishing the relationship between them not only by their glances but also by their careful placement — the separation between the old man and the young woman, and the closeness of Pierrot's head to the young man's, as if whispering mocking insinuations. The procession seems to move in step to the musical accompaniment.

[1] Washington, etc., 1984-85, no. 11.
[2] Eidelberg, 1970, fig. 24.
[3] Sold, Galerie Georges Petit, June 9-10, 1920, no. 345.
[4] Galerie Cailleux, 1968, no. 24; and *idem*, 1978, no. 59.
[5] Eidelberg, 1981, pl. 31b.
[6] *Oeuvres de Caylus*, Cabinet de Estampes, Bibliothèque Nationale, Paris, T.I. fol. 105, no. 32.
[7] See Cambridge, 1958, p. 50; and *Le Théâtre Italien d'Evaristo Gherardi*, Paris, 1700, IV.

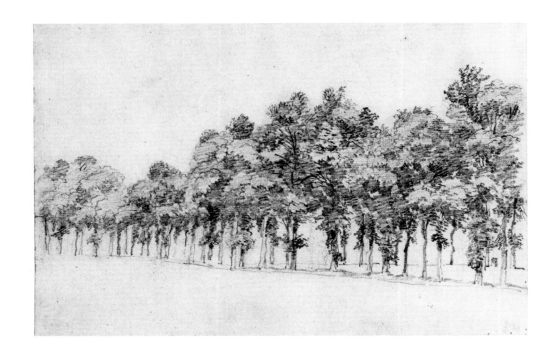

JEAN-HONORE FRAGONARD
Grasse, 1732 – Paris, 1806

59. *Trees along a Road*
Black chalk, 6⅜ × 9½ inches
(160 × 240 mm)

Provenance: Madame T.S.; Sale, Christie's, London, March 28, 1972, no. 111.

Bibliography: Ananoff, 1963, II, p. 145, no. 972, fig. 267.

Fragonard's interest in landscape studies began with his term as a *pensionnaire* at the French Academy in Rome beginning in 1755. While at first influenced by Natoire and Robert, he soon evolved his own manner of working in red and black chalk.

After his return to Paris, he exhibited some of his Roman landscape drawings at the Salon of 1765; they were praised by the noted connoisseur and collector Mariette.

Small black chalk landscapes dating from Fragonard's 1761 journey with the Abbé Saint-Non already display what Eunice Williams calls the "graphic schemata and the recognizable rhythm of the artist's handwriting."[1] This style of rapid jagged strokes, as seen in the Baer drawing, was employed for many other tree studies, including one with the date 1782.[2]

[1] Washington, etc., 1978-79, n.p. 22.
[2] See Ananoff, II, 1963, nos. 962, 966, 968, 969, figs. 262-265, and III, 1968, nos. 1592-93, figs. 419 and 420.

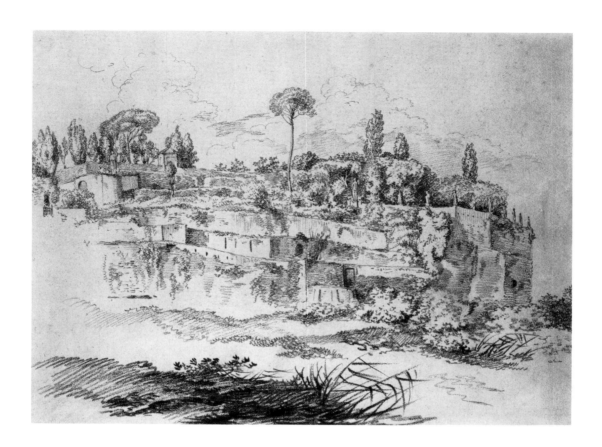

ATTRIBUTED TO
JACQUES-FRANÇOIS AMAND
Paris, 1730-1769

60. *View of the Villa Mattei*
Red chalk, 12¾ × 17 inches
(323 × 431 mm)

Provenance: C. Férault collection.

This drawing, like many other eighteenth century red chalk Roman landscapes, was formerly attributed to Fragonard. Although elegant, it lacks the strength of composition that we now associate with Fragonard's work. But there were several other French artists active about the same time in Rome who worked in a similar manner. Both Eunice Williams and Nathalie Volle (in correspondence) have noted that it could well be by Jean-Simon Berthélemy, who did a number of red chalk Roman landscapes.[1] Mathias Polakovits (in conversation) has attributed the drawing to Pierre-Charles Jombert. Victor Carlson (in conversation) first suggested the attribution to Amand. The use of the forceful jagged lines in the foreground, the more delicate rendering of the middle ground, and the openness of the surrounding sky are very close to the treatment found in other drawings attributed to Amand.[2]

A pupil of J. B. Pierre, Amand won the Prix de Rome in 1758 and went the following year to the French Academy in Rome, where he remained until 1763. Mariette wrote that Amand "showed promise, but was by nature so timid and self-effacing that he lost heart and produced very little. Eventually, he became so discouraged that he put an end to himself."[3] In fact, when the artist's posthumous sale took place (Paris, June 30, 1769), it included more than 1500 drawings and a number of sketchbooks. One must conclude that many drawings which are given the grander names of Fragonard and Hubert Robert are actually by Amand.

[1] See Volle, 1979, nos. 128-135.
[2] For example, one in the Louvre, ill. in Carlson, 1978, pl. 148; another in Indianapolis, ill. in Toronto, etc., 1972-73, no. 1; and especially one sold at the Hôtel Drouot, Paris, Dec. 10, 1980, no. 1.
[3] Quoted in London, 1977, under no. 76.

HUBERT ROBERT
Paris, 1733-1808

61. *Landscape*, ca. 1763
 Red chalk on paper, 13 × 17½ inches
 (330 × 445 mm)

 Possible monogram at left and dated at
 the lower right corner: *176(?)*

 Provenance: Sale, Galerie Charpentier, Paris,
 June 22, 1933, no. 23.

 Exhibition: Atlanta, 1983, no. 76.

 Bibliography: Baer, 1972, p. 3.

Robert, who had trained in the studio of the sculptor René-Michel Slodtz but had failed in the competition for the Prix de Rome, received permission to attend the French Academy in Rome as a supernumerary *pensionnaire* through the intervention of his patron, Comte de Stainville, later Duc de Choiseul. He arrived in Rome in 1745 and followed the Academy's normal course, which included study after both the antique and live models. Gian Paolo Panini, who taught at the Academy, inspired Robert's life-long taste for depicting ruins. Following the lead of Charles Natoire, the Director of the Academy, Robert and Fragonard (who arrived in Rome two years later) devoted much time to sketching the Roman landscape and its picturesque buildings.

This is a fine example of the many highly finished landscapes of the Roman countryside which Robert drew before his return to France in 1765. Victor Carlson has written that in these works "passages of foliage tend to spread across and remain on the paper's surface, lacking deep recession into space unless there is a natural or architectural feature to create linear perspective."[1] In this case the tower in the distance provides the contrasting depth.

Robert's focus here on the pattern of tall overlapping trees — rendered in what Carlson has described as "a combination of oval loops and sawtooth lines" — links it to a group of red chalk landscape drawings of the early 1760s, three of which are at Valence[2] and one of which is at Boston.[3] Two of the Valence sheets are dated 1763, which is most likely the date of this work as well.

[1] Carlson, 1978, p. 54.
[2] Ibid., nos. 14a and 14b; and Beau, 1968, no. 54a.
[3] Washington, D.C., 1978, no. 70.

110

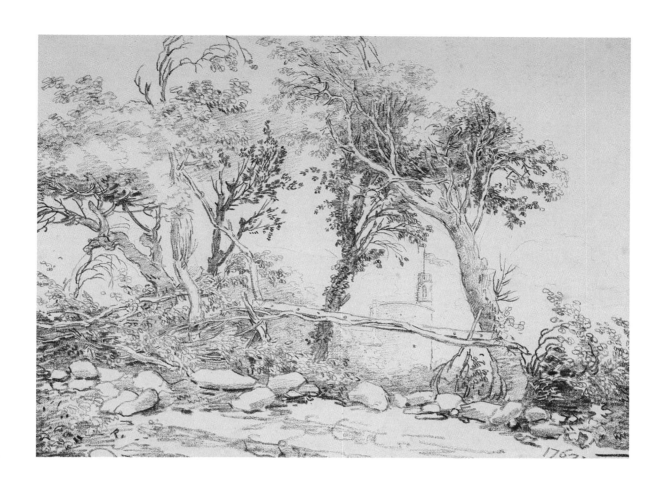

HUBERT ROBERT
Paris, 1733-1808

62. *Woman in a Gallery of Ancient Art*
Pen and brown and black ink with
touches of red wash, 8⅜ × 6¼ inches
(213 × 159 mm)

Robert's talent, especially his ability to depict the
natural and ancient wonders of Rome, made him
famous while he was still a *pensionnaire* at the
French Academy. The Marquise de Marigny, *Direc-
teur des bâtiments*, commissioned a work; the Abbé
de Saint-Non invited him to visit Naples in 1760;
and when his term at the Academy ended in
October 1763, the Ambassador from Malta, Bailli
de Breteuil, provided the funds for Robert to
remain in Italy and commissioned him, along with
fellow Academy student Etienne Lavallée-Poussin,
to decorate a room with paintings of ruins.

As Mariette recognized, Robert's drawings are
often more desirable than his paintings.[1] In addi-
tion to making highly finished landscape studies in
red chalk (cat. no. 61), Robert also developed a
rapid pen and ink style, sometimes combined with
watercolor washes, that he reserved primarily for
sketches of interesting monuments and studies of
everyday genre scenes.[2] Both Jean Cailleux and
Pierre Rosenberg (in conversation) have related the
subject of this drawing to the 1764 Roman visit of
the painter and writer Claude Henri Watelet and his
student and mistress Marguerite Le Comte. This
was such a noteworthy occasion that a small com-
memorative book, *Nella Venuta in Roma di Madama
Le Comte e dei Signori Watelet e Copette*, was
printed.[3] It contains sonnets by Louis de Subleyras;
the borders and illustrations, with the exception of
one border by Hubert Robert, are by Etienne Lav-
allée-Poussin. The sixth plate (fig. 18) depicts
Watelet sketching near the Colosseum and Mme.
Le Comte looking on with pleasure as Minerva
dissipates the rain clouds surrounding Trajan's col-
umn. Mme. Le Comte's bonnet and muff — as well
as her figure — are similar to those of the woman in
Robert's drawing. Certainly the artist would have
accompanied the celebrated visitors on such expe-
ditions.

In Robert's drawing, shorn of the print's alle-
gorical trappings, we are presented with a moment
of quiet contemplation. The modern woman con-

fronts the portrait busts of an ancient age. Curi-
ously, Robert's lively pen style makes these ancient
monuments seem more animated than the living
woman. They are truly speaking likenesses. Sim-
ilar collections of ancient monuments are found in
both paintings and drawings by Robert even after
his return to France in 1765,[4] but he seldom equaled
the poignant charm attained in this intimate draw-
ing.

[1] See Paris, 1967, under no. 265.
[2] See Carlson, 1978, nos. 7a and 7b, 25, and 38.
[3] See Hofer, 1956, pp. 5-13.
[4] For drawings, see Galerie Cailleux, 1957, pl. 1; and
London, 1977, fig. 93; for paintings see Atlanta, 1983, no.
67; and a painting of an artist sketching amidst a similar
assemblage of statuary is also with the Cailleux Gallery,
Paris.

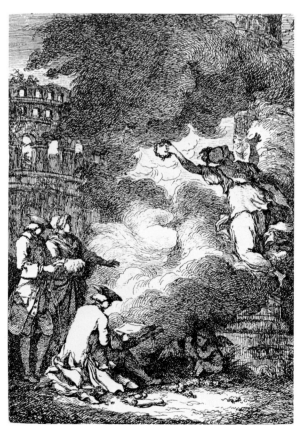

Fig. 18: Lavallée-Poussin, *Watelet and Mme. LeComte in
Rome*, etching, 1674.

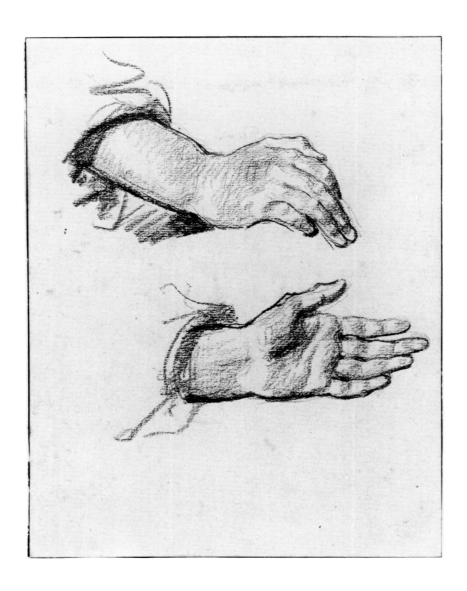

JEAN-BAPTISTE GREUZE
Tournus, 1725 - Paris, 1805

63. *Two Hands*
Sanguine, 12¹⁵⁄₁₆ × 9⅞ inches
(329 × 249 mm)

Provenance: Garnier and Kavaisson
collections; Dr. George Lapone, New York;
Delius Gallery.

Exhibition: Cambridge, 1958, no. 41.

Greuze's moralizing genre paintings made him one of the most popular eighteenth century French artists. To achieve the striking effects of these tableaux vivants, he made careful preparatory drawings. As his many powerful red chalk studies attest, he was most concerned with finding the proper expression and gesture to convey emotion. An inventory of Greuze's studio possessions taken at the time of his divorce in 1793 listed eighty-one studies of hands and feet, several of which are now at the Museum of Besançon.

The Baer sheet is very similar to another drawing of two hands in the Yale University Art Gallery.[1] As Edgar Munhall has suggested, both drawings may be preliminary studies for the painting *The Drunken Cobbler* of the early 1780s, now in the Portland Art Museum.[2] The hands of the four figures in the painting provide a rhythm of dramatic expressiveness across the surface. While the Yale drawing is for the hands of the father, the hands in the Baer drawing are most likely those of the supplicating mother.

[1] See Munhall, 1976, p. 187, no. 93.
[2] Ibid., pp. 188-189, no. 94.

114

Fig. 19: Choffard after Gravelot, frontispiece, engraving, 1761.

HUBERT-FRANÇOIS BOURGUIGNON,
CALLED GRAVELOT
Paris, 1699-1773

64. *Study for a Frontispiece*, 1761
 Graphite, 6½ × 3¾ inches
 (165 × 95 mm)

Provenance: Marquis de Fourquevaulx;
Emanuel Bocher; Louis Roederer; Dr. A. S.
W. Rosenbach, 1922; Este Gallery, New York,
1961.

Exhibition: New York, 1961, no. 55.

Gravelot was the rococo designer-draftsman *par excellence*. Although primarily known for his book illustrations, he also designed precious objects such as snuff boxes and watch cases. After a dissolute youth, he worked first in London and then settled in Paris by 1757. He gradually became a highly regarded illustrator of both the classics and works by contemporary writers such as Rousseau.

This drawing is typical of the small, witty vignettes which Gravelot produced for over four decades. As engraved by Choffard, it served as the frontispiece (fig. 19) for the 1761 book *Amusements d'un convalescent dediés à ses amis*, which contained a collection of songs with music.[1] The Goncourts, who ranked Gravelot as one of the four "*petits grands maîtres du genre*,"[2] described the charm of this subject:

> The pretty "cabinet" of an epicurean! The bit of a fireplace! The rows of delightful books; the table with its bronze fittings; the cup of tea cooling on the mantlepiece, and especially the charming gentleman, appearing thin under the voluminous folds of his dressing gown, as he thoughtfully regards his pen poised to write, while the cello which he will soon play rests with the bow against his thigh.[3]

[1] Hébert, 1968, X, p. 554, no. 119.
[2] Goncourts, 1882, II, p. 8.
[3] Ibid., p. 20.

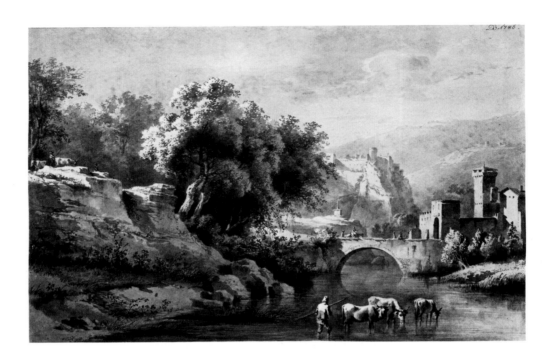

JEAN-JACQUES DE BOISSIEU
Lyon, 1736-1810

65. *Pastoral Landscape*, 1786
Grey wash over black chalk, 6 × 9 inches
(153 × 228 mm)

Signed with the artist's initials and dated
at the upper right corner: *DB 1786*

Provenance: Sale, Christie's, London, June 27,
1967, no. 112.

Boissieu was widely respected for his prints and
drawings. Although he chose to make his career in
his native city, he spent the years 1761 to 1764 in
Paris and then travelled for two years in Italy. It was
during this trip that he adopted his characteristic
manner of working in ink wash — especially grey
— over light indications of black chalk. Boissieu
returned to Lyon in 1771 and worked there success-
fully, surviving the period of the Revolution
through the intervention of Jacques-Louis David
on his behalf.

Boissieu produced relatively few paintings, pre-
ferring to concentrate on prints and highly finished
wash drawings. He did not exhibit his works in
Paris, but participated in the 1786 Salon des Arts in
Lyon, submitting one painting, eight drawings,
and two etchings.

As in an equally ravishing drawing of the pre-
vious year now in Sacramento,[1] the scene of this
drawing is set in the vicinity of Lyon. As M. F.
Perez has observed (in a letter of Dec. 5, 1984), the
artist combined various motifs of the Lyonnaise
mountains to compose the setting. It was engraved,
with slight changes and without the figures and
animals, as "*Vue de la Grande Croix Près de St.
Chamond*" by S. P. Schweyer.[2]

Writing to one of his German patrons late in his
life, Boissieu maintained that he had "always made
it a rule not to depart from a faithful imitation of
nature."[3] Certainly the freshness of drawings such
as this is part of their appeal. The picturesque ele-
ments and luminous atmosphere may have been
inspired by some of the "Italianate" Dutch painters
who passed through Lyon, but Boissieu's essen-
tially grisaille technique and his devotion to the
Lyonnaise landscape are entirely personal.

[1] See Rosenberg, 1970, p. 35, no. 17.
[2] An impression is in the Städelsches Kunstinstitut,
Frankfurt, inv. no. 53760.
[3] Quoted and translated in Paris, etc., 1974-75, p. 325.

JACQUES-LOUIS DAVID
Paris, 1748 - Brussels, 1825

66. *Portrait of Thirius de Pautrizel*, ca. 1795
Ink and wash with white highlighting on paper, 7½ inches (19 mm) in diameter

Signed in pen at lower right: *L. David*

Inscribed on the mat: *Thirius de Pautrizel, Capitaine de Cavallerie en 1785. Representant de la Nation Française en 1794 et 1795.*

Provenance: Gairac Collection, Paris; Wildenstein and Co., New York, 1961.

Exhibitions: Caracas, 1957, no. 8; Charleroi, 1957, no. 32; Los Angeles, 1961, no. 61; Atlanta, 1981, no. 1.

David, more than any other artist, captured the spirit of France — and recorded the look of the individuals involved — during the periods of Revolution and Empire. From the 1780s on, his portraits reflect the intensity of the times, using stark decor to focus on character. Even when imprisoned briefly following the fall of Robespierre, David continued his work, portraying his fellow Conventionnels, as in the study of Jeanbon Saint-André (Art Institute of Chicago).[1] In this and other portrait drawings in chalk or pen,[2] David adopted a type of small round profile portrait that had been employed by Cochin.[3] Probably inspired by antique coins and medals, the format may be related to David's plans for the multifigured 1791 composition *The Oath of the Tennis Court.*

Jean-Baptiste-Louis Thirius de Pautrizel was born at L'Ile de Ré (Charente-Inférieure) on August 25, 1754. He became a landowner in Basse-Terre on the French Caribbean island of Guadeloupe. In the Revolutionary period, he rose to the rank of captain and was appointed a member of the Convention (as deputy from Guadeloupe) in October 1792. He was eventually denounced before the Convention for a seditious attitude and was imprisoned for a time. The date of his death is unknown.[4] As a deputy he would undoubtedly have met David, who was also elected in 1792.

The emphasis on the aquiline nose and high forehead in the Baer drawing recalls David's *Portrait of Michel Lepeletier de Saint-Fargeau* (Bibliothèque Nationale). David's subtle modeling in wash adds warmth and atmosphere, enlivening what otherwise would be a coldly formal portrayal.

[1] Chicago, 1974, no. 60.
[2] For example, the *Portrait of a Man*, Louvre, RF 4233, and the *Self-Portrait*, private collection, Brussels. See Verbraeken, 1973, no. 0.69.
[3] See Amsterdam, 1974, nos. 25 and 26.
[4] See Bourloton, 1891, II, p. 562.

JEAN-AUGUSTE-DOMINIQUE INGRES
Montauban, 1780 – Paris, 1867

67. *Studies of Joan of Arc and the Head of a Woman*, ca. 1844
Pen and ink (recto) with graphite (verso) on tracing paper, now mounted on blue wove paper, 11⅞ × 15⅜ inches (302 × 391 mm)

Inscribed by Raymond Balze along the base of the altar: *ces croquis preparatoire a un tableau / autre que le portrait costumé / du Musée du Louvre*. And inscribed at the lower left: *Dessins pour Le plutarque français*; and at the lower center: *note de R. Balze*.

Provenance: Raymond Balze; Morin collection; Sale, R. W. P. de Vries, Amsterdam, May 10-11, 1927, no. 256; Sale, de Vries, Amsterdam, 1929; Sale, de Vries, Amsterdam, Feb. 21-23, 1933, no. 1011; Sale, Stuttgartner Kunstkabinett, Stuttgart, May 20, 1953, no. 709.

Exhibitions: Cambridge, 1967, no. 92; New York, 1970, no. 55; Atlanta, 1981, no. 2.

Bibliography: Delaborde, 1870, p. 302, no. 338 (?); Wildenstein, 1954, p. 221, under no. 273; Rosenblum, 1967, p. 161.

In 1841 Ingres returned to Paris from Rome, where he had been Director of the French Academy. He was named a Commander of the Legion of Honor in 1845, the first of his many official honors.

Beginning in the 1820s, Ingres had painted a series of works depicting episodes from French history, such as *The Entry of the Dauphin into Paris* (1821, Wadsworth Atheneum, Hartford). He was thus an appropriate choice as an illustrator of a new edition of *Le Plutarque français*, a compendium of biographies of great Frenchmen prepared by Edouard Mennechet and I. Hadot and published from 1844 to 1847. The first edition (1835) had included a depiction of Joan of Arc after a drawing by Boilly, but Ingres was more to the taste of the Louis-Philippe period. In addition to Joan of Arc, Ingres produced images of Le Sueur, Poussin, La Fontaine, Racine, and Molière.

Ingres chose to present Joan of Arc at the peak of her career, standing heroically by an altar at the coronation of Charles VII at Reims Cathedral in 1429, following the successful seige of Orléans. Her future sainthood is indicated by the halo, but this was not included by Pollet in the engraving he made after the drawing (fig. 20).

Preliminary sketches at the Musée Ingres in Montauban show that the artist first established the pose and then studied the figure nude.[1] After experimenting with an antique tunic, he arrived at the costume of medieval armor seen in this drawing. He drew in graphite on tracing paper the more finished of the two studies, now visible at the right. Then he folded the page and traced the figure in ink to achieve the outline drawing now seen at the left. As the open sheet is now preserved, the graphite drawing is thus on the back side of the tracing paper. Ingres obviously used this process of folding and tracing in order to determine how the engraving, which would be reversed from his drawing, would look.

A decade later, in 1854, Ingres painted a more elaborate version of *Joan of Arc at the Coronation of Charles VII* (Louvre).[2] As the two inscriptions by his former student Raymond Balze make clear, however, this sheet is not a preliminary study for the painting, although Ingres did reuse the same basic composition.

[1] See Louisville, 1984, p. 104; another nude study was sold at Parke Bernet, Feb. 6, 1957, no. 21.
[2] A preliminary drawing for this was sold at the Palais Galliera, Paris, June 22, 1965, no. 77.

Fig. 20: Pollet after Ingres, *Joan of Arc*, engraving, 1846.

118

JEAN-AUGUSTE-DOMINIQUE INGRES
Montauban, 1780 - Paris, 1867

68. *Studies for "The Apotheosis of Napoleon I"*
Graphite heightened with white, the
contours of the central figure reinforced
in pen, on buff paper, 8⅞ × 16¹¹⁄₁₆ inches
(225 × 423 mm)

Inscribed in Ingres's hand, *transparent*
with a pencil line pointing to the drapery
over the right hand, and below the
clenched fist, *plus racourci* (more
foreshortened)

Exhibitions: Iowa, 1951, no. 124; Cambridge,
1958, no. 43; Oberlin, 1967, no. 5; New York,
1970, no. 57.

Bibliography: Mongan, 1967, pp. 149 and 155.

In March 1853 Ingres signed a contract to paint
within the year a ceiling decoration for the Salon de
l'Empereur in the Hôtel de Ville of Paris. The sub-
ject he chose for the circular ceiling was *The Apoth-
eosis of Napoleon I.* This, along with Delacroix's
Peace Gathering Plenty, in the Salon de la Paix, was
destroyed in the fires of the Commune in 1871. The
design is preserved, however, in an oil sketch in the
Musée Carnavalet, Paris (fig. 21), and in drawings
in the Louvre, Musée Bonnat, Bayonne, and a pri-
vate collection, New York.[1] Through these one can
visualize the composition, which showed the nude
Emperor, holding an orb and scepter, standing in a
horsedrawn quadriga led by Victory to the Temple
of Immortality. Fame crowns him with laurels;
France wearing her veil of mourning looks on; the
imperial eagle guards the empty throne and the
fierce goddess of retribution, Nemesis, wards off
Crime and Anarchy. On the steps of the throne was
the inscription *In nepote redivinus* (returned in my
descendant), which was meant to lend legitimacy to
the reign of Napoleon III, who had become
emperor in 1852.

Ingres, a meticulous artist, seems to have taken
unusual care with this important commission.
There are many rough preliminary drawings at

Montauban,[2] as well as finished studies and vari-
ants for every figure. He turned to antique coins,
cameos, and vases for inspiration. The Baer draw-
ing shows studies of Napoleon's laurel wreath and
the figure of Nemesis. She is reminiscent of the
figure of the mother in Ingres's earlier painting *The
Martyrdom of St. Symphorian*. A similar neoclassical
profile appears in a drawing of the figure of France
(Fogg Art Museum) which is on the same light
paper as the Baer drawing.[3] The sinuous forms, the
delicate shading, the telling use of white highlight-
ing all are characteristic of Ingres. As Agnes
Mongan has written, "if the shaky pen line
bespeaks the age of the seventy-three-year-old art-
ist, his handwriting is still as steady and unmistak-
able as in his younger days and his orthography as
personal."[4]

[1] Louisville, 1984, no. 41.
[2] See Longa, 1942, figs. 122-123.
[3] Cambridge, 1980, no. 52.
[4] Mongan, 1967, p. 149.

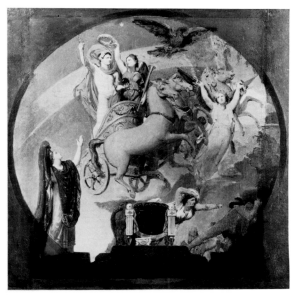

Fig. 21: Ingres, *Apotheosis of Napoleon I*, Musée
Carnavalet, Paris.

EUGENE DELACROIX
Charenton-Saint-Maurice, 1798 – Bordeaux, 1863

69. *Studies of Nude Male Figures for the "Frise de la Guerre,"* ca. 1833
Pencil on paper, 7⅛ × 9 inches (181 × 229 mm)

Stamped with the artist's estate stamp at the lower right (L.838): *ED*

Provenance: Private collection, Paris.

Exhibition: Atlanta, 1981, no. 3.

In 1833 Delacroix received his first commission for a large-scale mural decoration, the Salon du Roi in the Palais Bourbon. As he later wrote, the room was not appropriate for paintings, since there were so many windows and doors. Nevertheless, he designed a scheme of four friezes to fit on the narrow spaces between the arches and the ceiling cornice. These compositions symbolically represent various powers of the state: Justice, Agriculture, Industry, and War. The project was completed in 1838.

Delacroix set about his task in a traditional manner. A study for the overall scheme is in the Louvre (RF 23313).[1] The rough sketches for the arrangement on each wall are now in The Tate Gallery, London.[2] The artist then made studies from the nude model to get the proper pose for each figure. This sheet contains studies for figures in the War frieze.[3] The kneeling nude was transformed into a bearded barbarian (fig. 22) who laces his sandals in the first pendentive from the left in the section described by Delacroix as "*Les femmes emmenées en esclavage*" (women led away in captivity). The other two studies are for the robed figure holding a spear seated at the extreme right of the frieze in the section devoted to the preparation of armaments.

The pose in the drawing is quite close to the pose later employed by Rodin for his first monumental sculpture, *The Age of Bronze*, cast in 1876. These works probably share a similar source in Michelangelo's *Dying Slave*, which both Delacroix and Rodin could have studied in the Louvre.

Delacroix's powerful studies indicate not only what became the final forms of these figures, but also the pattern of light and dark shading that he attempted to achieve in the murals.

[1] See Sérullaz, *MD*, 1963, pl. 28a.
[2] See Sérullaz, *Memorial*, 1963, nos. 266-268.
[3] Sérullaz, *Murales*, 1963, figs. 6 and 13-14.

Fig. 22: Delacroix, detail of the *Frise de la Guerre*, Salon du Roi, Paris, 1848.

EUGENE DELACROIX
Charenton-Saint-Maurice, 1798 - Bordeaux, 1863

70. *Study for "Marphisa"*
Brush and bistre over pencil on ivory white paper, 9 × 8¾ inches (228 × 225 mm)

Provenance: Delacroix estate sale (L. 838); J. W. Böhler, Lucerne, 1955.

Exhibitions: Berlin, 1929-30, no. 51; Rotterdam, 1933-34, no. 58; Bern, 1934, no. 49; Brussels, 1936, no. 84; Amsterdam, 1938, no. 61; Zurich, 1939, no. 145; Bern, 1939, no. 145; Cambridge, 1958, no. 42; New York, 1970, no. 33.

Bibliography: *Der Cicerone*, XXII, Jan. 1930, p. 23.

Delacroix found several subjects in Ludovico Ariosto's *Orlando Furioso*, which had been popular in France since the eighteenth century.[1] This epic poem of 1516, full of fantastic adventures of Christian and pagan warriors, fired Delacroix's romantic imagination. As Sérullaz has convincingly argued, Delacroix's journal entry for February 17, 1850, noting that he had worked on his *Femme impertinente*, refers to the subject of this drawing.[2] The scene ultimately found its fullest expression in a painting (dated 1852) now in The Walters Art Gallery, Baltimore (fig. 23).[3]

The incident depicted comes from canto XX, lines 108-116, of *Orlando*. The warrior maiden Marphisa and the old woman Gabrina encounter the knight Pinabello and his lady. The knight's lady mocks the ragged clothes of Gabrina. Marphisa, insulted, challenges the knight and unseats him from his horse. She then demands that the lady exchange clothes with Gabrina. All four characters appear in the painting, but in the Baer drawing — obviously an early stage of the conception and probably one of seven "Marphisa" drawings dated to 1850 by Robaut[4] — Delacroix focuses on Marphisa's humiliation of the knight's lady. The rearing horse is just barely indicated. It is a more exciting pose than that of the placid beast in the painting. Marphisa is also more threatening in the drawing, reminiscent of a victorious Joan of Arc. The cowering figure of the lady clutching her dress is probably based on the classical type of the *Venus Pudica*. Delacroix's use of the watercolor washes serves to heighten the contrast between the two women: Marphisa, totally encased in her armor, and the quivering, naked lady.

[1] See Mongan, Hofer, and Seznec, 1945.
[2] Sérullaz, *Memorial*, 1963, pp. 325-326.
[3] Johnston, 1982, p. 48, no. 15.
[4] Robaut, 1885, no. 1773. Other drawings are in the Art Institute of Chicago and the Musée de Lille.

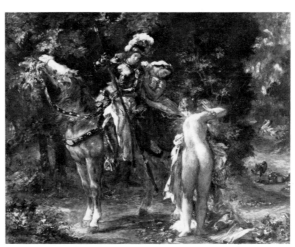

Fig. 23: Delacroix, *Marphisa*, The Walters Art Gallery, Baltimore.

JEAN-BAPTISTE-CAMILLE COROT
Paris, 1796-1875

71. *Clump of Trees at Cività Castellana*, 1826
Pen over pencil, with touches of white
highlighting, 10⅜ × 13⅞ inches
(265 × 353 mm)

Inscribed in pencil at the lower right:
Cività Castellana 1826

Provenance: A. Stroelin, Lausanne; Sale,
Gutekunst and Klipstein, Bern, Nov. 22, 1956,
no. 66.

Exhibitions: Cambridge, 1958, no. 44;
Chicago, 1960, no. 144; Newark, 1961, no. 15.

Corot had already begun to devote himself to land-
scape painting before his first trip to Italy in late
1825, but the scenery he saw there, particularly in
the Sabine hills around Rome, had a profound

effect on his development. The region, with its
rocky terrain, rich vegetation, and brilliant sun-
light, was a continual challenge. Working outside
of academic circles, Corot went on expeditions
with like-minded painters, notably Aligny, to
explore this new world. He made precise studies in
pen and pencil that served as the basis for more
freely rendered paintings.

This drawing, as Corot's inscription informs us,
is one of several made in June and July of 1826 at
Cività Castellana, a plateau surmounting two
rocky gorges between Rome and Viterbo.[1] In these
works Corot concentrated primarily on isolated
sections of rocks and trees. He sought to capture in
the linear forms of the trunks both a sense of natural
growth and the play of light. Obviously fascinated
by the charms of this humble spot, Corot returned
the following year and then again in the 1870s.[2]

[1] For other examples, see Paris 1975, nos. 124 and 126.
[2] Ibid., nos. 129, 131, and 170.

THEODORE ROUSSEAU
Paris, 1812 – Barbizon, 1867

72. *Landscape in Auvergne*, ca. 1830
Pencil, 7¾ × 11 inches (196 × 280 mm)

Stamped at the lower left with the artist's estate stamp (L. 2436)

Provenance: Spighel collection, Orléans; M. Feilchenfeldt, Zurich.

Rousseau, who was to become one of the leading Barbizon landscape painters, began at a very early age to sketch trees in the Bois de Boulogne. He studied with several minor artists in Paris, copied the Dutch masters in the Louvre, and made his first visit to both the Forest of Fontainebleau and the Auvergne in 1830.

As John Minor Wisdom, Jr. observed (in a letter of December 18, 1980), Rousseau's pencil draftsmanship did not change much during the years 1830-35. This study was most likely done during the 1830 visit to the Auvergne. A later view of the village of Thiers in the same region shows a similar vista of steep mountain cliffs.[1]

[1] In Amsterdam, 1964, no. 166.

HONORÉ DAUMIER
Marseilles, 1808 – Valmondois, 1879

73. *La veille funèbre* (*The Watch by the Deathbed*), ca. 1865
Pen and ink on paper, 9¹/₁₆ × 11⁷/₁₆ inches (230 × 290 mm)

Provenance: A. Vollard, Paris; Paul Cassirer; Marianne Feilchenfeldt, Zurich, 1959.

Exhibition: Atlanta, 1981, no. 9.

Bibliography: Maison, 1960, pl. 107; Maison, 1967, II, p. 141, no. 408.

As Agnes Mongan has shrewdly observed, the humorous quality of Daumier's work is subtly counterbalanced by the sinister. As he grew older, the artist shifted from the contemporary political scene, the theater, and the courtroom to the larger theme of *La Comédie Humaine*.[1] This drawing and a very similar one,[2] both depicting deathbed scenes, are among the most bizarre and horrifying in Daumier's extensive oeuvre. In this one, the old man in the chair has a demonic look. The subject, although not specifically identified, seems related to the biting satires of the medical profession which Daumier created after Molière's *Le Malade Imaginaire* and La Fontaine's *Fables*.[3] Death in the form of a skeleton coming to claim an old man lying in bed is seen in a charcoal drawing in a Parisian private collection.[4]

The style of pen drawing, in which the highly charged line creates powerful effects with remarkable economy, is characteristic of Daumier's work in the mid-1860s.

[1] Los Angeles, 1979, p. 12.
[2] Maison, 1967, no. 407.
[3] See Maison, 1967, nos. 485 and 486; and Adhémar, 1954, pls. 34 and 35.
[4] Maison, 1967, no. 402.

VICTOR HUGO
Besançon, 1802-1885

74a. *Stormy Landscape*, ca. 1865
Ink wash, 4¹⁵⁄₁₆ × 7¹⁵⁄₁₆ inches
(125 × 202 mm)

Inscribed in purple ink at the lower left:
V.H.

Exhibition: Atlanta, 1981, no. 8.

74b. *Landscape with a Castle*
Ink wash, 4¹⁵⁄₁₆ × 7¹⁵⁄₁₆ inches
(125 × 202 mm)

Victor Hugo, the celebrated novelist and poet, was also an artist of extraordinary originality. Baudelaire hailed "the magnificent imagination which streams through his drawings just as mystery streams through the heavens."[1] These two drawings are done in the free, broad style Hugo evolved in his works of the 1860s during his years in exile, when he travelled and lived in such rugged and scenic places as the Channel Islands and the Rhine Valley.[2] His miniature scenes on small pieces of paper have tremendous power, and his grandson described in vivid detail how Hugo achieved this:

> He would throw the ink at random, crushing the squeaking, spurting goose-quill into the paper. He then molded the black blot, as it were, transforming it into a town, a forest, a deep lake, or a cloudy sky; he would delicately moisten the hairs of the quill with his lips and burst open a cloud from which rain would fall on the damp paper; or, very precisely, he would use it to indicate the mist that blurred the horizon. He then finished the work with a matchstick, drawing delicate architecture details, bringing the ribs of an arch to flower, adding a grimace to a gargoyle, reducing a tower to a ruin, and the matchstick between his fingers became an etcher's needle.[3]

The rich ink tones of the artist's gloomy romantic visions were often achieved by the addition of coffee. In the *Stormy Landscape*, Hugo was so enraptured in his work that he incorporated into the composition his own fingerprint — a motif that he also used for creative effect in another work.[4]

[1] Salon review of 1852. See Baudelaire-Mayne, 1965, p. 202.
[2] See Picon, 1963, figs. 230-31, 238, 262, 271.
[3] Quoted and translated in Georgel, 1974, under no. 79.
[4] Ibid., no. 65.

JEAN-FRANÇOIS MILLET
Greville, 1814 - Barbizon, 1875

75. Recto: *Return from the Fields*, ca. 1867

Verso: *Peasant Leaning on a Staff and Studies of Cows*
Black chalk on blue-grey paper,
5 11/16 × 9 5/8 inches (144 × 244 mm)

Stamped in blue ink at the lower right corner (recto) with the artist's estate stamp (L. 1460): *J.F.M.*

Provenance: The Drawing Shop, New York.

Exhibitions: New York, 1963, no. 37; Atlanta, 1981, no. 10.

Millet was one of the greatest draftsmen of the nineteenth century. In innumerable chalk drawings, his powerful, broad manner captured the simple nobility of the peasants among whom he lived after settling in Barbizon. The vista on the recto of this sheet is unusually wide, dwarfing the mounted figure set against the austere sky. A similar composition of the weary return on horseback is found in a drawing in the Louvre.[1] The horseman holding his whip also occurs in two compositions of 1863 entitled *The Worker's Return*.[2]

On the verso, the figure of a peasant in his hat and cloak, leaning on his staff watching his animals, is one that Millet frequently repeated.[3] The image of the large cow grazing or drinking at the lower right also figures in compositions over many years, from a painting of 1858 to one of 1873.[4] The image also appears, in conjunction with the watchful peasant, in a large pastel in the Yale University Art Gallery.[5]

[1] Bacou, 1975, no. 48.
[2] Moreau-Nélaton, 1921, II, figs. 172 and 176.
[3] Ibid., III, fig. 346, and two others in Paris, 1975-76, nos. 232 and 233, as well as a painting in the Brooklyn Museum.
[4] Paris, 1975-76, nos. 67 and 238.
[5] Ibid., no. 212.

JOHAN-BARTHOLD JONGKIND
Latrop, 1819 - Côte-Saint-André, 1891

76. *View of Montmartre*, 1850
Pencil, 8⅝ × 12½ inches
(220 × 318 mm)

Inscribed and dated in pencil: *Montmartre 1850*

Stamped with the estate sale signature
(L. 1401)

Jongkind showed an early interest in art and became a pupil at The Hague Art School when he was eighteen. In 1846 he went to Paris and studied with Eugène Isabey. In 1850 he travelled to Normandy with Isabey. Coastal subjects were of particular interest to Jongkind. He made many watercolor and pencil sketches which later served as the basis for his paintings.[1]

When Jongkind first moved to Paris, he led a bohemian life in the then-undeveloped area of Montmartre, and that neighborhood appears in a number of his drawings and watercolors from that time.[2] With remarkable economy, Jongkind delineates the shapes and spaces of the vista. Carla Gottlieb has observed that "in the duality of simplicity and complexity, in the alternation of plain surfaces with 'embroidered' regions, resides the great charm of his work."[3]

[1] See Gottlieb, 1967, p. 296.
[2] See Hefting, 1975, nos. 72-73; Paris, 1971, no. 13; Grenoble, 1941, no. 47.
[3] Gottlieb, 1967, p. 298.

CAMILLE PISSARRO
St. Thomas Island, 1830 - Paris, 1903

77. *View of La Varenne*, ca. 1863
Pen and india ink over pencil, 8¼ × 14¼
inches (210 × 362 mm)

Signed with the artist's initials at the
lower right: *C.P.*

Inscribed at the lower right: *La Varenne*;
and with color notations on the sheet: *gris
chaud, temps chaud — ciel bleu gris chaud,
herbes.*

Provenance: Delius Gallery.

Exhibitions: Cambridge, 1958, no. 45;
Rotterdam, 1958, no. 175; Paris, 1958-59, no.
175; New York, 1959, no. 175.

Bibliography: Baer, 1977, no. 138.

In 1863, the year he exhibited at the Salon des
Refusés, Pissarro and his family settled at La
Varenne-Saint Maur on the river Marne, not far
from Paris. His work at that time was still deeply
indebted to the influence of the Barbizon School—
especially Corot, whom he had met in 1855. This
carefully rendered drawing, done in Pissarro's pre-
ferred style at this time, a combination of ink and
pen on a textured paper, clearly echoes Corot's love
of simple views treated in a straightforward man-
ner.

An 1863 painting of La Varenne-Saint Hilaire
now in Budapest[1] also gives special attention to the
shapes of the tall trees that act as a screen in the
middle ground. But in the drawing, the river and
the delicate strokes used to render the grasses on the
bank create a greater sense of atmosphere.
Pissarro's precise color notes reflect Corot's advice
to "study values . . . for they are the basis and
background of painting,"[2] and they indicate a nas-
cent impressionist concern for accurately capturing
the intensity of natural light.

[1] Pissarro and Venturi, 1939, no. 31, and Lloyd, 1981, p.
20.
[2] Lloyd, 1981, p. 28.

135

EDGAR DEGAS
Paris, 1834-1917

78. *View of Mt. Vesuvius*, ca. 1856
Pencil on white laid paper, 10¼ × 14¼
inches (260 × 368 mm)

Stamped on the verso with the atelier
stamp (L. 657)

Provenance: The Drawing Shop, New York.

Exhibitions: Dayton, 1951, no. 53; New York,
1968, no. 167; Atlanta, 1981, no. 15.

79. *Roman Landscape*, 1857
Pencil on pinkish paper, 10⅝ × 17¼
inches (270 × 438 mm)

Dated at the lower right: *15 fevrier 57*
Stamped on the verso with the atelier
stamp (L. 657)

Provenance: James Lord; Slatkin Gallery, 1958.

Exhibition: New York, 1958, no. 8.

In 1854 Degas made his first journey to Italy, where he had relatives. During 1856–57 he returned several times, spending time in Florence, Rome, and Naples.[1] His last trip, in 1860, was commemorated in one of his notebooks by a delicate drawing of the Bay of Naples[2] which, like the view exhibited here, showed the mountains in the distance.

While landscape studies abound in Degas's notebooks, landscape drawings as highly finished as these are rare. They are of remarkable delicacy. The *Roman Landscape*, which Professor Krautheimer suggested (in conversation) was a view of Monte Lepini beyond Velletri, is dated 1857, as are several other Roman drawings.[3] The *View of Mt. Vesuvius* is perhaps slightly earlier, but the memory of the volcano may have inspired Degas in his creation of the background for his 1860 painting, *The Young Spartans* (National Gallery, London).

[1] Lemoisne, 1954, I, pp. 16-19.
[2] Reff, 1976, II, fig. Nb.19, p. 3.
[3] See, for example, Rivière, 1973, pl. 3.

136

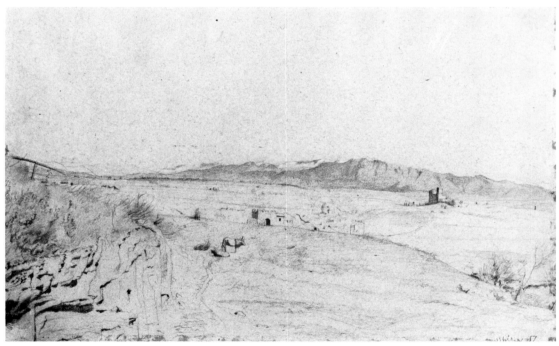

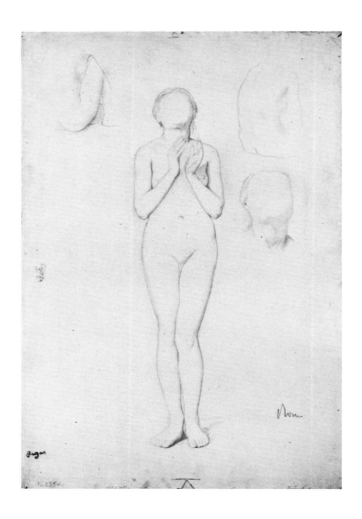

EDGAR DEGAS
Paris, 1834–1917

80. *Studies of a Female Nude*, 1856–58
Pencil on paper, 17¾ × 11⅜ inches
(450 × 290 mm)

Inscribed at the lower right: *Rome*; and in
pencil at the lower left corner: *Pb 2354*

Stamped at the lower left in red and on
the verso with the estate stamps (L. 657
and 658): *degas*.

Provenance: Degas Atelier Sale, fourth sale,
Georges Petit Gallery, Paris, July 2-4, 1919, p.
120, no. 126b; Lucien Heuraux, Paris.

Exhibitions: Iowa, 1964, no. 91; Atlanta, 1981,
no. 14.

Although they may have been made from a live
model, these studies appear to have been copied
from other works of art, either sculpture or paint-
ing. The full-length standing nude is reminiscent of
studies Degas made after paintings in his 1854–55
notebook (now in the Bibliothèque Nationale).
The facelessness of the nude reminds us of his copy
of Sodoma's *Leda* in the Louvre, and her upturned
head and prayerful hands are similar to a figure in
Perugino's *Ascension* at Lyon.[1]

[1] See Reff, 1976, II, figs. Nb 2, pp. 47 and 50.

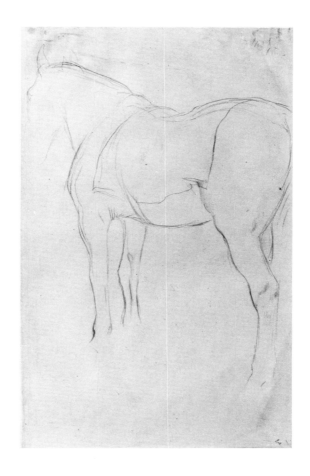

EDGAR DEGAS
Paris, 1834–1917

81. *Back View of a Horse*
 Pencil on paper, 12⅛ × 7½ inches
 (308 x 191 mm)

 Stamped on the verso with the artist's
 estate stamp (L. 657)

In the early 1860s Degas began to study horses,
probably as the result of visits to the estate of his
friend Paul Valpinçons, which was near a major
horse-breeding farm. The animals, usually with
jockeys, became one of the artist's favorite subjects,
and he studied their movement with the same
delight and concentration that he applied to his
ballerinas.

The sketchiness and placement of the horse on
the sheet are similar to two other drawings of
horses seen in back view, one in the Art Institute,
Chicago,[1] and the other (with the horse facing
right) in the Museum of Art, Rhode Island School
of Design.[2] All three drawings were probably pre-
paratory studies for Degas's first major race horse
painting, *Race Horses*, 1869–72 (now in Paris, Musée
d'Orsay).

[1] Chicago, 1984, no. 21.
[2] St. Louis, etc., 1967, no. 42.

EDOUARD MANET
Paris, 1832-1883

82a. *Mme. Edouard Manet*, 1880
Brush with black wash on graph paper,
6³⁄₁₆ × 4⁵⁄₈ inches (168 x 127 mm)

Provenance: Cottereau collection.

Exhibitions: Cambridge, 1958, no. 48;
Atlanta, 1981, no. 11.

Bibliography: Duret, 1910, p. 42; de Leiris,
1969, p. 137, no. 579, fig. 422; Rouart and
Wildenstein, 1975, I, p. 264, II, p. 152, no.
409.

82b. *Mme. Jules Guillemet*, 1880
Pencil and brush with black wash on
graph paper, 6³⁄₁₆ × 4⁵⁄₈ inches
(168 × 127 mm)

Exhibition: Cambridge, 1958, no. 49.

Bibliography: de Leiris, 1969, p. 139, no.
600; Rouart and Wildenstein, 1975, II, p.
208, no. 584.

Throughout his career Manet dashed off closely
observed sketches of people around him, especially
attractive and well-attired ladies. He seems to have
had a fondness for interesting hats. Such studies
were not always preliminary ideas for paintings,
but they often led to larger works. In the case of
these two studies, the drawing of Mme. Manet is
quite similar to the painting *Mme. Manet at Bellevue*
(fig. 24), in which she is shown seated on a bench
and turned to reveal her profile.[1] A nearly identical
head study in black wash appears on a letter of 1880
sent by Manet to Henri Guerard to accompany
greetings from his wife and mother.[2]

Mme. Jules Guillemet was an elegant American
who, with her husband, ran a fashionable dress
shop. Manet painted them together in the
impressive canvas *In the Conservatory* (Staatliche
Museen, Berlin) and did a number of individual
drawings and portraits of Mme. Guillemet in dif-
ferent outfits. This sketch of her in a derby-like
travelling hat is probably related to a pastel portrait
of her.[3] A very similar design also occurs in a letter
addressed to her by Manet on July 25, 1880.[4]

Manet had the ability to suggest color and form
with just a few strokes, and in this type of drawing
he used the brush and his favorite black wash with
great facility, much like an Oriental calligrapher.

[1] Rouart and Wildenstein, I, no. 345.
[2] Ibid., II, no. 599; and Moreau-Nélaton, 1926, II, fig.
282.
[3] Ibid., II, no. 36.
[4] Ibid., II, no. 583; de Leiris, no. 575.

Fig. 24: Manet, *Madame Manet*.

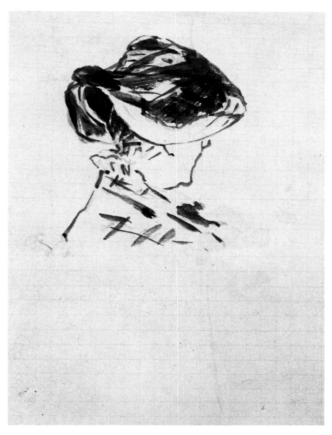

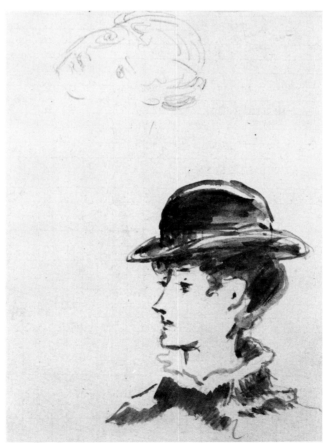

PAUL CEZANNE
Aix-en-Provence, 1839-1906

83. Recto: *The Unmade Bed*
Numbered at the upper right: *LXV*

Verso: *Drapery Sketch*
Numbered *LXVI*
Graphite on white paper, 10¾ × 8¼
inches (270 × 210 mm)

Provenance: Cézanne family; Paul Guillaume,
Paris; A. Chappuis, Tresserver; A. Stroelin;
Sale, Gutekunst & Klipstein, Bern, Nov. 22,
1956, no. 60; Wertheimer, Paris.

Exhibitions: London, 1939, no. 83; Nice, etc.,
1953, no. 42; Cambridge, 1958, no. 51;
Newark, 1961, no. 57.

Bibliography: Venturi, 1936, I, p. 313;
Chappuis, 1938, no. 41; Neumeyer, 1958, pp.
50 and 60, no. 51; Chappuis, 1973, I, p. 224,
nos. 959 and 959a; Rewald, 1984, p. 129.

Cézanne wrote to the young Emile Bernard:
"Drawing and painting are not different things. To
the degree that one paints, one draws. The more the
color becomes harmonious, the more the line
becomes precise."[1] This is entirely true for
Cézanne, and his line drawings convey a sense of
color as well as pure form. Cézanne's sketchbooks
of the late 1880s concentrate on small details from
his daily surroundings, investing them with an
unexpected monumentality through simplification
and expressive modeling. In this powerful exam-
ple, the unmade bed seems ominous, oppressive, as
if sleep were something the artist had to struggle
against. The same bed (although not as rumpled) is
found in a watercolor from the same sketchbook.[2]

[1] Bernard, 1912, p. 35.
[2] Rewald, 1984, no. 186.

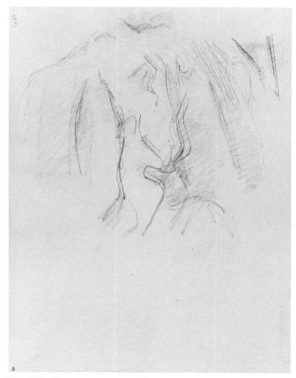

Fig. 25: Cézanne, verso of no. 83.

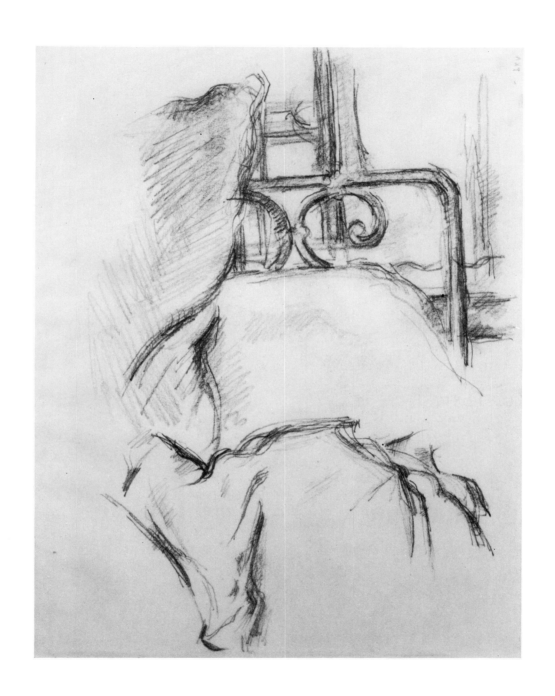

PIERRE-AUGUSTE RENOIR
Limoges, 1841 - Cagnes-sur-Mer, 1919

84. *Studies of Trees*, ca. 1885
 Pen and ink with watercolor on paper
 with the watermark J WHATMAN
 Turkish Mill 1884, 11¼ × 9¼ inches (285
 × 234 mm)

 Signed with the artist's initial at the lower
 right: *R*

 Provenance: A. Vollard; Edouard Jonas.

About 1883 Renoir became dissatisfied with his
spontaneous impressionist style and felt he was at a
dead end. John Rewald has written that Renoir then
"destroyed some paintings and was seized by an
actual hatred for impressionism. As an antidote, he
painted several canvases in which every detail —
including the leaves of trees — was first carefully
drawn with pen and ink on the canvas before he
took up his brush. A number of watercolors were
done in the same fashion, that is, color was *added* to
more or less complete drawings; it was not part of
them but played the role of supplementary decora-
tion."[1]
 A number of similar sheets from this same time
show small bits and pieces of trees and leaves, all
lovingly detailed.[2] Their seemingly random
arrangement on the paper creates a lively mosaic of
colored forms.

[1] Rewald, 1946, p. 12.
[2] Ibid., pls. 4a and 5b; Vollard, 1918, II, pp. 122, 156, and
182; Paris, 1976-77, no. 69.

ODILON REDON
Bordeaux, 1840 - Paris, 1916

85. *Study of a Man's Back and a Melancholy
 Angel*, ca. 1865
 Pencil on paper, 11⅜ × 8¾ inches
 (290 × 221 mm)

Signed in pencil at the lower left corner:
ODILON REDON

Provenance: E. & A. Silberman Gallery, New
York; Dr. Paul Weiss, Woodside, New York;
Sale, Parke Bernet, New York, May 6, 1970,
no. 27.

Exhibition: Atlanta, 1981, no. 28.

The careful draftsmanship of these drawings sug-

gests a dating in the mid-1860s, before Redon
developed the broad, black manner of his later
work. A drawing of a striding figure sometimes
known as *Le Géant*, in the collection of the Fogg
Art Museum, shows the same early style.[1] The
decorative pattern of lines composing the muscles
of the man's back is also seen in the mountains and
rocks in Redon's etchings of this period.

The man in the upper study appears to be bald, as
Redon depicted the *Fallen Angel* in a charcoal of
1871 (Rijksmuseum Kröller-Müller, Otterlo); and
this figure too has a pose suggesting a defiant
Lucifer. The despondent little angel is one of many
such winged figures in Redon's work and is charac-
teristic of this artist's bizarre imagination.

[1] Mongan and Sachs, 1946, I, no. 719; III, fig. 385.

HENRI DE TOULOUSE-LAUTREC
Albi, 1864 - Céleyran, 1901

86. Recto: *A Monkey*

Verso: *Two Sketches of a Woman's Head*
Pencil, 6³⁄₁₆ × 10¹⁄₁₆ inches
(157 × 256 mm)

Recto signed with the artist's monogram at the right and inscribed at the lower left: *1880*; Verso monogrammed between the two heads

Provenance: G. Pellet; Maurice Exsteens; Sale, Parke Bernet, New York, April 12, 1945, no. 40.

Exhibitions: Paris, 1938; New York, 1943; Cambridge, 1958, no. 50.

Bibliography: Joyant, 1927, II, p. 180; Dortu, 1971, IV, p. 266, no. D.1.624.

The work of the youthful Toulouse-Lautrec con-stitutes a veritable menagerie. On countless sketchbook pages of the late 1870s and early 1880s Lautrec — following the lead of the deaf and dumb painter René Princeteau, a family friend — drew keenly witty line studies of a wide variety of animals as well as many caricatures.

Fig. 26: Toulouse-Lautrec, verso of no. 86.

20th Century

PAULA MODERSOHN-BECKER
Dresden, 1876 - Worpswede, 1907

87. *Fruit Tree in Bloom*, ca. 1900-02
Charcoal on blue paper, 10¼ × 12¼
inches (260 × 311 mm)

Inscribed by the artist's daughter at the
lower right corner: *f. PMB/T.Modersohn*
(?)

Provenance: Sale, Parke Bernet, New York,
Sept. 18, 1968, no. 5.

Exhibition: Atlanta, 1981, no. 52.

Paula Becker began her art lessons at an early age,
studying first in Bremen, then (1888) in London,
and later in Berlin. Despite her parents' objections,
she dedicated herself to becoming an artist and in
the fall of 1898 joined the artists' colony at the small
village of Worpswede near Bremen. It had been
founded ten years earlier by Fritz Makensen,
Henrich Vogeler, and Otto Modersohn as an alter-
native to the formal training of the Düsseldorf
Academy. These artists had no specific creed and
did not live communally, but they were united in an
almost mystical dedication to the study of nature
and the local peasant community. Writers, musi-
cians, and poets (notably Rainer Maria Rilke) were
attracted to this congenial setting.

Paula Becker's teacher was Makensen, and in
1901 she married Modersohn. Her work was little
known until after her tragic death following the
birth of her daughter. She developed a powerful,
often crude technique in her search for "great sim-

plicity of form."[1] She was influenced by her study
of Rembrandt and her trips to Paris (in 1900, 1903,
and 1905), where she studied contemporary art
movements.

Makensen's teaching stressed careful observation
of natural details, and his own works depicted
romanticized peasant scenes. Modersohn-Becker's
prime themes were mothers and children and land-
scapes, which she transformed into powerful,
unsentimental forms. Nature was all important,
and her intensely personal response to it is evident
in the first impression of Worpswede she recorded
in her diary:

> Worpswede, Worpswede, Worpswede! 'Versunkene
> Glocke' feeling! Birches, birches, pines and old
> willows. The beautiful brown moor, delicious brown!
> . . . Worpswede, Worpswede, you are always on my
> mind. That was real feeling to the tip of my tiniest
> finger. Your mighty grandiose pines! I call them my
> men, broad, gnarled and large, and yet with fine, fine
> sinews and nerves. I think this is an ideal artistic form.
> And your birches, the delicate slender young women,
> which bring joy to the eye.[2]

This feeling for the shape of trees found expression
in the Baer drawing and others of the period around
1900.[3] There is still an element of art nouveau ele-
gance in these, and, as Modersohn-Becker herself
observed in a 1903 letter to her husband: "I have a
feeling for the interlacing and the layering of
objects, I must develop and refine this carefully."[4]

[1] Perry, 1979, p. 4.
[2] Ibid., p. 13.
[3] New York, 1983-84, no. 14.
[4] Perry, 1979, p. 114.

FRANZ MARC
Munich, 1880 – Verdun, 1916

88. Recto and Verso: *Studies of a Horse's Head*,
ca. 1907
Charcoal, 9¹/₁₆ × 6½ inches
(230 × 165 mm)

Provenance: Frau Maria Marc.
Exhibition: Atlanta, 1981, no. 53.
Bibliography: Lankheit, 1953, pl. 5.

Throughout his brief career Marc concentrated on animal subjects. His aim was to suggest a vision of animal life that was not anthropocentric, but spiritual. He wrote:

> Is there a more mysterious idea for an artist than to imagine how nature is reflected in the eyes of an animal? How does a horse see the world, how does an eagle, a doe, a dog? It is a poverty-stricken convention to place animals into landscapes as seen by men; instead we should contemplate the soul of the animal to divine its way of sight.[1]

In this early sketch, Marc's sympathy for animal life is strongly evident, as is his ability to seize on rhythmic and decorative features of his subject. On the recto, the turning of the horse's head is not only a keenly observed action study, but also a unified circular sweep of movement. The strength of the horse is emphasized in the powerful neck, breast, and shoulder, and its intelligence is stressed by the fullness of forms of its head. On the verso, the bending of the horse's neck to the ground provides a motif of great dynamism.

[1] See Chipp, ed., 1971, p. 178.

ERNST BARLACH
Wedel, 1870 – Guestrow, 1938

89. *Two Men with a Dog, Walking in the Moonlight*, 1909
Brush and sepia with charcoal and white chalk over a preliminary pencil sketch on paper with the watermark P. R. Fabriano, 9⁷⁄₁₆ × 13¼ inches (241 × 335 mm)

Signed and dated at the lower left: *Barlach Florence 1909*

Exhibitions: Cambridge, 1958, no. 59; Washington, etc. 1965-66, no. 4.

Bibliography: Schult, 1971, p. 95, no. 690.

Barlach is best known as a sculptor, but he was also a printmaker and dramatist. In addition, he produced more than a thousand drawings. His early works were in an art nouveau style learned in Dresden and Paris, but a trip to Russia in 1906 changed his view of humanity and his art. There he saw man as an oppressed creature. Inspired by German Gothic sculpture, Barlach's figures became swathed in heavy drapery, their features crudely realized, and their actions constricted to ritualized gestures. A sense of gloom permeates most of his subsequent work.

In 1909 Barlach was awarded a fellowship to work at the Villa Romano in Florence, but as he later wrote, "Italy did not revolutionize me. I left as I had come, in cold blood."[1] However, at the Villa he met the poet Theodor Däubler, who was finishing *Nordlicht*, a mystic epic which espoused the theory that "man must overcome the pull of Earth and let his earthly form melt to the ecstasy of the spirit."[2] This drawing, which depicts a strong interaction between the figures (sometimes described as hunters) and the heavenly sphere, may relate to Däubler's imagery. Or perhaps Barlach, while in Dante's city, imagined an updated pilgrimage through Purgatory. Barlach applied the charcoal in typically emphatic, brutal strokes to form the outlines and structure and then smudged it to create atmosphere and shading. The result is a scene of eerie bleakness.

[1] Jackson, 1955, p. 41.
[2] Ibid.

PABLO PICASSO
Malaga, 1881 – Vallauris, 1973

90. *Six Circus Horses with Riders*, 1905
Pen and ink, 9¾ × 12⅞ inches (247 × 327 mm)

Signed at the lower left: *Picasso*[1]

Provenance: Leo Stein; Henry Kleeman; Curt Valentin, New York.

Exhibitions: Princeton, 1949, no. 4; Iowa, 1951, no. 212; Middletown, 1955; Cambridge, 1958, no. 53.

Bibliography: Zervos, 1954, 6, p. 87, no. 716.

Beginning late in 1904 Picasso and his circle of painters and poets began regularly attending the Cirque Médrano at the foot of Montmartre, not far from his studio-residence. Two aspects of the circus particularly fascinated Picasso — the clowns and the horse acrobats. Through 1905 he made a variety of his quick, on-the-spot sketches. Then, as was his method, he gradually refined his ideas toward the production of large-scale works. The major clown composition was the *Saltimbanques*, now in the National Gallery, Washington.[2] The boy riders were to be the subject of a large painting called *The Watering Place*, which was never carried out; we know of its conception from a drawing, a watercolor, a gouache, and a drypoint (fig. 27), all done during the spring and summer of 1906.[3] Picasso isolated the central element for the oil *Boy Leading a Horse*, now in the Museum of Modern Art, New York.[4]

The Baer drawing is one of several 1905 drawings, including several in the Cone Collection (Baltimore Museum),[5] that record Picasso's spontaneous reaction to youthful acrobats and their animals. It is drawn with pure flowing outlines. This same effect is evident in the drypoint, in which similar motifs are transformed from individual sketches into an integrated composition set in a landscape.

[1] The signature was added by Picasso in 1948 at the request of Curt Valentin.
[2] See Carmean, 1980.
[3] Daix and Boudaille, 1966, I, p. 288, nos. XIV, 14-16.
[4] New York, 1980, p. 68.
[5] See Carlson, 1976, nos. 16-18.

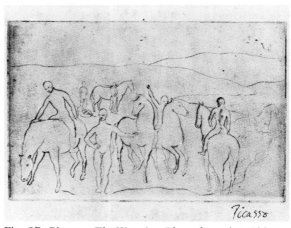

Fig. 27: Picasso, *The Watering Place*, drypoint, 1905.

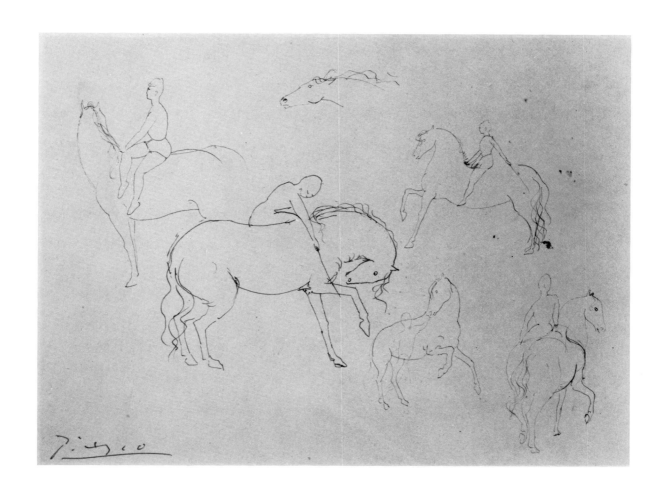

PABLO PICASSO
Malaga, 1881 - Vallauris, 1973

91. *Two Men Contemplating a Bust of a Woman's Head*, 1931
Pencil on paper, 12¹³⁄₁₆ × 10¼ inches (329 × 261 mm)

Signed and dated in pencil at the lower left edge: *Picasso Paris le 27 novembre XXXI*

Exhibitions: Cambridge, 1958, no. 54; Atlanta, 1981, no. 44.

From his earliest days, Picasso had dealt with the theme of the artist in his studio and its variants — the artist and his model and the artist admiring his work. He seems to have been fascinated with the idea of artistic creation, especially his own, and often related it to procreation or sexual desire.

In the late 1920s this theme was given a new impetus in the series of illustrations Picasso made for Balzac's *Le Chef d'oeuvre inconnu* (*The Unknown Masterpiece*), published by Vollard in 1931. It was the story of a mad old painter who spent ten years upon the picture of a woman, repainting it until only he could discern the masterpiece. The theme of the artist in his studio, and particularly the sculptor, also came to be the predominant theme in the *Vollard Suite*, a series of etchings done from 1930 to 1937.

Picasso's art, especially in his graphic work, often paralleled events in his own life. In 1931 he had converted the stables of the Château de Boisgeloup near Gisors into a sculpture studio and began a series of large-scale plaster female heads based loosely on the features of his mistress, Marie-Thérèse Walter. The head evolved from a pure, realistic form into protuberant, abstract deformations, and ultimately, as he fell out of love with Marie-Thérèse, a surreal scarecrow. The noble, somewhat archaic form of the sculpted head seen in this drawing is closest to the *Head of a Woman* cast in bronze in 1934.[1]

This drawing, executed in November 1931, is in the "classical" manner Picasso employed in his etchings for Ovid's *Metamorphoses* that same year. It is close to a drawing of August 4 done at Juan-les-Pins[2] that also shows two bearded men in shorts regarding a sculpture. We can identify the older bearded man as the artist/sculptor, since another drawing of the same day shows him modeling the sculpted head.[3] The theme of contemplating such a head continues in a drawing of December 4 and, more abstractly, in *Le Sculpteur* of December 7.[4]

In the example presented here, Picasso delineates with great economy the rapt countenances of the two men, gazing upon this imposing female head. One feels that they are almost in awe of it, both as a work of art and the embodiment of a goddess-like woman. Her noble features and their simple attire — combined with the lack of any real setting or props — suggest an idyllic, timeless realm, where art and inspiration are in perfect harmony.

[1] Spies, 1971, p. 115, no. 128.
[2] Zervos, VII, no. 335.
[3] Ibid., no. 337.
[4] Ibid., V, no. 352 and no. 346.

154

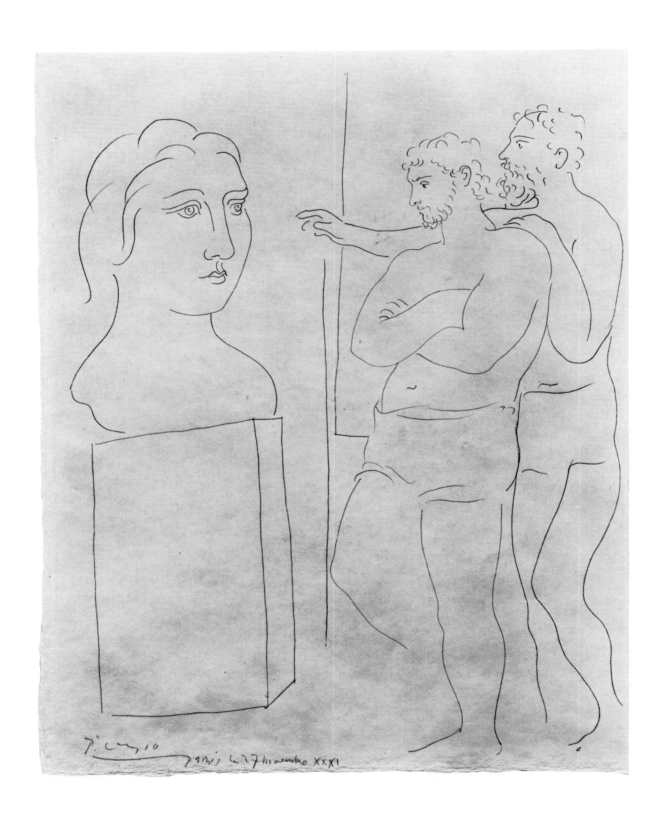

AUGUSTE RODIN
Paris, 1840 – Meudon, 1917

92. *Head of a Cambodian*, ca. 1906
Pencil and crayon with watercolor,
12⅝ × 9⅝ inches (330 × 255 mm)

Provenance: Roche collection.

Exhibition: Cambridge, 1958, no. 46; Atlanta,
1981, no. 40.

Bibliography: Geissbuhler, 1963, p. 41, pl. 15.

Toward the end of his career Rodin increasingly
turned his creative energies to his drawings, which,
as he told an interviewer, he considered "the syn-
thesis of his life's work, the outcome of all his labor
and knowledge."[1] No drawings show this better
than those inspired by the troupe of Cambodian
dancers that came to France in the summer of 1906.[2]
Having seen their performance in Paris, Rodin fol-
lowed them to Marseilles, where they appeared at
the Exposition Coloniale. He had the opportunity
to study them in rehearsal at the Villa des Glycines
and wrote enthusiastically: "From the point of view
of form, these dancers are all adorably beautiful.
Their faces astonish us. They recall our Italian

models. There is a simplicity of modeling which
also reminds us of the Egyptian granites."[3]

This figure has often been identified as the
group's patron, King Sisowath, but comparison
with a contemporary photograph of the King
makes this unlikely, unless we assume that Rodin
took great artistic liberties.[4] The man was probably
one of the musicians or another member of the
entourage.

Rodin's sculptural training is evident in his
reduction of the head to a simple sphere and, most
strikingly, in the treatment of the hand with the
unusually long fingers. The tubular simplicity of
this form invites comparison with the abstraction
being carried out by the younger sculptor Brancusi
(see cat. no. 93). As much as the stylized movement
and the exotic faces, the Cambodians' brightly col-
ored costumes impressed Rodin. His drawings
from this time onward make greater use of color
washes to enliven the rapid pencil lines.

[1] Quentin, 1898, p. 194.
[2] See Elsen and Varnedoe, 1971, p. 98.
[3] Translated in Geissbuhler, 1963, p. 38.
[4] See Descharnes and Chabrun, 1965, p. 252.

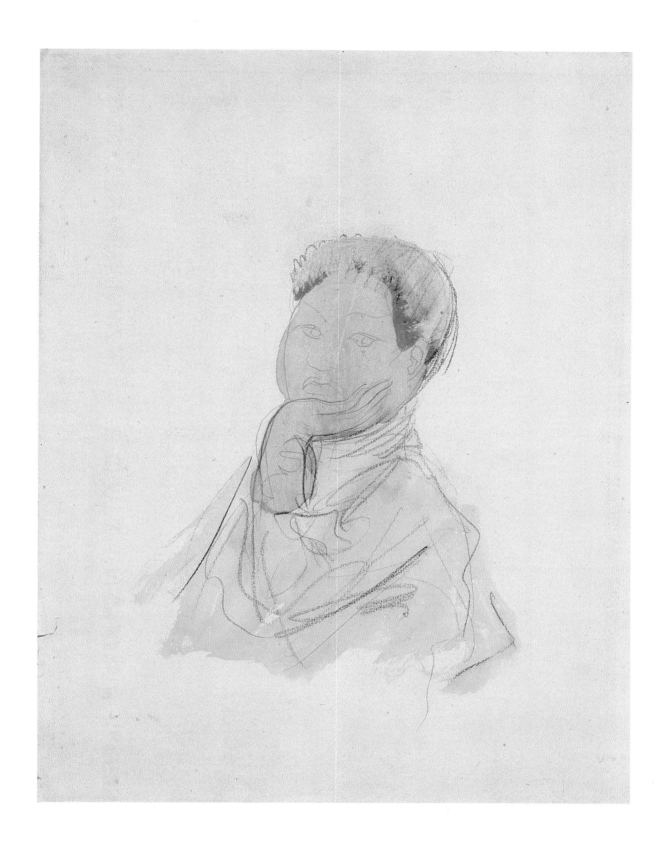

CONSTANTIN BRANCUSI
Hobitza, Romania, 1876 - Paris, 1957

93. *Studies of Hands*
Pencil on paper, 16⅛ × 21⅛ inches (413 × 537 mm)

Signed at the lower right corner: *Brancusi*

Exhibitions: New York, etc. 1969; The Hague, 1970, no. 46; New York, 1981, no. 92; Atlanta, 1981, no. 49.

Bibliography: Geist, 1975, p. 96.

Brancusi usually preferred to work out his ideas directly in his sculpture and thus made very few drawings. Of these, Sidney Geist has written, "Brancusi's touch, whether with pencil, pen or brush, is never monotonous or mechanical; one senses the hand and its movement. . . .Rationality may inform the sculpture; an undisguised lyricism pervades the drawings. . . . They are for the most part a sheer indulgence in beauty. . . ."[1]

On this beautiful sheet, Brancusi creates a circular rhythm. Each study can be viewed independently but the three together form a sculptural entity. These studies probably relate to the creation of one of the sculptor's most significant works, *The Portrait of Mlle. Pogany*, done in marble and bronze in 1912 and repeated later, each time with a different treatment of the hands. In the drawing Brancusi seems to be striving for the purest abstraction of human forms that would retain the characteristics of his model. Mlle. Margit Pogany, a Hungarian painter studying in Paris, has recorded that during the posing sessions in late 1910 and early 1911 she once "had to sit for my hands but the pose was quite different to that of the present bust, he only wanted to learn them by heart as he already knew my head by heart."[2] The bunching of the fingers together to form one smooth unit, as seen in the sketch at the left, recurs in a 1912 drawing of Mlle. Pogany in the Streep collection,[3] and the ultimate abstraction of the elegant hand is seen in another drawing[4] and in the small sculpture in yellow marble made by Brancusi in 1920 for John Quinn (fig. 28).[5]

[1] In New York, etc., 1969, p. 137.
[2] Geist, 1968, p. 191.
[3] See Geist, 1975; sold Parke Bernet, April 28, 1966, no. 757.
[4] Sold Sotheby's, June 23, 1965, no. 35.
[5] Now in the Fogg Art Museum, see Geist, 1975, p. 96, no. 133.

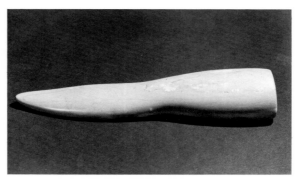

Fig. 28: Brancusi, *Hand*, yellow marble, courtesy of the Fogg Art Museum.

HENRI MATISSE
Le Cateau-Cambrésis, 1869 – Nice, 1954

94. *Head of a Young Woman*, ca. 1919
Pen and black ink on white paper, 14⅜ ×
10½ inches (366 × 267 mm)

Signed at the lower right: *Henri Matisse*

Exhibition: Cambridge, 1958, no. 52.

In 1939 Matisse made the following statement
about his drawings and their subjects:

My line drawing is the purest and most direct transla-
tion of my emotion. The simplification of the
medium allows that. At the same time, these drawings
are more complete than they may appear to some
people who confuse them with a sketch. They gener-
ate light; seen on a dull day or in indirect light they
contain, in addition to the quality and sensitivity of
line, light and value differences which quite clearly
correspond to color. My models, human figures, are
never just "extras" in an interior. They are the prin-
cipal theme in my work. I depend entirely on my
model, whom I observe at liberty, and then I decide on
the pose which best suits her nature. When I take a
new model, I intuit the pose that will best suit her
from her un-selfconscious attitudes of repose, and

then I become the slave of that pose. I often keep those
girls several years, until my interest is exhausted.[1]

This expressive quality is found particularly in
the drawings done by Matisse in Nice between 1918
and 1919. Some of these published by him in 1920
show models who, like that in the Baer drawing,
wear flowered dresses and have a similar melan-
cholic attitude.[2] The same model in the same dress
appears in another drawing of 1918.[3] Named
Henriette, she was the one Matisse retained the
longest from his Nice period, and she appears in a
similar pensive, chin-on-hand pose in his 1923
lithograph *Girl with a Bouquet of Flowers*.[4] Victor
Carlson has written of these Nice drawings that
"they share the appearance of having been executed
with ease and unvarying sureness. . . . A complete
harmony exists between the relaxed character of
the model's pose and the artist's unforced drafts-
manship."[5]

[1] Translated in Flam, 1978, pp. 81-82.
[2] *Cinquante Dessins par Henri-Matisse*, Paris, 1920, pls.
XXIV, XXXIX, and L.
[3] Schneider, 1984, p. 492.
[4] Elderfield, 1978, p. 122.
[5] Carlson, 1971, p. 84.

OSKAR KOKOSCHKA
Pöchlarn, 1886 – Montreux, 1980

95. *Mary Merson*, 1931
 Red chalk, 17¾ × 12¼ inches
 (445 × 310 mm)

 Signed at the lower right: *O. Kokoschka*

 Provenance: Paul Cassirer & Co.,
 Amsterdam, 1965.

 Exhibition: Atlanta, 1981, no. 57.

 Bibliography: Westheim, 1962, no. 126.

This drawing is one of about twenty red chalk studies Kokoschka made in 1931 of a Russian woman, Mary Merson.[1] Another is in the Baer collection (cat. no. 175), while others are in the Feilchenfeldt collection, Zurich, the Lütjens collection, Amsterdam, and the Art Institute of Chicago. Peter Morrin has observed that:

> As a group, they display a remarkable variety of moods and attitudes, from bovine placidity to open eroticism and here one is impressed by the sitter's quiet strength in reserve; her demure classical profile and tender gesture of holding drapery to her breasts is contrasted with her broad back and the rawness of her accented neck, backbone, shoulder, arm, and ribs. In opposition to the relaxation of the pose is the febrile energy and sense of urgency which always characterizes Kokoschka's draftsmanship. Broad zigzag shading, hard stabbing lines defining the body's contours, and dark abstract calligraphy in the areas of her hair and the drapery serve more to convey the vitality of the model than to describe her physical forms.[2]

[1] See Hoffman, 1947, p. 330.
[2] Atlanta, 1981, p. 118.

162

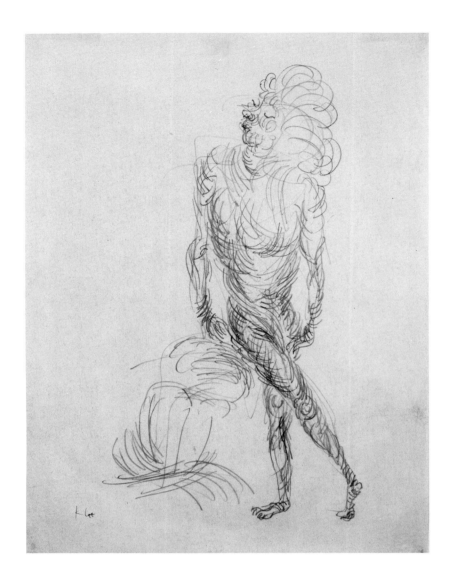

PAUL KLEE
Münchenbuchsee, 1879 - Muralto, 1940

96. *Akt in geschraubter Bewegung* (*Nude in Spiraling Movement*), 1933
Pencil, 16¼ × 12⅝ inches
(413 × 320 mm)

Signed at the lower left: *Klee*

Titled, and inscribed on the original mount by Klee: *1933 Y 8*

Provenance: New Art Center Gallery, New York, 1962.

In 1933, in the face of National Socialism, Klee left Düsseldorf, where he had been teaching at the Academy, and returned to his native Switzerland. His work of that year shows a wide fluctuation in style — even for this most versatile of artists. According to the Swiss sculptor Zschokke, Klee had made a cycle of two hundred "apocalyptic drawings" dealing with the oppressive situation in Germany.[1] These seem to be lost, but a feeling of anxiety is also generated by other drawings of 1933-34 in which human figures appear.[2] Works such as this *Nude in Spiraling Movement* are the result of Klee's experiments with spontaneous drawing, a serious form of scribbling in which the hand "freed from the will for precision and clear-cut line follows with its long-trained exercise like a seismograph the inner stimulus."[3] The resulting fantastic figures become pictorial symbols of emotional states and concepts of movement which Klee had sought to analyse in his notebooks.[4]

[1] Giedion - Welcker, 1952, p. 78.
[2] See the examples reproduced in Cologne, 1979, nos. 372 and 375; and Huggler, 1961, pl. XI.
[3] Huggler, 1961, p. 10.
[4] See P. Klee, 1973, esp. p. 175.

164

VASILY KANDINSKY
Moscow, 1866 - Neuilly, 1944

97. *"Flying Dragon,"* 1938
Ink on paper, 11½ × 9 inches
(292 × 229 mm)

Signed at the lower left with monogram:
VK 38

Provenance: Madame Nina Kandinsky, Paris,
1944-1961; Galerie Karl Flinker, Paris,
1961-1963; Galerie Dresdener, Montreal, 1963;
Sale, Parke Bernet, New York, February 11,
1965, no. 56.

Exhibition: Atlanta, 1981, no. 56.

Forced to flee Germany, Kandinsky and his wife
arrived in Paris in the fall of 1933 and there he settled
for the remainder of his life. He considered the
works produced in these Paris years the synthesis of
his earlier experiments with abstraction. In 1937 he
wrote, "Abstract forms are *who knows?* natural
forms,"[1] and his work of this period is composed
primarily of biomorphic forms. In his major the-
oretical tract, *Point and Line to Plane* (1926), Kan-

dinsky had noted the relation of zoomorphic shapes
to cells and protoplasm, but it was undoubtedly the
influence of the free flowing surrealist creations of
Miró and Arp that led him to abandon the strict
geometric forms of his previous style.[2]

Most of Kandinsky's Parisian works are richly
colored but, as titles like *Variegated Black* (1935) and
Two Blacks (1941) and works such as *Thirty* (1937)
reveal, he was also concerned with the emotive
power of black and the contrast of positive and
negative form. The title applied to the present work
is probably a later invention, but the one huge
"dragon" form seems to move through space and
time, encompassing and spinning off microcosmic
constellations and cellular projections. The check-
erboard motif had been frequently employed in his
earlier work; and the tower-like structures on the
edge of the form at the left recall, as in other works,
his Russian origins.[3]

[1] Quoted in New York, 1969, p. 8.
[2] See the untitled drawing of 1933 reproduced in Barnett,
1983, p. 47, fig. 12.
[3] Most notably the painting and drawing of *Untitled (no.
639)* of 1940. See Barnett, pp. 268-269.

FERNAND LEGER
Argentan, 1881 - Gif-sur-Yvette, 1955

98. *Illustration for Rimbaud's Poem "Parade,"*
1948
Pen and ink, 13 × 9⅞ inches
(330 × 250 mm)

Signed in pen with the artist's initials and
dated at the lower right: *F.L. 48*

Exhibitions: New York, 1962; Atlanta, 1981,
no. 46.

In 1948, the Swiss publisher Louis Grosclaude
asked Leger to design lithographic illustrations for
a deluxe edition of Arthur Rimbaud's hallucinatory
series of forty-two poems known as *Les Illumina-
tions*, first published in 1886. The book, printed in
an edition of 375 numbered copies in 1949, con-
tained fifteen lithographs in color and black and
white, including one after this design.[1]

Leger delighted in the task of matching his
flattened, decorative forms to the images conjured
by the poems. Here, he resurrected the early Cubist
practice, originated by Picasso and Braque, of inte-
grating words into the collage-like design. *J'ai seul
la clef de cette parade sauvage* ("I alone have the key to
this wild parade"), the last line of poem four, *Parade
(Circus)*, is one of the most potent phrases in Rim-
baud's entire suite. The final section of the poem
may be translated as follows:

> Oh! the most violent Paradise of the enraged smile!
> No comparison with your Fakirs and other stage
> antics. In improvised costumes and in the style of a
> bad dream, they recite sad poems and perform trag-
> edies of brigands and spiritual demigods such as his-
> tory or religion never had. Popular and maternal

scenes are mixed with bestial poses and love by Chi-
nese, Hottentots, gypsies, fools, hyenas, Molochs,
old fits of madness and wily demons. They would
interpret new plays and sentimental songs. As master
jugglers they transform the place and the characters
and use magnetic comedy. Their eyes catch fire, their
blood sings, their bones grow big, tears and red
rivulets stream. Their farce or their terror lasts a min-
ute or for months on end.[2]

This was material particularly welcome to Leger.
He wrote in his introduction to an album of circus
lithographs, *Le Cirque*, of the same period: "If I
have drawn circus-folk, acrobats, clowns, jugglers,
it is because I have been interested in their work for
the last thirty years — since the time I was design-
ing Cubist-style costumes for the Fratinellis." His
interest in these subjects had been restimulated by
the circus and music halls on Broadway, which he
frequented during his residence in New York in the
early 1940s. This same scratchy pen style and fig-
ures with similar upraised arms can be seen in a
large drawing of *Acrobats and Musicians of 1948*; the
strange Chinese-style crown-headdress recurs in a
pen study of an *Acrobat* of 1953.[3]

In this drawing, however, the imagery of the
poem demands a fiercer design. The winged figure
at the top is probably the "demigod." The imper-
ious mustachioed figure, acting like a ringmaster
directing the action, is probably meant to be the
poet's alter ego, declaiming the words, so boldly
lettered that we read them as a shout.

[1] See Saphire, 1979, p. 84, no. 36.
[2] *Rimbaud, Complete Works*, trans. by Wallace Fowlie,
Chicago, 1966, p. 225.
[3] See Cassou and Leymarie, 1972, figs. 289 and 291.

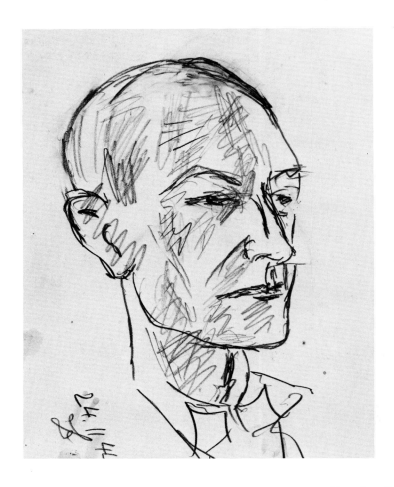

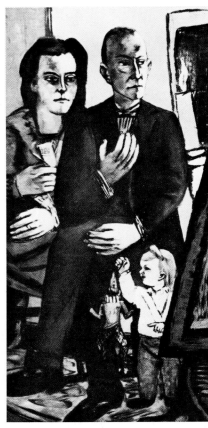

Fig. 29: Beckmann, *The Lütjens Family.*

MAX BECKMANN
Leipzig, 1884 – New York City, 1950

99. *Portrait Study of Dr. Helmut Lütjens*, 1944
Charcoal on paper, 10⅞ × 8⅝ inches
(275 × 218 mm)

Dated and signed with initial at the lower
left: *24.4.44 b*

Provenance: Dr. Helmut Lütjens, Amsterdam;
Gift to Curtis Baer on his 70th birthday.

Exhibition: Atlanta, 1981, no. 60.

Bibliography: Gopel, 1976, I, p. 410.

Beckmann lived in Amsterdam from 1939 to 1947.
Much of the time he lived in partial hiding from the
German occupation forces, but he never ceased
working at a furious pace. Several devoted friends
sheltered him and his paintings, which were liable
to confiscation. In turn, he immortalized their fea-
tures in paint. One of the most important of these
friends was the art historian Dr. Helmut Lütjens,
who was the local representative of the German art
gallery Paul Cassirer. For a week in September
1944, while the Battle of Arnhem was being waged,
Beckmann and his wife stayed in Lütjens's home.

Shortly afterwards, Beckmann decided to paint a
portrait of Lütjens, his wife Nelly, and their
daughter Anne Marie (fig. 29). Lütjens has
described the conditions under which the group
portrait was made — the family huddled in their
kitchen, where the only heat was a small stove and
the only reliable source of light was kerosene lan-
terns. As he wrote, "the milieu of that time remains
remarkably strong in the picture, a certain coldness
and harshness, the flickering light, and yet an
accord in coziness, life reduced to the essentials."[1]

A careful worker, even under adverse circum-
stances, Beckmann made eight preliminary studies
of Lütjens. The artist noted in his diary for the day
he made this sketch, November 24, 1944: "Drew at
Lütjens, always very congenial."[2] This is reflected,
as Peter Morrin has observed, in "the ease and
apparent rapidity with which Beckmann blocked
in the essential features of his sitter with hard
angular contours and sharp, precise accents."[3] In
this manner the artist has succeeded in capturing
the forceful personality of Dr. Lütjens.

[1] Quoted in Gopel, 1976, p. 410.
[2] Ibid.
[3] Atlanta, 1981, p. 124.

MAX BECKMANN
Leipzig, 1884 - New York City, 1950

100. *Vogelspiel* (*Birdplay*), 1949
Pen and india ink on white paper,
17½ × 22⁵⁄₁₆ inches (445 × 583 mm)

Signed and dated at the lower left:
Beckmann Boulder 49

Provenance: Mrs. Max Beckmann.

Exhibitions: New York, 1949, no. 27; Iowa,
1951, no. 156; Cambridge, 1958, no. 60.

Beckmann spent the summer of 1949 teaching at
the Art School of the University of Colorado in
Boulder. He made excursions into the Rocky
Mountains, and to the Natural History Museum in
Denver. He found little time for painting and
devoted himself instead to drawings inspired by the
rugged landscape.[1]

Beckmann always resisted giving specific inter-
pretations to his creations, but large, aggressive
birds had been appearing in his paintings for some
time; examples include *The Departure* (1932-35),
The Temptation (1936), *Studio* and *Bird's Hell* (1938),

Perseus (1941), and especially *Begin the Beguine*
(1946).[2] Fischer describes the birds in *Begin the
Beguine* as "emblems of freedom."[3]

In the Baer drawing the birds seem to be per-
forming a ritual dance. Perhaps their gestures, as
much as the setting, reflect Beckmann's response to
the elemental force of the Rockies and its native
peoples, for in his diary of the period he mentions
seeing Indian dances.[4] Agnes Mongan has inter-
preted the drawing as follows:

> The birds are almost men in stature and in action; and
> their talk seems to be a mimicking of the
> unenlightened ways of man. . . . They charm the
> huge, unthinking women, whose small heads, huge
> bodies and primitive dress also suggest a lack of intel-
> ligence. The long hair paralleling the fumes from the
> distant volcano, suggests a wind force. . . . The
> whole bird-play, then, is an imaginative representa-
> tion of the frivolous and unreal preoccupations of
> man. . . .[5]

[1] See St. Louis, 1984, no. 202.
[2] Ibid., nos. 84, 85, and 111, and fig. 29.
[3] Fischer, 1972, p. 76.
[4] See Beckmann, 1965, p. 181.
[5] Cambridge, 1958, pp. 73-74.

Additional Drawings

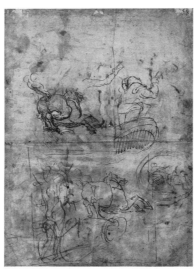

Italian and Spanish

ATTRIBUTED TO GIULIO PIPPI,
CALLED GIULIO ROMANO
Rome, 1499 – Mantua, 1546

101. *Standing Male Figure after the Antique*

Pen and brown ink and wash over black chalk, 15½ × 8½ inches (390 × 213 mm)

Inscribed at the lower left corner in dark brown ink: *G. Romano*

Provenance: Sale, Sotheby's, London, Nov. 21, 1974, no. 23.

The head is that of Socrates, as can be seen in other drawings by Giulio Romano (see the Ellesmere collection, II, Sotheby's, London, Dec. 5, 1972, no. 46), but the torso is that of a barbarian, as in a drawing at the Louvre (3503). Mario di Gianpaolo has suggested an attribution to Pirro Ligorio, who also drew such barbarian figures (see *MD*, Autumn 1971, pl. 11).

ITALIAN (LOMBARD SCHOOL?)
16th century

102. Recto: *The Assumption of the Virgin*

Verso: *Studies of a Figure Ascending in a Horse Drawn Chariot*

Pen and ink, 15½ × 10⅞ inches (394 × 277 mm)

Provenance: Ferber and Maison, London, 1969.

Formerly attributed to Bertoia; Annamaria Petrioli Tofani (in a letter of May 3, 1982) has suggested that it is by Jacopo di Giovanni di Francesco called Jacone. The chariot drawn by horses is similar to a drawing given to Cambiaso in the Victoria and Albert and one attributed to Tempesta in the Fernside collection.

BARTOLOMEO PASSAROTTI
Bologna, 1529-1592

103. *Study of a Hand*
Pen and ink, 6⅛ × 8⅞ inches
(153 × 226 mm)

Provenance: Herbert Feist,
New York.

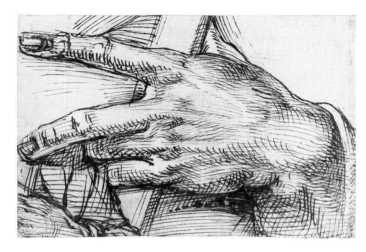

VENETIAN SCHOOL
16th century (?)

104. *Cardinal in Front of a Church*
Pen and ink, 11 × 6⅝ inches
(280 × 169 mm)

Numbered at the lower right
corner: *56*

Provenance: Winslow and Anna
Ames (L. 2602a).

WORKSHOP OF JACOPO
TINTORETTO
Venetian, 16th Century

105. *Profile Head after
Michelangelo's Sculpture of
Giuliano de'Medici*
Black chalk heightened with
white on brown paper, 15¼ x
10⅜ inches (388 × 244 mm),
the bottom right corner a later
addition.

Provenance: Mrs. Rayner-
Wood collection; Skippe
collection; Sale, Christie's,
London, Nov. 20-21, 1958, no.
214; H. Lütjens, Amsterdam.

Bibliography: Russell, 1930,
XI, no. 7; Tietze and Tietze-
Conrat, 1936, p. 188; Fröhlich
Bum, 1938, p. 446; Tietze and
Tietze-Conrat, 1944, p. 289,
no. 1717; Andrews, 1968, I,
p. 120.

Similar studies by the Tintoretto
workshop are at Frankfurt (464),
Edinburgh (1853), and the Uffizi
(1840).

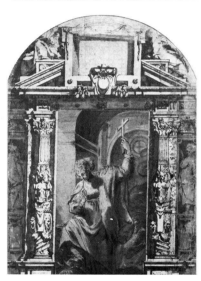

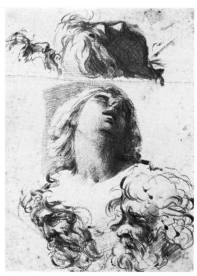

ITALIAN
16th century

106. Recto and Verso: *Scene of a Saint Resurrecting a Child* (?)
Pen and ink with wash, 5 × 6½ inches (127 × 165 mm)

Provenance: Rudolf Wien.

James Byam Shaw (in a letter of Jan. 28, 1985) notes that this work is "surely Venetian, not far from Palma Giovane."

ITALIAN
16th century

107. *St. Margaret of Cortona*
Ink and wash on blue paper with touches of white heightening, 12⅛ × 5½ inches (310 × 140 mm)

An Architectural Niche
Pen and ink with wash, total sheet size 18¼ × 11½ inches (464 × 293 mm)

Julien Stock has attributed the architectural framing element to Andrea Boscoli, and both Philip Pouncey and Nicholas Turner have noted the similarity of the St. Margaret to the style of the school of Giuseppe Salviati.

EMILIAN
Late 16th century

108. *Studies of Five Heads*
Brush with brown and black ink, and red chalk, 11⅞ × 8¼ inches (302 × 210 mm)

Provenance: Cassirer.

Nicholas Turner (in a letter of Oct. 26, 1981) has pointed out a similarity to drawings by Giulio Cesare Procaccini (1574-1625).

ITALIAN
17th century

109. *Head of a Bearded Man*
Pen and brown ink, 6⅛ × 4⅜
inches (154 × 105 mm)

Provenance: P. de Beyser, Paris,
1956.

Both Mario di Gianpaolo and Philip
Pouncey have noted a similarity to
works by Aureliano Luini, and others
have pointed out a Spanish flavor.

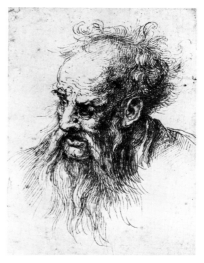

BOLOGNESE
Early 17th century

110. *Landscape with Fishermen*
Pen and ink, 8⅜ × 6¼ inches
(212 × 159 mm)

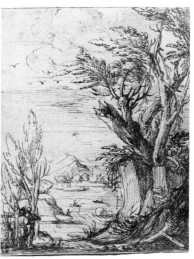

BOLOGNESE
17th century

111. *A Landscape with Two Figures*
Pen and brown ink on paper
with a watermark of a crown
surmounted by a star, 15³⁄₁₆ ×
10³⁄₁₆ inches (385 × 259 mm)

Inscribed with brown ink at
lower left: *A. Carraci*; and at the
lower right: *A. Carraci*

Provenance: Jan Enaht (?), 1829;
Kaye Dowland (L. 691).

Exhibitions: New York, 1962,
no. 6; New York, 1967, no. 28
(as Domenichino).

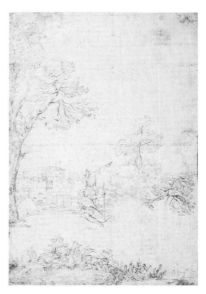

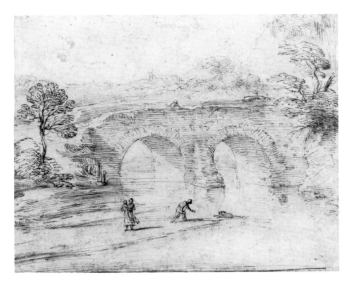

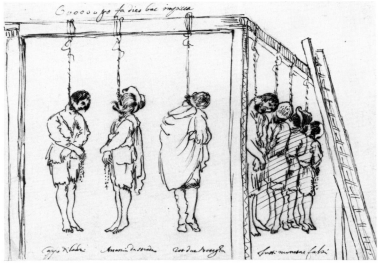

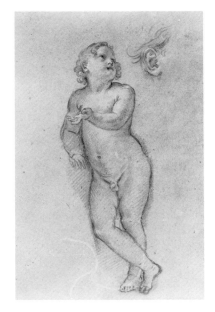

GIOVANNI FRANCESCO
BARBIERI, CALLED IL
GUERCINO
Cento, 1591 - Bologna, 1666

112. *Landscape with Bridge and Figures*
Pen and brown ink, 6⅝ × 7¾ inches (160 × 194 mm)

Provenance: Freiherr Richard von Kuehlmann.

Exhibition: Cambridge, 1958, no. 6.

The attribution to Guercino has been accepted by Denis Mahon.

BOLOGNESE
17th century

113. *Seven Men on the Gallows*
Pen and brown ink over black chalk, 7⅜ × 10⅜ inches (188 × 261 mm)

Inscribed at the top: *Gooooo po fa dies bac impicca*; and under the hanged men: *Cappo di Ladri*; *Assassin da Strada*; *Rob.. due Boseglia*; and *Tutti monetre falsi*

Provenance: Sir Thomas Lawrence Collection (L. 2445); Colnaghi's, London, 1970.

Bibliography: Baer, 1972, p. 2.

Exhibition: London, 1970, no. 20 (as Annibale Carracci).

The former attribution of this drawing to Annibale Carracci was made on the basis of its similarity in subject to a drawing in Windsor Castle. However, the style is quite different, resembling much more closely the work of the Guercino shop.

SCHOOL OF MARATTA
Roman, 17th Century

114. *Study of a Young Boy*
Red chalk on blue gray paper, 13⅝ × 9¼ inches (346 x 234 mm)

Provenance: Shirley Family, Ettingham Park; Sir Robert Witt; Colnaghi's, London; Slatkin Galleries.

From an album of drawings by Maratta and his pupils; Carl von Tuyl's suggestion of Giancinto Calandrucchi is convincing. See especially his drawing at Düsseldorf (FP9070).

SPANISH
17th century

115. *St. Dominic Preaching*
Brown ink and wash, 5¾ × 4½
inches (146 × 113 mm)

Provenance: Herbert E. Feist,
New York.

Bibliography: Advt. in
Burlington Magazine, Jan. 1973
(as Alonso Cano).

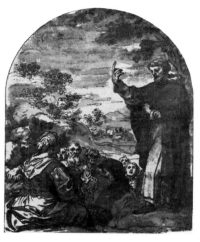

STEFANO DELLA BELLA
Florence, 1610-1664

116. *Design for a Cartouche with
Two Skeletons Supporting an
Hourglass*
Black chalk, pen and brown
ink, with grey wash, 6⅜ × 5¾
inches (159 × 144 mm)

Provenance: Sale, Christie's,
London, March 18, 1975,
no. 67.

LEONARDO SCAGLIA
Italian, late 17th century

117. *Figures in a Landscape*
Brown ink and wash, 8⅛ × 5⅞
inches (206 × 149 mm)

Inscribed at the center of the
upper edge: *19*

Provenance: Herbert Bier,
London, 1965.

A similar drawing is at the Fogg Art
Museum (1979.231).

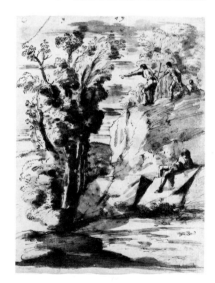

ATTRIBUTED TO
GIUSEPPE ZOCCHI
Florence, 1711–1767

118. Recto: *View of a Town*

Verso: *Buildings on a Hill*
Brown ink and wash, 7¼ × 9⅞
inches (184 × 251 mm)

Inscribed in pen on the lower
right of the recto: *Crespellano*

Provenance: Schaeffer Galleries.

The attribution is the suggestion of
Marco Chiarini.

GAETANO GANDOLFI
San Matteo della Decima, 1734 –
Bologna, 1802

119. *Studies of Heads*
Pen and brown ink with brown
wash on light brown paper, 7⅛
x 8½ inches (180 × 215 mm)

Provenance: Sale, Christie's,
London, Dec. 2, 1969, no. 106.

German, Dutch, and Flemish

GERMAN
16th century

120. *Knights in Armor Jousting and Fighting*
Pen and ink, 3¾ × 7¾ inches
(95 × 197 mm)

Provenance: Winslow and Anna
Ames (L. 2602a).

Exhibition: New York, 1962,
no. 1.

The previous attribution to Joost
Amman may have been based on the
work's similarity to a drawing of bat-
tling men in Berlin (no. 4763). It is
more likely to be from the circle of the
Augsburg artist Hans Burgkmair.

ATTRIBUTED TO
THOMAS HOFFMANN
Landshut, ca. 1600 – Munich, 1646

121. *Mucius Scaevola*
Pen and ink with brown wash,
5¼ × 10¾ inches
(133 x 273 mm)

Provenance: Alfred von
Wurzbach, Vienna; Sale,
Dorotheum, Vienna, Feb. 5-10,
1912; Victor Spark, New York.

The drawing, possibly a design for a
glass window, has been attributed to
Hoffmann by Heinrich Geissler.

GERMAN
Early 17th century

122. *A Crayfish*
Pen and watercolor, 3⅞ × 6⅛
inches (98 × 155 mm)

Inscribed in pen at the lower
right corner: *Im 14 April / Anno
160? / F.B.*

Provenance: Gift of Eduard
Schilling, 1962.

Heinrich Geissler (in a letter of Nov.
27, 1984) has suggested that the artist
is Friedrich Brentel.

GERMAN(?)
Early 17th century

123. *Painting and Poetry*, 1618
Gouache with white
heightening on dark grey
prepared paper, 5¾ × 7½
inches (146 × 191 mm)

A partly effaced inscription at
the lower right corner with the
date: *13 Dicember Anno 1618*

Provenance: Dr. Walter
Gernsheim.

Exhibition: Cambridge, 1958,
no. 28.

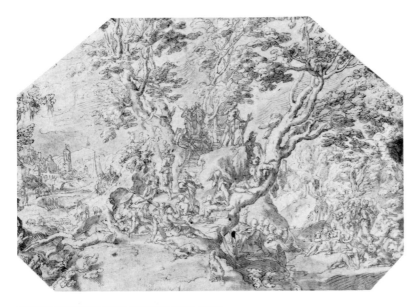

FOLLOWER OF
JOACHIM UTEWAEL
Dutch, early 17th century

124. *St. John the Baptist Preaching*
Ink and wash, 10⅝ × 14⅜
inches (270 × 368 mm)

Exhibitions: New York, 1962;
Poughkeepsie, 1970, no. 104.

Anne Lowenthal (in a letter of Oct. 1,
1984) suggests that this is one of a
group of drawings assigned to an art-
ist called by her the Pseudo-Utewael
and possibly identical with Gerrit
Pietersz. Eliane de Wilde has noted a
similarity to Frans Francken II.

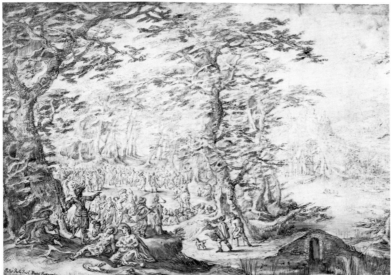

MANNER OF
DAVID VINCKBOONS
Dutch, 17th century

125. *St. John the Baptist Preaching*
Pen and ink with purple wash,
12⅝ × 17 inches
(321 × 431 mm)

Inscribed in pen at the lower
left corner: *Paul Bril figure (?)
Rothamer*

Provenance: Paul Drey Gallery.

ATTRIBUTED TO PAUL BRIL
Antwerp, 1554 – Rome, 1626

126. *Landscape with Bridge*
Ink with colored wash, 10½ ×
8¼ inches (266 × 206 mm)

Provenance: Rudolf Wien,
New York.

Exhibition: Cambridge, 1958,
no. 26.

DUTCH
Early 17th century

127. *Landscape with Roman Ruins*
Pen and ink, 8⅛ × 11½ inches
(207 × 291 mm)

Provenance: Nathaniel Hone
(L. 2793).

Exhibition: Cambridge, 1958,
no. 16.

Although the previous attribution to
Maarten van Heemskerck placed the
drawing too early, it was probably
made by a Dutch artist working in
Rome.

PIETER STEVENS
Mechelen, ca. 1567 – Prague, after
1641

128. *View of a Town with a Canal*
Pen and ink, 6 × 7⅞ inches
(150 × 195 mm)

Provenance: Sale, Sotheby's,
London, Nov. 22, 1974, no. 32.

Bibliography: Oslo, 1976, p. 21;
Zwollo, 1982, pp. 96 and 116,
ill. 2.

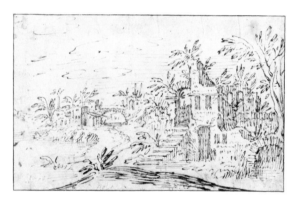

ATTRIBUTED TO
LODEWIYK TOEPUT, CALLED
LUDOVICO POZZOSERRATO
Antwerp, ca. 1550 – Treviso, 1605

129. *Landscape*
Pen and ink, 5½ × 8⅛ inches
(140 × 206 mm)

Inscribed in pen at the lower
left edge: *cento novente*

Provenance: J. B. de Graaf,
Amsterdam (L. 1220); Jules
Dupan (L. 1440); Seiferheld
Gallery.

DUTCH
17th century

130. *Landscape with Ruined
Buildings*
Ink and wash, 8⅛ × 10½
inches (206 × 266 mm)

Although the ruins are similar to
those found in the backgrounds of
paintings by Jan Pynas, the drawing is
of a later period. Carlos van Hasselt
has noted a similarity to the work of
Balthasar Lauwers.

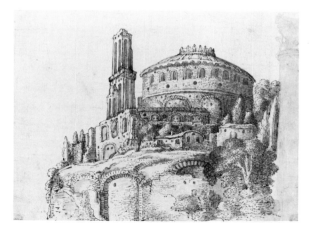

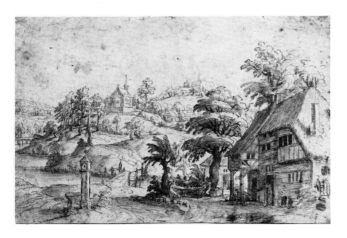

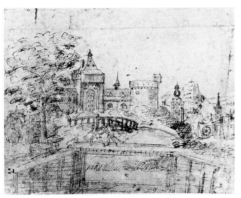

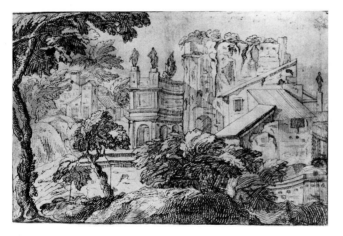

131. Recto: *Landscape with Abraham and the Angels*

Verso: *Figures Crossing a Bridge*
Pen and ink with wash, 7⅝ × 11⅛ inches (193 × 282 mm)

Provenance: Erherzog Friedrich, Vienna; Paul Drey Gallery, New York.

The two sides seem to be by different hands. Eliane de Wilde has noted the similarity of the verso to a drawing by Anton Mirou (ca. 1586–ca. 1661) in Budapest.

ATTRIBUTED TO
ABRAHAM GENOELS II
Antwerp, 1640–1723

132. *Landscape with Ruins*
Pen and ink, 7¾ × 11½ inches (197 × 292 mm)

Provenance: William Kennedy.

The attribution is by Eliane de Wilde. Similar drawings by Genoels are in the Royal Museum in Brussels and the Louvre. As Guy Grieten pointed out, the style is also close to that of Johannes Glauber (1646–ca. 1726).

ALBERT FLAMEN
Active 1640s

133. *Landscape with a Manor*
Brown ink, 7 × 12¾ inches (179 × 324 mm)

Provenance: Rudolf Wien, New York.

Exhibition: Cambridge, 1958, no. 38.

CLAES JANSZ. VISSCHER
Amsterdam, 1583–1652

134. *Cloveniersdoelen, Amsterdam,*
1607
Pen and brown ink with grey
wash on white paper, 4⅞ x 7⅜
inches (125 × 188 mm)

Inscribed in ink at the upper
edge: *1607 Cloveniers Doelen*

Provenance: Herbert Horne,
Florence, 1914; Paul Sachs,
Boston; Weyhe, New York; Dr.
G. Seligmann, New York,
1919.

Exhibition: Cambridge, 1958,
no. 24.

Bibliography: Simon, 1958,
no. 53.

ATTRIBUTED TO
AUGUSTIN BRAUN
Cologne, 1570–1639

135. *Milkmaids and Cows*
Black ink and pink wash, 6⅝
× 10⅝ inches (168 × 270 mm)

Monogrammed at the lower
left: *AB*

A similar style can be seen in a draw-
ing at Karlsruhe (see Geissler, 1979, II,
p. 84), and the monogram signature
occurs on a drawing in Cologne (see
Vey, 1964, p. 117, fig. 83).

ATTRIBUTED TO PIETER MULIER
THE YOUNGER, CALLED
CAVALIER PIETRO TEMPESTA
Haarlem, 1637 – Milan, 1701

136. *Brook with Rocks*
Ink and wash, 3½ × 8⅞ inches
(89 × 225 mm)

Provenance: Colnaghi's,
London, 1964.

Bibliography: Roethlisberger-
Bianco, 1970, p. 102, no. 167.

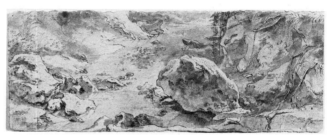

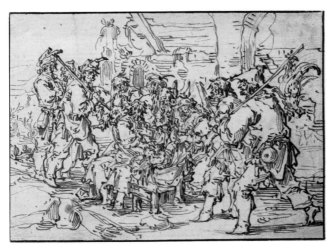

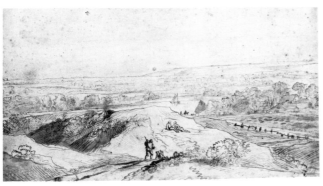

ANDRIES BOTH
Utrecht, ca. 1611 – Venice, ca. 1641

137. *The Adoration of the Shepherds*
Pen and sepia ink, 6 × 8 inches (152 × 203 mm)

Provenance: Walther Schrott, Vienna (L. 2383); Schnakenberg collection, Vienna; Leroy M. Backus; Sale, Parke-Bernet, New York, March 15, 1963, no. 39 (as Adriaen Pieter van der Venne).

JAN LIEVENS
Leiden, 1607 – Amsterdam, 1674

138. *Wooded Landscape with Stags by a Pond*
Pen and brown ink, 8½ × 14¼ inches (215 × 361 mm)

Inscribed at lower left in ink: *J. Lievens*

Provenance: Prouvin (?) collection; Private collection, Connecticut; Sale, Kende Galleries, Inc., New York, Feb. 10, 1951, no. 83.

Bibliography: Sumowski, 1983, 7, p. 3744.

ATTRIBUTED TO
PIETER DE WITH
Dutch, 17th century

139. Recto: *Landscape*
Pen and ink

Inscribed at upper right corner: *Keer om ū papier*(?)

Verso: *Figures in a Landscape*
Ink and wash, 9⅛ × 15⅛ inches (232 × 383 mm)

Provenance: Woodburn collection; Sheepshanks, London, 1914; Sale, A.W.M. Mensing, Amsterdam, April 27, 1937, no. 292; B. Houthakker, Amsterdam.

The two sides of the sheet are probably by different artists of the Rembrandt school. The recto is close to de With, but the verso is more in the manner of Jacob Konninck.

LEONAERT BRAMER
Delft, 1596–1674

140. Recto and Verso: *Women Singing and Playing Instruments*
Pen and wash, 5 × 11⅛ inches (127 × 282 mm)

Inscribed on the recto, center: *vrouwen gesang*(?)

Provenance: Walter Schab, New York.

Similar drawings attributed to C. Saftleven are in Munich (see Wegner, 1973, pls. 197–198).

MANNER OF
ADRIAEN VAN OSTADE
Dutch, 17th century

141a. *A Courtyard*
Pen and watercolor over black chalk, 7 × 5¼ inches (180 x 135 mm)

Inscribed at the lower left corner: *AVO*

Provenance: Gilbert Davis, London, 1953; Colnaghi's, London, 1958.

Exhibitions: London, 1953, no. 327; London, 1958.

Possibly by Isaac van Ostade.

141b. Recto: *A Village Fair*
Pen and dark grey and brown ink over charcoal with light grey wash

Verso: *A Village Fair*
Ink over pencil on paper with an eagle watermark, 6 × 5⅞ inches (151 × 149 mm)

Inscribed on the recto at the lower left corner in pencil: *A. V. Ostade 1669*

Provenance: Sale, Klipstein and Kornfeld, Bern, June 16, 1960, no. 189.

Bibliography: Trautscholdt, 1967, pp. 162–163, pls. 22a and b.

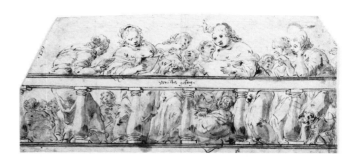

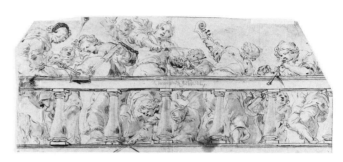

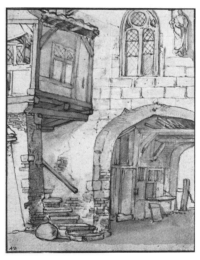

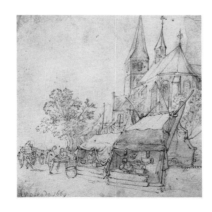

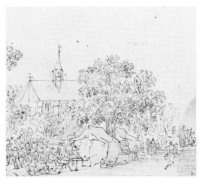

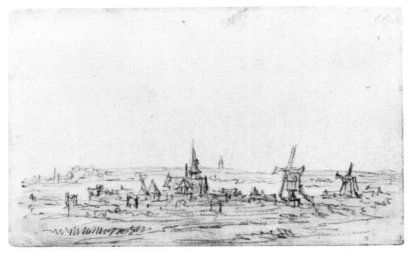

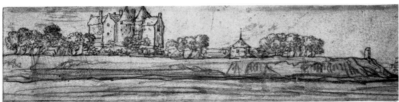

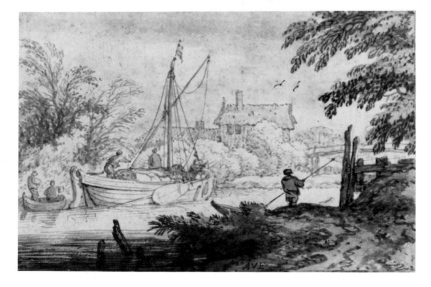

JAN VAN GOYEN
Leiden, 1596 – The Hague, 1656

142. *Landscape with Windmills*, 1650–51
Black chalk with grey wash, 3⅞ × 6¼ inches (100 × 159 mm)

Provenance: See nos. 41a and b.

Bibliography: Beck, 1972, I, p. 303, no. 847/140B.

AELBERT CUYP
Dordrecht, 1620–1691

143. *Loevestein Castle*
Black chalk, 2 × 7½ inches (51 × 191 mm)

Provenance: S. Reitlinger, London; Sale, Sotheby's, London, June 6, 1954, no. 640.

Bibliography: Reitlinger, 1922, pl. 40.

The drawing has been cut since the time of the Reitlinger sale when it measured 3¾ × 7¼ inches. The same castle appears in works by Salomon van Ruysdael.

ALLAERT VAN EVERDINGEN
Alkmaar, 1621 – Amsterdam, 1675

144. *Landscape with Boat*
Grey and brown wash, 4⅛ × 5⅞ inches (104 × 150 mm)

Signed with the artist's monogram at lower center: *AVE*

Provenance: N. D. Goldsmid, The Hague (L. 1962); Schaeffer Gallery.

JOSUA DA GRAVE
The Hague, 1660–1712

145a. *Landscape with Fortified Castle*, 1671
Ink and watercolor, 3⅞ × 6 inches (98 × 152 mm)

Inscribed at the lower right corner: *J. da Grave*; and dated at the upper right edge *1671*, and again at the lower left *A. 1671*

Provenance: Walter Schatzki, New York.

The locale is probably in the vicinity of Maastricht.

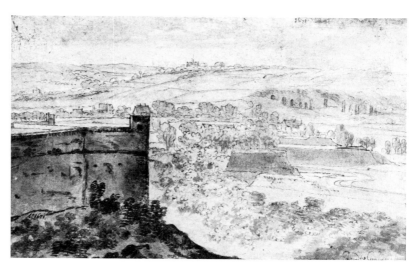

145b. *View at Bodegraven*
Black and brown ink, 5 × 7⅞ inches (127 × 200 mm)

Inscribed and dated at upper left edge: *¾ 1672 uit quartier van sÿn hoogsÿt*

L. J. van der Klooster has noted that at the date given Prince William III of Orange was at Bodegraven.

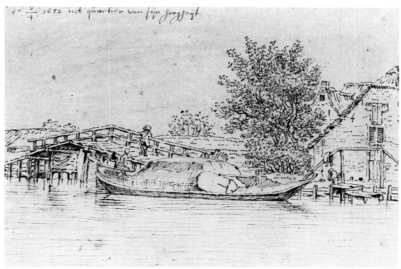

VALENTIJN KLOTZ
The Hague, ca. 1669 – after 1712

146. *Landscape with Peasants*, 1675
Pen and black ink with wash, 6⅜ × 8⅜ inches (162 x 213 mm)

Signed and dated at the lower left edge: *V. Klotz fe d ½9 1675*

Provenance: Baroness A. V. Brandde, Middleburgh.

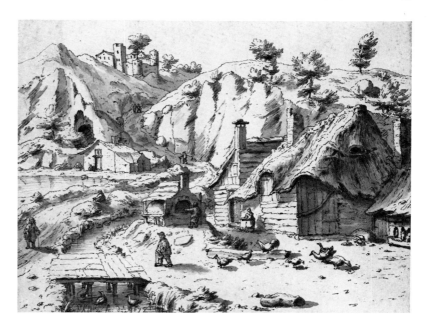

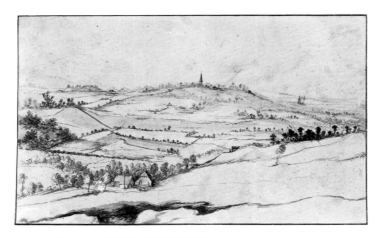

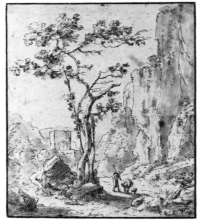

JAN SIBERECHTS
Antwerp, 1627 – London, ca.
1700

147. *A Hilly Landscape*
Grey and black ink wash on tan
paper with a fleur-de-lis
watermark, 8⅛ × 13¼ inches
(208 × 338 mm)

Inscribed on the verso: *van
Uden*

Provenance: Bernard
Houthakker, Amsterdam, 1965;
Helmut Lütjens, Amsterdam.

Exhibition: Amsterdam, 1965,
no. 64.

Most likely done during the artist's
residence in England.

JAN HACKAERT
Amsterdam, ca. 1629–1699

148. *Landscape with a Traveller*
Pen and ink with wash, 8¾ ×
7⅜ inches (222 × 187 mm)

Inscribed at center lower edge:
Berghem

French and Spanish
17th and 18th Centuries

ATTRIBUTED TO
ETIENNE DU PERAC
Paris, ca. 1525–1604

149. *View of the Tiber*
Pen and ink, 6⁵⁄₁₆ × 10⁵⁄₁₆ inches
(160 × 262 mm)

Exhibitions: Cambridge, 1958,
no. 34; Dayton, 1971, no. 1.

FOLLOWER OF JACQUES CALLOT
French, early 17th century

150. *A Knight Looking at a City*
Pen and ink, 2⅜ × 3 inches
(61 × 76 mm)

ATTRIBUTED TO PIERRE PUGET
Marseilles, 1620-1694

151. *Ships entering a Harbor*
Ink and colored wash, 7⅝ ×
12¾ inches (194 × 324 mm)

Inscribed on the verso at left:
Descartes

Provenance: Colnaghi's,
London.

Bibliography: Schilling, 1974,
p. 177, ill. 1.

NICOLAS POUSSIN
Les Andelys, 1594 - Rome, 1665

152. *Wounded Soldier, after Trajan's
Column*
Ink and bistre wash, 10 × 8¼
inches (250 × 210 mm)

Inscribed at lower right:
Le Poussine

Provenance: Sir Joshua
Reynolds (L. 2064); Sale,
Christie's, Dec. 2, 1969, no.
208; Agnew's, London; Paul
Drey Gallery, New York, 1971.

Bibliography: Blunt, 1974, pp.
243 and 247, pl. 12;
Friedlaender and Blunt, 1974,
V, p. 37, no. 335a.

One of a group of drawings after Tra-
jan's column which Blunt dated to the
late 1630s or early 1640s but others
have dated 1640-42 (see Oberhuber,
ed., 1977, p. 133).

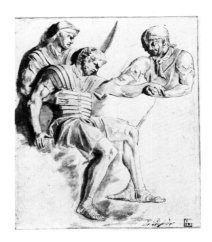

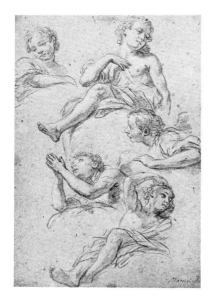

CLAUDE LORRAIN
Chamagne, 1600 – Rome, 1682

153a. *Goats and Figures*, 1635–1645
Pen and brown wash over
black chalk, 4⅝ × 7¼ inches
(119 × 185 mm)

Provenance: Seiferheld
Gallery, New York.

Exhibition: New York, 1961,
no. 18.

Bibliography: Roethlisberger,
1968, p. 143, fig. 258.

153b. *Study of Cows*, 1635–1645
Black chalk, 4⅞ × 7⅜
inches (124 × 189 mm)

Provenance: Seiferheld
Gallery, New York

Exhibition: New York, 1961,
no. 3.

Bibliography: Roethlisberger,
1968, p. 141, fig. 239.

CIRCLE OF CHARLES LA FOSSE
French, 17th century

154. *Studies of Figures Amidst
Clouds*
Black chalk on grey paper, 15⅜
×10¼ inches (391 x 261 mm)

Inscribed at lower right corner:
Baccicio

FRENCH
18th Century

155. *Portrait of a Young Boy*
Black chalk with white
heightening, 9½ × 8 inches
(241 x 202 mm)

Provenance: B. Lasquin; Sale,
Georges Petit, Paris, June 7-8,
1928, no. 53 (as François-
Hubert Drouais); Colnaghi's,
London, 1968-1969.

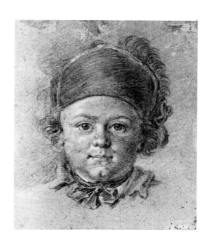

FOLLOWER OF
JEAN-BAPTISTE OUDRY
French, 18th Century

156. *Landscape with a Distant
Village*
Black chalk heightened with
white on blue paper, 8⅝ x 19⅝
inches (218 × 499 mm)

Inscribed at top left: *8*; and at
top right: *10*

Provenance: Colnaghi's,
London, 1966.

Exhibition: London, 1966, no.
41 (as J.-B. Oudry).

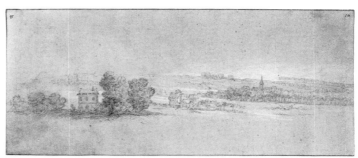

FRENCH
18th century

157. *Quiver, Arrows, and Bow*
Red chalk, 16 × 10 inches
(406 × 254 mm)

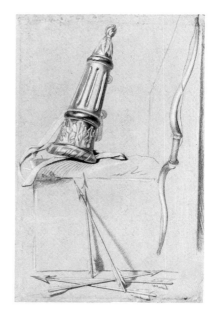

JEAN-BAPTISTE PILLEMENT
Lyon, 1727–1808

158. Recto and Verso: *Decorative Design*
Ink and color wash, 6⅞ × 9½ inches (172 × 241 mm)

LUIS PARET Y ALCAZAR
Madrid, 1746–1799

159. *Costume Studies*
Pen and ink, 11½ × 7½ inches

Provenance: F. Kleinberger & Co., New York, 1958.

Related drawings for an unpublished study of historical dress are at the Metropolitan Museum and Allen Memorial Art Museum (see Oberlin, 1976, no. 261).

19th and 20th Centuries

JACQUES-LOUIS DAVID
Paris, 1748 – Brussels, 1825

160. *Landscape*
Ink and red chalk, 6⅛ × 8½ inches (153 × 215 mm)

Provenance: Jules and Eugène David (L. 839 and 1437); David estate sale, Paris, April 17, 1828; Adolphe Stein.

Other small landscape drawings by David are reproduced in Calvet-Sérullaz, 1969, p. 66.

PIERRE JUSTIN OUVRIE
Paris, 1806 – Rouen, 1879

161. *View of the Hospital of St. Louis*
Pencil with watercolor, 6¾ × 10½ inches (172 × 268 mm)

Signed with the artist's initials and inscribed at the lower left edge: *Vue de l'hopital St. Louis pres des bords du Canal St. Martin*

Provenance: Ouvrié atelier sale (L. 2002a); Paul Prouté, Paris.

EUGENE DELACROIX
Charenton, 1798 – Paris, 1863

162a. *Two Plant Studies*
Green watercolor and charcoal, 6¼ × 3⅞ inches (159 x 98 mm)

Stamped in red at the lower right with the artist's estate stamp (L. 838): *ED*

Provenance: Mrs. K. E. Maison, London.

Exhibition: Atlanta, 1981, no. 5.

162b. *Studies for the Figure of Ceres*, ca. 1852
Pen and ink on paper, 5⅛ × 8 inches (130 × 204 mm)

Stamped at lower center edge with the artist's estate stamp (L. 838): *ED*

Provenance: Sale, Gutekunst and Klipstein, Bern, Dec. 22, 1956, no. 78.

Exhibition: Atlanta, 1981, no. 4.

A preliminary design for the ceiling decoration of the Salon de la Paix in the Hôtel de Ville, Paris.

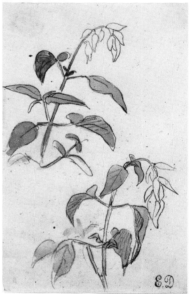

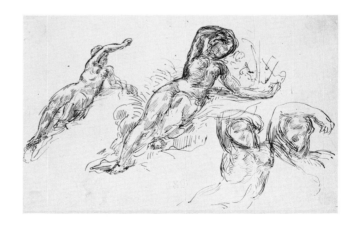

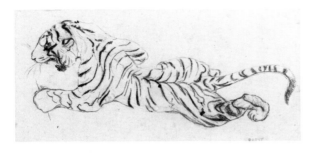

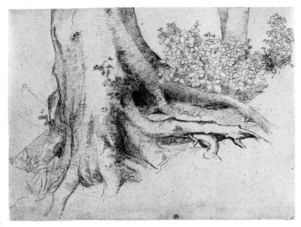

ANTOINE-LOUIS BARYE
Paris, 1796–1875

163. *A Tiger*, ca. 1835
Pencil and charcoal on tracing paper, 4¼ × 8¾ inches (118 × 223 mm)

Stamped at the lower right edge with the artist's estate stamp (L. 220): *BARYE*

Provenance: Mr. and Mrs. John Rewald; Sale, Sotheby's, London, July 7, 1960, no. 4.

Exhibitions: Los Angeles, 1959, no. 3; Newark, 1961, no. 8; New York, 1962, no. 8; Atlanta, 1981, no. 6.

Bibliography: Bouret, 1973, fig. 117.

AUGUSTE ANASTASI
Paris, 1820–1889

164. *Study of a Tree with Exposed Roots*
Pen and ink on thin white paper, 7⅝ × 10 inches (194 x 254 mm)

Stamped with the artist's estate stamp (L. 60)

Provenance: Shepherd Gallery, New York.

Exhibitions: New York, 1968, no. 116; New York, 1972, no. 82.

XIMINES DOUDAN
Douai, 1800 - Paris, 1872

165. Recto and Verso: *Studies after Paintings and Sculpture*
Pen and ink over pencil, 8¾ × 11⅝ inches (223 × 296 mm)

Initialed on both sides at the lower left corner: *X.D.*

Provenance: Walter Schatzki, New York.

The attribution was made by Agnes Mongan. A similar sheet is in the Vassar College Art Gallery.

CONSTANTINE GUYS
Flushing, 1802 – Paris, 1892

166. *Bust of a Woman*
Ink and wash, 4⅜ × 3½ inches
(110 × 89 mm)

PAUL HUET
Paris, 1803–1869

167. *Landscape at Ornes de St. Cloud*
Pen and ink, 8¹⁵⁄₁₆ × 13⅛ inches (227 × 333 mm)

Stamped with estate stamp
(L. 1268)

Provenance: Adolphe Stein.

Exhibition: New York, 1972, no. 11.

CAMILLE PISSARRO
St. Thomas Island, 1830 – Paris, 1903

168. *A Cow in Back View*
Charcoal, 6½ × 4¾ inches
(165 × 120 mm)

Stamped with the artist's initials

Provenance: Mme. Rodo Pissarro, Paris; Sale, Parke-Bernet, New York, March 7, 1968, no. 14.

Bibliography: Baer, 1972, p. 1.

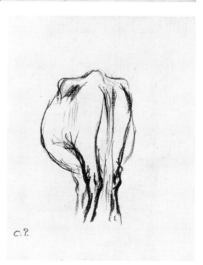

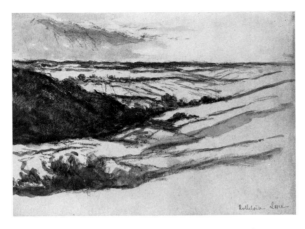

MAXIMILIEN LUCE
Paris, 1858–1941

169. *Landscape at Rolleboise*
Charcoal and grey wash, 9¼ ×
12¼ inches (235 × 310 mm)

Inscribed and signed at the
lower right: *Rolleboise Luce*

Provenance: Alfred C. Haley;
Sale, Sotheby's, London, May
29, 1974, no. 149.

EDWARD VON STEINLE
Vienna, 1810 – Frankfurt am
Main, 1886

170. *Study of a Young Boy*
Pencil, 15 × 9⅛ inches
(382 × 232 mm)

Stamped on the verso with the
artist's estate stamp (L. 2312a)

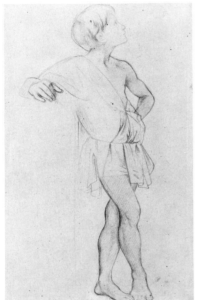

ADOLPH VON MENZEL
Breslau, 1815 – Berlin, 1905

171. *The Cat with a Wig:
Illustration for Kleist's "Der
Zerbrochene Krug,"* 1877
Pen and ink with wash, 3¾ ×
5½ inches (97 × 139 mm)

Signed at the middle right with
the artist's initials: *A.M.*

Exhibition: Atlanta, 1981,
no. 38.

ATTRIBUTED TO
JOHN FLAXMAN
York, 1755 – London, 1826

172. *A Ghostly Apparition*
Pen and wash, 4½ × 6⅞ inches
(115 × 175 mm)

Inscribed at the lower left
corner: *W. Blake / 464*

Provenance: Kende Gallery.

Both Martin Butlin and David Bind-
man (in correspondence) support the
attribution to Flaxman. Bindman
suggests that the drawing may illus-
trate a subject from Swedenborg. A
similar style is evident in Flaxman's
Lamenting Figures, National Gallery of
Victoria, Melbourne (1278.40.3).

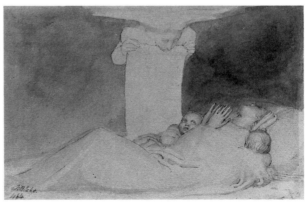

PAUL GAUGUIN
Paris, 1848 – Marquesas Islands, 1903

173. Recto: *Head of a Tahitian Man*
Pencil with addition of blue and black ink

Inscribed at the upper right corner in blue crayon: *15*

Verso: *Seated Figure and Other Studies*
Pencil and black ink, 6½ × 4¼ inches (175 × 118 mm)

Provenance: Ambroise Vollard.

Exhibition: Cambridge, 1958, no. 47.

Bibliography: Dorival, 1954, p. 15.

A page from Gauguin's Tahitian notebook with sketches of 1891.

JUAN GRIS
Madrid, 1887 – Paris, 1927

174. *Le Gentilhomme, Costume Design for "Les Tentations de la Bergère,"* 1923
Watercolor, 7¾ × 5¾ inches (268 × 178 mm)

Inscribed at the lower left: *A M Simon Lissim Bien Cordialement Juan Gris/1924*

Provenance: Simon Lissim, Dobbs Ferry, New York; Perls Galleries, New York; Sale, Parke-Bernet, New York, Nov. 3, 1966, no. 22.

Exhibitions: New York, 1959, no. 304; Atlanta, 1981, no. 45.

OSKAR KOKOSCHKA
Pöchlarn, 1886 – Montreux, 1980

175. *Mary Merson*, 1931
Red chalk, 17¾ × 12¼ inches (445 × 310 mm)

Signed at the lower right: *O. Kokoschka*

Provenance: Paul Cassirer and Co., Amsterdam, 1965.

Exhibition: Cambridge, 1958, no. 61.

Bibliography: Westheim, 1962, pl. 121.

Bibliography

Adhémar, 1954
Jean Adhémar, *Honoré Daumier, Drawings and Watercolors*, New York, 1954.

Ames-Lewis and Wright, 1983
Francis Ames-Lewis and Joanne Wright, *Drawing in the Italian Renaissance Workshop*, Nottingham and London, 1983.

Amsterdam, 1938
P. Cassirer, *Fransche Meesters uit de 19e eeuw: Teekeningen, Aquarellen, Pastels*, 1938.

Amsterdam, 1965
Bernard Houthakker, *Master Drawings*, Amsterdam, 1965.

Amsterdam, 1974
Rijksmuseum, *Franse Tekenkunst van de 18de eeuw uit nederlandse verzamelingen*, June 8 - Aug. 4, 1974.

Ananoff, 1963-68
Alexandre Ananoff, *L'oeuvre dessiné de Jean-Honoré Fragonard 1732-1806, Catalogue Raisonné*, Paris, 3 vols., 1963-68.

Andrews, 1967
Keith Andrews, "Recent Acquisitions at the National Gallery of Scotland," *MD*, 5, 4, 1967, pp. 379-381.

Andrews, 1968
Keith Andrews, *Catalogue of Italian Drawings, National Gallery of Scotland*, Cambridge, 2 vols., 1968.

Angulo Iñiguez, 1981
Diego Angulo Iñiguez, *Murillo*, Madrid, 3 vols., 1981.

Antwerp, 1977
Royal Museum of Fine Arts, *P. P. Rubens*, June 29-Sept. 30, 1977.

Atlanta, 1981
High Museum of Art, *Drawings from Georgia Collections*, May 14 - June 28, 1981.

Atlanta, 1983
High Museum of Art, *The Rococo Age: French Masterpieces of the Eighteenth Century*, 1983.

Baccheschi, 1971
Edi Baccheschi, *L'opera completa di Guido Reni*, Milan, 1971.

Bacou, 1975
Roseline Bacou, *Millet, One Hundred Drawings*, New York, 1975.

Badt, 1960
Kurt Badt, *Wolkenbilder und Wolkengedichte der Romantik*, Berlin, 1960.

Badt, 1969
Kurt Badt, *Die Kunst des Nicholas Poussin*, 1969.

Baer, 1972
Curtis O. Baer, "Thoughts on Collecting Drawings," *The Print Collector's Newsletter*, 3, 1, March - April 1972, pp. 1-4.

Baer, 1977
Curtis O. Baer, *Landscape Drawing*, New York, 1977.

Baldinucci, 1812 ed.
Filippo Baldinucci, *Opere*, Milan, 1812.

Barnett, 1983
Vivian Endicott Barnett, *Kandinsky at the Guggenheim*, New York, 1983.

Bartsch-Buffa, 1984
The Illustrated Bartsch, vol. 35, *Antonio Tempesta*, ed. by Sebastian Buffa, New York, 1984.

Batorska, 1972
Danuta Batorska, "Grimaldi at Frascati," *MD*, 10, 2, Summer 1972, pp. 145-149.

Bauch, 1965
Kurt Bauch, "Zu Tizian als Zeichner," in *Walter Friedlaender zum 90. Geburtstag*, Berlin, 1965.

Baudelaire-Mayne, 1965
Charles Baudelaire, *Art in Paris*, trans. by Jonathan Mayne, Greenwich, 1965.

Beau, 1968
Marguerite Beau, *La Collection des dessins d'Hubert Robert au Musée de Valence*, Lyon, 1968.

Beck, 1957
Hans-Ulrich Beck, "Jan van Goyens Handzeichnungen als Vorzeichnungen," *Oud Holland*, 72, 1957, pp. 241-250.

Beck, 1972
Hans-Ulrich Beck, *Jan van Goyen 1596-1656*, Amsterdam, 2 vols., 1972.

Beckmann, 1965
Max Beckmann, *Tagebücher 1940-1950*, Hamburg, 1965.

Benesch, 1954
Otto Benesch, *The Drawings of Rembrandt*, London, 1954.

Benesch and Buchner
O. Benesch and E. Buchner, *Jörg Breu*, Augsburg, n.d.

Berenson, 1938
Bernard Berenson, *The Drawings of the Florentine Painters*, Chicago, 1938.

Berlin, 1929-30
Paul Cassirer, *Ein Jahrhundert französischer Zeichnung*, Berlin, 1929-30.

Berlin, 1975
Staatliche Museen, Kupferstichkabinett, *Pieter Bruegel d. Ä. als Zeichner*, Sept. 19 - Nov. 16, 1975.

Berlin, 1977
Staatliche Museen, *Peter Paul Rubens*, 1977.

Bern, 1934
Kunsthalle, *Französische Meister des 19. Jahrh. und Van Gogh*, 1934.

Bern, 1939
Kunsthalle, *Eugène Delacroix*, 1939.

196

Bernard, 1912
Emile Bernard, *Souvenirs sur Paul Cézanne*, Paris, 1912.

Bernhard, 1978
Marianne Bernhard, *Hans Baldung Grien, Handzeichnungen, Druckgraphik*, Munich, 1978.

Bloomington, 1983-84
Indiana University Art Museum, Bloomington Gallery of Art, University of Pittsburgh, Allen Memorial Art Museum, Oberlin College, *Italian Portrait Drawings, 1400-1800, from North American Collections*, Oct. 1983 - April 1984.

Blunt, 1958
Anthony Blunt, *Nicolas Poussin, The A. W. Mellon Lectures in the Fine Arts*, Washington, D.C., 2 vols., 1958.

Blunt, 1966
Anthony Blunt, *The Paintings of Nicolas Poussin, A Critical Catalogue*, London, 2 vols., 1966.

Blunt, 1974
Anthony Blunt, "Newly Identified Drawings by Poussin and his Followers," *MD*, 12, 3, Autumn 1974, pp. 239-248.

Blunt, 1979
Anthony Blunt, *The Drawings of Poussin*, New Haven and London, 1979.

Bologna, *Disegni*, 1956
Palazzo dell'Archiginnasio, *Mostra dei Carracci, I Disegni*, 1956.

Bologna, *Disegni*, 1963
Palazzo dell'Archiginnasio, *Mostra dei Carracci, Disegni*, 2nd ed., 1963.

Bologna, *Dipinti*, 1956
Palazzo dell'Archiginnasio, *Mostra dei Carracci, I Dipinti*, 1956.

Bolten, 1969
J. Bolten, "Messer Ulisse Severino da Cingoli, A Bypath in the History of Art," *MD*, 7, 3, Summer 1969, pp. 123-147.

Bourloton, 1891
Adolphe Robert and Edgar Bourloton, *Dictionnaire des Parlementaires Français*, Paris, 1891.

Bremen and Zurich, 1967
Kunsthalle, Bremen and Kunsthaus, Zurich, *Handzeichnungen alter Meister aus Schweizer Privatbesitz*, April - Dec. 1967.

Brendel, 1955
Otto Brendel, "Borrowings from Ancient Art in Titian," *The Art Bulletin*, 37, 1955, pp. 115-125.

Brown, 1973
Jonathan Brown, "Notes on Princeton Drawings 9: Bartolomé Estebán Murillo," *Record of the Art Museum, Princeton University*, 32, 2, 1973, pp. 29-33.

Brown, 1975
Christopher Brown, "Bruegel Drawings in Berlin," *The Burlington Magazine*, 117, Dec. 1975, pp. 828-832.

Brussels, 1936
Palais des Beaux-Arts, *Ingres - Delacroix*, 1936.

Byam Shaw, 1962
J. Byam Shaw, *The Drawings of Domenico Tiepolo*, Boston, 1962.

Calvesi, 1980
Maurizio Calvesi, *Il Sogno di Polifilo Prenestino*, Rome, 1980.

Calvet-Sérullaz, 1969
Arlette Calvet-Sérullaz, "Un album de croquis inédits de Jacques-Louis David," *Revue de l'Art*, 5, 1969.

Cambridge, 1967
Fogg Art Museum, *Ingres Centennial Exhibition, 1867-1967*, Feb. 12 - April 1967.

Cambridge, 1980
Fogg Art Museum, *Works by J.-A.-D. Ingres in the Collection of the Fogg Art Museum*, 1980.

Cambridge and New York, 1956
Fogg Art Museum and the Pierpont Morgan Library, *Drawings & Oil Sketches by P. P. Rubens from American Collections*, Jan. - April 1956.

Caracas, 1957
Exposicion de dibujos del renacimiento al siglo XX, May 24 - June 9, 1957.

Carlson, 1971
Victor Carlson, *Matisse as a Draughtsman*, Baltimore, 1971.

Carlson, 1976
Victor Carlson, *Picasso, Drawings and Watercolors*, Baltimore Museum of Art, 1976.

Carlson, 1978
Victor Carlson, *Hubert Robert, Drawings and Watercolors*, Washington, 1978.

Carmean, 1980
E. A. Carmean, Jr., *Picasso, The Saltimbanques*, Washington, D.C., 1980.

Cassou and Leymarie, 1972
Jean Cassou and Jean Leymarie, *Fernand Léger*, Greenwich, 1972.

Champion, 1921
Pierre Champion, *Notes critiques sur les vies anciennes d'Antoine Watteau*, Paris, 1921.

Chappuis, 1938
Adrien Chappuis, *Dessins de Paul Cézanne*, Paris, 1938.

Chappuis, 1973
Adrien Chappuis, *The Drawings of Paul Cézanne, A Catalogue Raisonné*, Greenwich, 2 vols., 1973.

Charleroi, 1957
Palais des Beaux-Arts, *Fragonard - David*, Oct. 24 - Dec. 1, 1957.

Chiarini, 1972
Marco Chiarini, *I Disegni Italiani di Paesaggio dal 1600 al 1750*, Treviso, 1972.

Chicago, 1960
The Art Institute of Chicago, *Corot, 1796-1875*, Oct. 6 - Nov. 13, 1960.

Chicago, 1974
The Art Institute of Chicago, *The Helen Regenstein Collection of European Drawings*, 1974.

Chicago, 1984
The Art Institute of Chicago, *Degas in the Art Institute of Chicago*, 1984.

Chipp, ed., 1971
Herschel B. Chipp, ed., *Theories of Modern Art*, Berkeley, 1971.

Cologne, 1979
Museen der Stadt, *Paul Klee, das Werk der Jahre 1919-1933*, April 11 - June 4, 1979.

Dacier and Vuaflart, 1922
Emile Dacier and A. Vuaflart, *Jean de Julienne et les graveurs de Watteau au XVIIIe siècle*, Paris, 4vols., 1921-22.

Daix and Boudaille, 1966
Pierre Daix and Georges Boudaille, *Picasso, The Blue and Rose Periods, A Catalogue Raisonné of the Paintings, 1900-1906*, Greenwich, 1966.

Dartmouth, 1980
Dartmouth College Museum and Galleries, *Theater Art of the Medici*, 1980.

Dattenberg, 1967
Heinrich Dattenberg, *Niederrheinansichten Holländischer Künstler des 17. Jahrhunderts*, 1967.

Dayton, 1971
Dayton Art Institute, *French Artists in Italy 1600-1900*, Oct. 15 - Nov. 28, 1971.

Degenhart and Schmitt, 1968
Bernhard Degenhart and Annegrit Schmitt, *Corpus der Italienischen Zeichnungen 1300-1450*, Berlin, vol. I-2, 1968.

Delaborde, 1870
Henri Delaborde, *Ingres*, Paris, 1870.

de Leiris, 1969
Alain de Leiris, *The Drawings of Edouard Manet*, Berkeley, 1969.

della Pergola, 1955
Paola della Pergola, *Galleria Borghese, I Dipinti*, Rome, 2 vols. 1955.

Denkstein, 1979
Vladimir Denkstein, *Hollar Drawings*, New York, 1979.

Descharnes and Chabrun, 1967
Robert Descharnes and Jean-François Chabrun, *Auguste Rodin*, Paris, 1967.

Detroit, 1965
The Detroit Institute of Arts, *Art in Italy, 1600-1700*, 1965.

Dodgson, 1918
Campell Dodgson, "A Dutch Sketchbook of 1650," *The Burlington Magazine*, 1918, pp. 234-240.

Dorival, 1954
Bernard Dorival, *Carnet de Tahiti*, Paris, 2 vols., 1954.

Dortu, 1971
M. G. Dortu, *Toulouse-Lautrec et son oeuvre*, 1971.

Duret, 1910
T. Duret, *Edouard Manet*, Berlin, 1910.

Düsseldorf, 1968
Stadtisches Kunsthalle, *Niederländische Handzeichnungen: 1500-1800*, March 10 - May 5, 1968.

Edinburgh, 1981
National Gallery of Scotland, *Poussin, Sacraments and Bacchanals*, 1981.

Eidelberg, 1970
Martin Eidelberg, "P. A. Quillard, An Assistant to Watteau," *The Art Quarterly*, 33, 1, 1970.

Eidelberg, 1981
Martin Eidelberg, "Quillard as Draughtsman," *MD*, 19, 1, Spring 1981, pp. 27-38.

Elderfield, 1978
John Elderfield, *Matisse in the Collection of the Museum of Modern Art*, New York, 1978.

Elsen and Varnedoe, 1971
Albert Elsen and J. Kirk T. Varnedoe, *The Drawings of Rodin*, New York, 1971.

Enggass, trans., 1968
Catherine Enggass, translator, *The Lives of Annibale and Agostino Carracci by Giovanni Pietro Bellori*, University Park and London, 1968.

Fischer, 1972
Friedhelm W. Fischer, *Max Beckmann*, Phaidon, 1972.

Flam, 1978
Jack D. Flam, *Matisse on Art*, New York, 1978.

Fleming, 1958
John Fleming, "Mr Kent . . . ," *Connoisseur*, 112, June 1958, p. 227.

Folie, 1951
Jacqueline Folie, "Les Dessins de Jean Gossart dit Mabuse," *GBA*, April - June 1951, pp. 77-98.

Fox, 1980
Frank Fox, *Great Ships: The Battlefleet of King Charles II*, Greenwich, 1980.

Franz, 1965
H. Gerhard Franz, "Hans Bol als Landschaftszeichner," *Jahrbuch des Kunsthist Inst. der Universität Graz*, I, 1965.

Friedländer, 1967
Max J. Friedländer, *Early Netherlandish Painting, IV, Hugo van der Goes*, Leyden, 1967.

Friedlaender and Blunt
Walter Friedlaender and Anthony Blunt, *The Drawings of Nicholas Poussin, Catalogue Raisonné*, London, 5 vols., 1939-1974.

Fröhlich Bum, 1938
Lily Fröhlich Bum, "Tietze, Tizian, Leben und Werk," *The Art Bulletin*, 20, 1938, pp. 444-46.

Galerie Cailleux, 1957
Hubert Robert, Louis Moreau, Exposition du cent-cinquantenaire de leur mort, Nov. 26 - Dec. 20, 1957.

Galerie Cailleux, 1968
Watteau et sa génération, Paris, 1968.

Galerie Cailleux, 1978
Sanguine, dessins français du dix-huitième siècle, Paris, 1978.

Gatteaux, 1875
Edouard Gatteaux, *Collection de 120 dessins . . . de M. Ingres*, Paris, 1875.

Gealt, 1984
Adelheid M. Gealt, "Agostino Carracci . . . ," *Art News*, April 1984, pp. 106-107.

Geissbuhler, 1963
Elisabeth Chase Geissbuhler, *Rodin: Later Drawings*, Boston, 1963.

Geissler, 1979
Heinrich Geissler, *Zeichnung in Deutschland*, Stuttgart, 1979.

Geist, 1968
Sidney Geist, *Brancusi, A Study of the Sculpture*, New York, 1968.

Geist, 1975
Sidney Geist, *Brancusi, The Sculpture and Drawings*, New York, 1975.

Georgel, 1974
Pierre Georgel, *Drawings by Victor Hugo*, Victoria and Albert Museum, London, 1974.

Gere, 1963
J. A. Gere, "Two Panel-Pictures by Taddeo Zuccaro . . . ," *The Burlington Magazine*, Sept. 1963, pp. 390-394.

Gere, *MD*, 1963
J. A. Gere, "Drawings by Niccolo Martinelli, Il Trometta," *MD*, Winter 1963, I, 4, pp. 3-18.

Gerszi, 1971
Terez Gerszi, *Netherlandish Drawings in the Budapest Museum, 16th Century Drawings*, 2 vols., 1971.

Gerszi, 1982
Terez Gerszi, *Paulus van Vianen. Handzeichnungen*, Hanau, 1982.

Ghent, 1954
Musée des Beaux-Arts, *Roelandt Savery, 1576-1631*, April 10 - June 13, 1954.

Gibbons, 1968
Felton Gibbons, *Dosso and Battista Dossi, Court Painters at Ferrara*, Princeton, 1968.

Giedion-Welcker, 1952
Carola Giedion-Welcker, *Paul Klee*, New York, 1952.

Goncourts, 1882
Edmond and Jules de Goncourt, *L'Art du Dix-Huitième Siècle*, 3rd ed., Paris, 2 vols., 1882.

Gopel, 1976
Erhard and Barbara Gopel, *Max Beckmann, Katalog der Gemälde*, Bern, 2 vols., 1976.

Gottlieb, 1967
Carla Gottlieb, "Observations on Johan-Berthold Jongkind as a Draughtsman," *MD*, 5, 3, 1967, pp. 296-303.

Gregori, 1961
Mina Gregori, "Nuovi accertamenti in Toscana sulla pittura 'caricata' e giocosa," *Arte Antica e moderna*, 4, 1961, pp. 400-416.

Grenoble, 1941
Musée de Grenoble, *Exposition du Cinquantenaire de la mort de Jongkind*, Oct. - Dec. 1941.

Gronau, 1957
Carmen Gronau, "Preface," *Catalogue of Drawings of Landscapes and Trees by Fra Bartolommeo . . . The Property of a Gentleman*, Sotheby and Co., London, 1957.

The Hague, 1970
Gemeentemuseum, *Brancusi*, Sept. 19 - Nov. 19, 1970.

Harth, 1959
Isolde Harth, "Zu Landschaftszeichnungen Fra Bartolommeo . . . ," *MKIF*, 9, 1959, pp. 124-130.

Haverkamp-Begemann, 1965
Egbert Haverkamp-Begemann, "Jan Gossaert gennamd Mabuse," *MD*, 3, 4, 1965, pp. 403-405.

Hébert, 1968
Michèle Hébert, *Inventaire du Fonds Français, Graveurs du XVIIIe siècle*, Bibliotheque Nationale, Paris, 1968.

Hefting, 1975
Victorine Hefting, *Jongkind*, Paris, 1975.

Held, 1947
Julius Held, *Rubens in America*, New York, 1947.

Held, 1959
Julius Held, *Rubens, Selected Drawings*, London, 2 vols., 1959.

Herzog, 1968
Sadja Jacob Herzog, *Jan Gossaert called Mabuse*, diss. Bryn Mawr, April 1968.

Hibbard, 1969
Howard Hibbard, "Guido Reni's Painting of the Immaculate Conception," *The Metropolitan Museum of Art Bulletin*, Summer 1969, pp. 19-31.

Hoetink, 1961
H. R. Hoetink, "Heemskerck en het zestiende eeuwse spiritualisme," *Bulletin Museum Boymans-van Beuningen*, 12, 1, 1961, pp. 12-25.

Hofer, 1956
Philip Hofer, *A Visit to Rome in 1764*, Cambridge, Mass., 1956.

Hoffman, 1947
Edith Hoffman, *Kokoschka, Life and Work*, London, 1947.

Hofstede de Groot, 1906
C. Hofstede de Groot, *Die Handzeichnungen Rembrandts*, Haarlem, 1906.

Hollstein
F. W. H. Hollstein, *Dutch and Flemish Etchings, Engravings and Woodcuts, c. 1450-1700*, Amsterdam.

Horton, 1960
Anne K. Horton, "A Drawing by Guercino," *Allen Memorial Art Museum Bulletin*, Oberlin College, Autumn 1960, pp.5-19.

Huggler, 1961
Max Huggler, *Paul Klee, Second Part: Paintings and Drawings for the Years 1930-40*, Bern, 1961.

Indianapolis, 1954
John Herron Art Museum, *Pontormo to Greco; The Age of Mannerism*, 1954.

Iowa, 1951
State University of Iowa, *Six Centuries of Master Drawings*, 1951.

Iowa, 1964
 University of Iowa, *Drawing and the Human Figure, 1400-1964*, 1964.

Jackson, 1955
 Naomi C. A. Jackson, "Ernst Barlach: Gothick Modern," *Art News*, Dec. 1955, pp. 38-41.

Jaffé, 1977
 Michael Jaffé, *Rubens and Italy*, Oxford, 1977.

Jeudwine, 1957
 W. R. Jeudwine, "A Volume of Landscape Drawings by Fra Bartolommeo," *Apollo*, 66, 1957, pp. 132-135.

Joachim and McCullagh
 Harold Joachim and S. F. McCullagh, *Italian Drawings in the Art Institute, Chicago*, Chicago, 1979.

Johnston, 1982
 William R. Johnston, *The Nineteenth Century Paintings in the Walters Art Gallery*, Baltimore, 1982.

Joyant, 1927
 Maurice Joyant, *Henri de Toulouse-Lautrec*, Paris, 1927.

Judson, 1973
 J. Richard Judson, *The Drawings of Jacob de Gheyn II*, New York, 1973.

Karlsruhe, 1959
 Staatliche Kunsthalle, *Hans Baldung Grien*, July 4 - Sept. 27, 1959.

Kennedy, 1959
 Ruth Wedgwood Kennedy, "A Landscape Drawing by Fra Bartolommeo," *Smith College Museum of Art Bulletin*, 30, 1959, pp. 1-12.

Kitson, 1978
 Michael Kitson, *Claude Lorrain: Liber Veritatis*, London, 1978.

F. Klee, 1962
 Felix Klee, *Paul Klee, His Life and Work in Documents*, New York, 1962.

P. Klee, 1973
 Paul Klee, *Notebooks, Volume 2, The Nature of Nature*, New York, 1973.

Knab, 1971
 Eckhart Knab, "Observations about Claude . . . ," *MD*, 9, 4, 1971, pp. 367-383.

Knab, 1977
 Eckhart Knab, *Daniel Gran*, Vienna, 1977.

Knipping, 1974
 John B. Knipping, *Iconography of the Counter Reformation in the Netherlands*, Leiden, 2 vols., 1974.

Knox, 1964
 George Knox, "Drawings by Giambattista and Domenico Tiepolo at Princeton," *Record of the Art Museum, Princeton University*, 23, 1964, 1.

Koschatzky, et al., 1971
 Walter Koschatzky, et al., *Italian Drawings in the Albertina*, Greenwich, Conn., 1971.

Kratochvíl, 1965
 Miloš V. Kratochvíl, *Hollar's Journey on the Rhine*, Prague, 1965.

Kurz, 1936
 Otto Kurz, "Drei Zeichnungen Pieter Brueghels des Älteren," *Die Graphischen Künste*, NF, I, 1936.

Kurz, 1955
 Otto Kurz, *Bolognese Drawings of the XVII & XVIII Centuries in the Collection of Her Majesty the Queen at Windsor Castle*, London, 1955.

Latour, 1974
 Marielle Latour, "Un Dessin d'Israel Silvestre," *La Revue du Louvre*, 4-5, 1972, pp. 317-318.

Lemoisne, 1954
 Paul-André Lemoisne, *Degas et son oeuvre*, Paris, I, 1954.

Lilienfeld, 1914
 K. Lilienfeld, *Arent de Gelder*, The Hague, 1914.

London, 1938
 Royal Academy, *Seventeenth Century Art in Europe*, 1938.

London, 1946
 Arcade Gallery, *Stefano della Bella; Exhibition of 60 of his Drawings*, Dec. 2-30, 1946.

London, 1953
 Royal Academy of Art, *Drawings by Old Masters*, Summer 1953.

London, 1958
 Colnaghi's, *Exhibition of Old Master Drawings*, June - July 1958.

London, 1970
 Colnaghi's, *Exhibition of Old Master and English Drawings*, June 2-26, 1970.

London, 1974
 British Museum, *Netherlands Prints and Drawings*, 1974.

London, 1977
 British Museum, *French Landscape Drawings and Sketches of the Eighteenth Century*, 1977.

London, Agnew's, 1977
 Thomas Agnew and Sons Ltd., *Old Master Drawings from Holkham*, May 2-27, 1977.

London, Rubens, 1977
 British Museum, Department of Prints and Drawings, *Rubens Drawings and Sketches*, 1977.

Longa, 1942
 René Longa, *Ingres inconnu*, Tours, 1942.

Los Angeles, 1959
 Los Angeles Municipal Art Gallery, *Collection of Mr. and Mrs. John Rewald*, March 31 - April 9, 1959.

Los Angeles, 1961
 The UCLA Art Gallery, *French Masters, Rococo to Romanticism*, March 5 - April 18, 1961.

Los Angeles, 1979
 Los Angeles County Museum of Art, *Daumier in Retrospect, 1808-1879*, March 20 - June 3, 1979.

Louisville, 1984
 J. B. Speed Art Museum, *Ingres*, 1984.

Madrid and London, 1982-83
 Museo del Prado and Royal Academy of Arts, *Bartolomé Estebán Murillo, 1617-82*, 1982-83.

Mahoney, 1977
 Michael Mahoney, *The Drawings of Salvatore Rosa*, New York, 2 vols., 1977.

Maison, 1960
 K. E. Maison, *Daumier Drawings*, New York, 1960.

Maison, 1967
 K. E. Maison, *Honoré Daumier, Catalogue Raisonné*, London, 1967.

200

Manchester, 1963
City of Manchester Art Gallery, *Wenceslaus Hollar, 1607-1677, Drawings, Paintings and Etchings*, Sept. 25 - Nov. 17, 1963.

Marchese, 1879
V. Marchese, *Memorie dei più insigni pittori . . .* , 4th ed., Bologna, 1879.

Mariuz, 1971
Adriano Mariuz, *Giandomenico Tiepolo*, Venice, 1971.

Mariuz, 1982
Adriano Mariuz, *L'opera completa del Piazzetta*, Milan, 1982.

Martin, 1959
Kurt Martin, *Skizzenbuch des Hans Baldung Grien "Karlsruher Skizzenbuch,"* Basel, 1959.

Massar, 1977
Phyllis Dearborn Massar, "Scenes for a Calderon Play by Baccio del Bianco," *MD*, 15, 4, Winter 1977, pp. 365-375.

Massar-de Vesme, 1971
Phyllis Dearborn Massar, ed., Alexandre de Vesme, *Stefano della Bella*, New York, 1971.

Middletown, 1955
Wesleyan University, *Symposium of the Graphic Arts*, 1955.

Miesel, 1963
Victor H. Miesel, "Rubens' Study Drawings after Ancient Sculpture," *GBA*, May - June 1963, pp. 311-326.

Milan, 1976
Il Gabinetto delle Stampe, *Disegni di Stefano della Bella*, Nov. 12 - Dec. 4, 1976.

Mongan, 1967
Agnes Mongan, "Ingres and his Friends," *Allen Memorial Art Museum Bulletin*, 24, Spring 1967, 3.

Mongan and Sachs, 1946
Agnes Mongan and Paul Sachs, *Drawings in the Fogg Museum of Art*, Cambridge, 1946.

Mongan, Hofer, and Seznec, 1945
Elizabeth Mongan, Philip Hofer, and Jean Seznec, *J. Fragonard: Drawings for Ariosto*, New York, 1945.

Montreal, 1953
The Montreal Museum of Fine Arts, *Five Centuries of Drawings*, Oct. - Nov. 1953.

Morassi, 1962
Antonio Morassi, *A Complete Catalogue of the Paintings of G. B. Tiepolo*, Greenwich, Conn., 1962.

Moreau-Nélaton, 1921
E. Moreau-Nélaton, *Millet raconté par lui-même*, Paris, 1921.

Moreau-Nélaton, 1926
E. Moreau-Nélaton, *Manet raconté par lui-même*, 2 vols., Paris, 1926.

Mras, 1956
George Mras, "Some Drawings by G. B. Tiepolo," *Record of the Art Museum, Princeton University*, 15, 1956, 2.

Munhall, 1976
Edgar Munhall, *Jean-Baptiste Greuze, 1725-1805*, Hartford, 1976.

Münz, 1961
L. Münz, *Bruegel, The Drawings*, London, 1961.

Neumeyer, 1958
Alfred Neumeyer, *Cézanne Drawings*, New York, 1958.

Newark, 1960
The Newark Museum, *Old Master Drawings*, March 17 - May 22, 1960.

New York, 1943
Weyhe Gallery, *Toulouse-Lautrec Exhibition*, 1943.

New York, 1949
Buchholz Gallery, *Max Beckmann Recent Work*, Oct. 18 - Nov. 5, 1949.

New York, 1959
The Metropolitan Museum of Art, *French Drawings from American Collections, Clouet to Matisse*, Feb. 3 - March 15, 1959.

New York, etc., 1959-60
American Federation of Arts, *Fifty Years of Ballet Design*, 1959-60.

New York and Cambridge, 1960
The Pierpont Morgan Library and Fogg Art Museum, *Rembrandt Drawings from American Collections*, 1960.

New York, 1961
Este Gallery, *Seventh Annual Exhibition of Master Drawings from Five Centuries*, May 1 - June 17, 1961.

New York, 1962
IBM Gallery, *Fine Art in Sport*, Nov. 13-30, 1962.

New York, 1962
New York University, Institute of Fine Arts, *Master Drawings XVI-XX Century from The Collection of Curtis O. Baer*, 1962.

New York, Seiferheld, 1962
Helene C. Seiferheld Gallery Inc., *Animal Drawings from the XV to the XX Century*, Dec. 1962.

New York, 1963
The Drawing Shop, *The Non-Dissenters*, March 5 - April 19, 1963.

New York, 1965
Metropolitan Museum of Art, *Drawings from New York Collections I: The Italian Renaissance*, 1965.

New York, 1967
The Metropolitan Museum of Art, *Drawings from New York Collections, II: The Seventeenth Century in Italy*, 1967.

New York, etc., 1967
Solomon R. Guggenheim Museum, Pasadena Art Museum, etc., *Paul Klee 1879-1940, A Retrospective Exhibition*, 1967.

New York, 1968
The Shepherd Gallery, *The Non-Dissenters*, 4, May - June 1968.

New York, Slatkin, 1968
Charles E. Slatkin Gallery, *Renoir, Degas, A Loan Exhibition of Drawings, Pastels, and Sculptures*, Nov. 7 - Dec. 6, 1958.

New York, 1969
Shepherd Gallery, *The Non-Dissenters, David Through Puvis de Chavannes*, May - June 1969.

New York and Chicago, 1969
Guggenheim Museum, New York, Philadelphia Museum of Art, The Art Institute of Chicago, *Constantin Brancusi 1876-1957: A Retrospective Exhibition*, 1969.

New York, etc., 1969
The Pierpont Morgan Library, New York, Museum of Fine Arts, Boston, The Art Institute of Chicago, *Drawings from A Loan Exhibition from the National Museum, Stockholm*, 1969.

New York, 1970
Metropolitan Museum of Art, *Classicism and Romanticism, French Drawings and Prints, 1800-1860*, Sept. 15 - Nov. 1, 1970.

New York, 1972
The Shepherd Gallery, *The Forest of Fontainebleau*, April 22 - June 10, 1972.

New York-Paris, 1977-78
Pierpont Morgan Library, *Rembrandt and His Century, Dutch Drawings of the Seventeenth Century From the Collection of Frits Lugt, Institut Néerlandais*, 1977-78.

New York, 1980
The Museum of Modern Art, *Pablo Picasso, A Retrospective*, 1980.

New York, 1981
The Drawing Center, *Drawings by Sculptors*, April - May 1981.

New York, 1983-84
Galerie St. Etienne, *Paula Modersohn-Becker*, Nov. 15, 1983 - Jan. 7, 1984.

Oberhuber, ed., 1977
Konrad Oberhuber, ed., *Renaissance and Baroque Drawings from the Collections of John and Alice Steiner*, Fogg Art Museum, Cambridge, 1977.

Oberlin, 1967
Allen Memorial Art Museum, *Ingres and his Circle*, March 3-24, 1967.

Oberlin, 1976
Allen Memorial Art Museum, *Oberlin College, Catalogue of Drawings*, 1976.

Oslo, 1976
Nasjonalgalleriet, *Nederlandske Tegninger (ca. 1600 - ca. 1700), i Nasjonalgalleriet*, June - Aug. 1976.

Ottawa, 1965
National Gallery of Canada, *European Drawings*, 1965.

Ottawa, 1982
National Gallery of Canada, *Bolognese Drawings in North American Collections, 1500-1800*, 1982.

Pallucchini, 1937
R. Pallucchini, "H. Tietze, *Tizian, Leben und Werk*," *L'Arte*, S. VIII, 1937, pp. 330-334.

Pallucchini, 1944
Rodolfo Pallucchini, *Sebastian Viniziano*, Milan, 1944.

Panofsky, 1969
Erwin Panofsky, *Problems in Titian, Mostly Iconographic*, New York, 1969.

Paris, 1938
Galerie Thannhauser, *Cézanne*, 1938.

Paris, 1958-59
Musée de l'Orangerie, *De Clouet à Matisse, dessins français des collections américaines*, 1958-59.

Paris, 1967
Musée du Louvre, *Le Cabinet d'un grand amateur, P. J. Mariette, 1694-1774*, 1967.

Paris, 1971
Institut Néerlandais, *Aquarelles de Jongkind*, Jan. 30 - March 17, 1971.

Paris, 1974
Fondation Custodia collection Frits Lugt, *Acquisitions Récentes de Toutes Epoques*, 1974.

Paris, etc., 1974-75
Grand Palais, The Detroit Institute of Arts, The Metropolitan Museum of Art, *French Painting 1774-1830: The Age of Revolution*, Nov. 1974 - Sept. 1975.

Paris, 1975
Musée de l'Orangerie, *Hommage à Corot*, June 6 - Sept. 29, 1975.

Paris, 1975-76
Grand Palais, *Millet*, 1975-76.

Paris, 1976-77
Musée du Louvre, *Dessins français de l'Art Institute de Chicago, de Watteau à Picasso*, Oct. 15, 1976 - Jan. 17, 1977.

Paris, 1984-85
Musée du Louvre, Cabinet des Dessins, *Dessins français du XVIIe siècle*, Oct. 1984 - Jan. 1985.

Parker, 1938
K. T. Parker, *Catalogue of the Collection of Drawings in the Ashmolean Museum*, Oxford, 2 vols., 1938.

Parker and Mathey, 1957-58
K. T. Parker and J. Mathey, *Antoine Watteau, Catalogue complet de son oeuvre dessiné*, Paris, 2 vols., 1957-58.

Pepper, 1984
D. Stephen Pepper, *Guido Reni*, Oxford, 1984.

Perry, 1979
Gillian Perry, *Paula Modersohn-Becker: Her Life and Work*, New York, 1979.

Picon, 1963
Gaëton Picon, *Victor Hugo Dessinateur*, Paris, 1963.

Pignatti, 1979
Terisio Pignatti, *Tiziano*, Florence, 1979.

Pissarro and Venturi, 1939
Ludovic Pissarro and Lionello Venturi, *Camille Pissarro*, Paris, 2 vols., 1939.

Popham, 1928
A. E. Popham, "Notes on Flemish Domestic Glass Painting," *Apollo*, 7, 1928, pp. 175-179.

Popham, 1932
A. E. Popham, *Catalogue of Drawings by Dutch and Flemish Artists*, British Museum, London, 1932.

Poughkeepsie, 1970
Vassar College Art Gallery, *Dutch Mannerism: Apogee and Epilogue*, April 15 - June 7, 1970.

Princeton, 1949
The Art Museum, Princeton University, *Picasso Drawings*, Jan. 1949.

Princeton, 1966
The Art Museum, Princeton University, *Italian Drawings in the Art Museum, Princeton University; 106 Selected Examples*, 1966.

Princeton, 1976
The Art Museum, Princeton University, *Murillo and His Drawings*, 1976.

Princeton, 1982
The Art Museum, Princeton University, *Drawings from the Holy Roman Empire, 1540-1680, A Selection from North American Collections*, 1982.

Procacci, 1965
Ugo Procacci, *La Casa Buonarroti a Firenze*, Milan, 1965.

Providence, 1983
Old Master Drawings from the Museum of Art, Rhode Island School of Design, 1983.

Quentin, 1898
Charles Quentin, "Rodin," *The Art Journal*, July 1898.

Rearick, 1959
W. R. Rearick, "Battista Franco and the Grimani Chapel," *Saggi e Memorie*, 2, 1959, pp. 105-140.

Rearick, 1977
W. R. Rearick, "Titian Drawings, 1510-1512," in *Tiziano nel quarto Centenario della sua morte 1576-1976*, Venice, 1977, pp. 173-186.

Rearick, 1978
W. R. Rearick, *Maestri Veneti del Cinquecento*, Florence, V, 1978.

Reff, 1976
Theodore Reff, *The Notebooks of Degas*, Oxford, 2 vols., 1976.

Reitlinger, 1922
Henry Scipio Reitlinger, *Old Master Drawings*, London, 1922.

Rewald, 1946
John Rewald, *Renoir Drawings*, New York, 1946.

Rewald, 1951
John Rewald, *Paul Cézanne, Carnets de Dessins*, Paris, 1951.

Rewald, 1984
John Rewald, *Paul Cézanne, The Watercolors*, Boston, 1984.

Reznicek, 1961
E. K. J. Reznicek, *Die Zeichnungen von Hendrick Goltzius*, Utrecht, 2 vols., 1961.

Richards, 1962
Louise S. Richards, "Three Early Italian Drawings," *Bulletin of the Cleveland Museum of Art*, Sept. 1962, pp. 167-174.

Rivière, 1973
Henri Rivière, ed., *Degas' Drawings*, New York, 1973.

Robaut, 1885
Alfred Robaut, *L'Oeuvre Complet de Eugène Delacroix*, Paris, 1885.

Roethlisberger, 1961
Marcel Roethlisberger, *Claude Lorrain: The Paintings*, New Haven, 2 vols., 1961.

Roethlisberger, 1965
Marcel Roethlisberger, "Drawings Around Claude . . . ," *MD*, 3, 4, 1965, pp. 369-380.

Roethlisberger, 1968
Marcel Roethlisberger, *Claude Lorrain, The Drawings*, Berkeley and Los Angeles, 2 vols., 1968.

Roethlisberger-Bianco, 1970
Marcel Roethlisberger-Bianco, *Cavalier Pietro Tempesta and His Times*, University of Delaware Press, 1970.

Rosenberg, 1956
Jakob Rosenberg, "Otto Benesch, The Drawings of Rembrandt," *Art Bulletin*, 38, March 1956, pp. 63-70.

Rosenberg, 1964
Jakob Rosenberg, *Rembrandt: Life & Work*, London, 1964.

Rosenberg, 1970
Pierre Rosenberg, "Twenty French Drawings in Sacramento," *MD*, 8, 1, Spring 1970, pp. 31-39.

Rosenblum, 1967
Robert Rosenblum, *Jean-Auguste-Dominique Ingres*, New York, 1967.

Rotterdam, 1933-34
Museum Boymans, *Teekeningen van Ingres tot Seurat*, 1933-34.

Rotterdam, 1958
Museum Boymans, *H. Goltzius als Tekenaar*, 1958.

Rotterdam, 1958
Museum Boymans, *Van Clouet tot Matisse*, Rotterdam, 1958.

Rotterdam and Bruges, 1965
Museum Boymans-van Beuningen and Groeningemuseum, *Jan Gossaert genaamd Mabuse*, May 15 - August 1965.

Rouart and Wildenstein, 1975
Denis Rouart and Daniel Wildenstein, *Edouard Manet, Catalogue raisonné*, Paris, 2 vols., 1975.

Russell, 1930
A. C. B. Russell, ed., Vasari Society, *Reproductions*, ser. 2, pt. 11, 1930.

St. Louis, etc., 1967
City Art Museum of Saint Louis, Philadelphia Museum of Art, The Minneapolis Society of Fine Arts, *Drawings by Degas*, Jan. 20 - June 25, 1967.

St. Louis, 1984
The St. Louis Art Museum, *Max Beckmann Retrospective*, 1984.

Salzburg, 1981
Salzburger Barockmuseum, *Österreichische Barockzeichnungen aus dem Museum der Schönen Künste in Budapest*, June 4 - Sept. 15, 1981.

Sandrart, 1675-79
Joachim von Sandrart, *L'Academia Todesca*, Nuremburg, 2 vols., 1675-79.

Saphire, 1979
Lawrence Saphire, *Fernand Léger, The Complete Graphic Work*, New York, 1979.

Schilling, 1979
Edmund Schilling, "Zwei Unbekannte Landschaftszeichnungen von Pierre Puget," *Jahrbuch der Berliner Museen*, 1974, pp. 176-180.

Schneider, 1984
Pierre Schneider, *Matisse*, New York, 1984.

Schönbrunner and Meder
J. Schönbrunner and J. Meder, *Handzeichnungen alter Meister aus den Albertina und anderen Sammlungen*.

Schult, 1971
Friedrich Schult, *Ernst Barlach Werkkatalog der Zeichnungen*, Hamburg, 1971.

Schulz, 1978
Wolfgang Schulz, *Cornelis Saftleven 1607-1681*, Berlin, 1978.

Sérullaz, *MD*, 1963
Maurice Sérullaz, "Delacroix Drawings for the Salon du Roi," *MD*, 1, 4, 1963, pp. 41-43.

Sérullaz, *Memorial*, 1963
Maurice Sérullaz, *Memorial de l'exposition Eugène Delacroix*, Paris, 1963.

Sérullaz, *Murales*, 1963
Maurice Sérullaz, *Les Peintures Murales de Delacroix*, Paris, 1963.

Shearman, 1960
John Shearman, "Les dessins de paysages de Poussin," in *Nicolas Poussin*, I, Colloques Internationaux, Paris, 1960.

Snoep, 1970
D. P. Snoep, "Gerard Lairesse als plafond-en kamerschilder," *Bulletin van het Rijksmuseum*, Dec. 1970, pp. 159-218.

Spicer, 1970
Joaneath Ann Spicer, "The 'Naer Het Leven' Drawings . . . ," *MD*, 8, 1, Spring 1970, pp. 3-30.

Spicer-Durham, 1979
Joaneath Ann Spicer-Durham, *The Drawings of Roelandt Savery*, diss. Yale University, May 1979.

Spies, 1971
Werner Spies, *Sculpture by Picasso*, New York, 1971.

Springell, 1963
Francis C. Springell, *Connoisseur and Diplomat*, London, 1963.

Stechow, 1948
Wolfgang Stechow, "Drawings and Etchings by Jacques Fouquier," *GBA*, 34, 1948, pp. 419-434.

Stechow, 1964
Wolfgang Stechow, "Heemskerck, The Old Testament, and Goethe," *MD*, 2, 1, 1964, pp. 37-39.

Suida Manning and Suida, 1958
Bertina Suida Manning and William Suida, *Luca Cambiaso — la vita e le opere*, Milan, 1958.

Sumowski, 1980-83
Werner Sumowski, *Drawings of the Rembrandt School*, New York, 1980-83.

Thiem, 1977
Christel Thiem, *Florentiner Zeichner des Frühbarock*, Munich, 1977.

Thöne, 1960
Friedrich Thöne, *Ein Deutschrömisches Skizzenbuch von 1609-11*, Berlin, 1960.

H. Tietze, 1950
Hans Tietze, *Titian*, London, 1950.

Tietzes, 1936
H. Tietze and E. Tietze-Conrat, "Tizian-Studien," *Jahrbuch der Kunsthistorischen Sammlungen in Wien*, N.F. X, 1936.

Tietzes, 1944
H. Tietze and E. Tietze-Conrat, *The Drawings of the Venetian Painters of the 15th and 16th Centuries*, New York, 1944.

de Tolnay, 1952
Charles de Tolnay, *The Drawings of Pieter Brueghel the Elder*, Salzburg, 1952.

Toronto, etc., 1972-73
Art Gallery of Ontario, *French Master Drawings of the 17th & 18th Centuries in North American Collections*, 1972-73.

Trautscholdt, 1967
Eduard Trautscholdt, "Some Remarks on Drawings from the Studio and Circle of the Van Ostade Brothers," *MD*, 5, 2, 1967, pp. 159-164.

Valentiner, 1934
Wilhelm R. Valentiner, *Die Handzeichnungen Rembrandts*, Stuttgart, II, 1934.

van Gelder, 1960
J. G. van Gelder "Pieter Bruegel: Na(e)rt het leven . . . ," *Bulletin des Musées royaux des beaux-arts de Belgique*, 9, 1-2, 1960, pp. 29-36.

van Gelder, 1971
J. G. van Gelder, "Jan de Bisschop 1628-1671," *Oud Holland*, 86, 1971, pp. 201-270.

van Leeuwen, 1970
Frans van Leeuwen, "Iets over het handschrift van de 'naar het leven' — tekenaar," *Oud Holland*, 85, 1970, pp. 25-32.

van Leeuwen, 1971
Frans van Leeuwen, "Figuurstudies van P. Bruegel," *Simiolus*, 5, 3/4, 1971, pp. 139-149.

van Regteren Altena, 1983
I. Q. van Regteren Altena, *Jacques de Gheyn: Three Generations*, The Hague, 3 vols., 1983.

Vasari, 1851
G. Vasari, *Lives of the Most Eminent Painters . . .* , London, 1851.

Veldman, 1977
Ilja M. Veldman, *Maarten van Heemskerck and Dutch Humanism in the Sixteenth Century*, Maarssen, 1977.

Venice, 1976
Fondazione Giorgio Cini, *Tiziano*, Venice, 1976.

Venturi, 1936
A. Venturi, *Cézanne, Son Art, Son Oeuvre*, Paris, 1936.

Verbraeken, 1973
René Verbraeken, *Jacques-Louis David*, Paris, 1973.

Vey, 1964
Horst Vey, "Kölner Zeichnungen . . . ," *Wallraf-Richartz-Jahrbuch*, 26, 1964.

Viatte, 1974
Françoise Viatte, *Inventaire Général des Dessins Italiens, II, Dessins de Stefano della Bella, 1610-1664*, Musée du Louvre, Paris, 1974.

Vienna, 1981
Albertina, *Guido Reni, Zeichnungen*, May 14 - July 5, 1981.

Vivian, 1971
Frances Vivian, "Guercino seen from the Archivio Barberini," *Burlington Magazine*, Jan. 1971, pp. 22-29.

Vlieghe, 1978
Hans Vlieghe, "Rubens and Italy," *Burlington Magazine*, July 1978, pp. 471-73.

Vollard, 1918
Ambroise Vollard, *Tableaux, Pastels & Dessins de Pierre-Auguste Renoir*, Paris, 2 vols., 1918.

Volle, 1979
Nathalie Volle, *Jean-Simon Berthélemy (1743-1811)*, Paris, 1979.

von der Osten, 1961
Gert von der Osten, "Studien zu Jan Gossaert," *De Artibus Opuscula XL, Essays in Honor of Erwin Panofsky*, New York, 1961, I, pp. 454-475.

von Mandach, etc.
C. von Mandach, etc., *Niklaus Manuel Deutsch*, Basel, n.d.

Washington, etc., 1958-59
National Gallery of Art, The Pierpont Morgan Library, New York, The Minneapolis Institute of Arts, etc., *Dutch Drawings, Masterpieces of Five Centuries*, 1958-59.

Washington, etc., 1965-66
National Gallery of Art, *19th and 20th Century European Drawings*, 1965-66.

Washington, 1973
National Gallery of Art, *Early Italian Engravings*, 1973.

Washington, etc., 1974-75
National Gallery of Art, Kimbell Art Museum, Fort Worth, The St. Louis Art Museum, *Venetian Drawings from American Collections*, 1974-75.

Washington, etc., 1977
National Gallery of Art, The Denver Art Museum, Kimbell Art Museum, Fort Worth, *Seventeenth Century Dutch Drawings from American Collections*, 1977.

Washington, etc., 1978-79
National Gallery of Art, Fogg Art Museum, Cambridge, The Frick Collection, New York, *Drawings by Fragonard in North American Collections*, 1978-79.

Washington, etc., 1981-82
National Gallery of Art, etc., *French Master Drawings from the Rouen Museum*, 1981-82.

Washington, 1983
National Gallery of Art, *Piazzetta*, 1983.

Washington, etc., 1984-85
National Gallery of Art, Galeries Nationales du Grand Palais, Paris, Schloss Charlottenburg, Berlin, *Watteau, 1684-1721*, 1984-85.

Westheim, 1962
Paul Westheim, *Kokoschka Drawings*, London, 1962.

Wild, 1980
Doris Wild, *Nicolas Poussin, Katalog der Werke*, 2 vols., Zurich, 1980.

Wilde, 1978
Johannes Wilde, *Michelangelo*, Oxford, 1978.

Wildenstein, 1954
George Wildenstein, *Ingres*, New York, 1954.

Winzinger, 1952
Franz Winzinger, *Albrecht Altdorfer Zeichnungen*, Munich, 1952.

Winzinger, 1979
Franz Winzinger, *Wolf Huber*, Munich, 1979.

Wittkower, 1952
R. Wittkower, *The Drawings of The Carracci in the Collection of Her Majesty the Queen at Windsor Castle*, London, 1952.

Yale, 1970
Yale University Art Gallery, *Catalogue of European Drawings at Yale, 1600-1900*, 1970.

Zervos, 1954
Christian Zervos, *Pablo Picasso*, Paris, 6, 1954.

Zurich, 1939
Kunsthaus, *Eugène Delacroix*, 1939.

Zwollo, 1968
An Zwollo, "Pieter Stevens . . . ," *Jahrbuch der Kunsthistorischen Sammlungen in Wien*, 64, N.F. 28, 1968, pp. 119-180.

Zwollo, 1970
An Zwollo, "An Additional Study . . . ," *MD*, 8, 3, Autumn 1970, pp. 272-275.

Zwollo, 1982
An Zwollo, "Pieter Stevens: Nieuw Werk . . . ," *Leids Kunsthistorisch Jaarboek*, 1982, pp. 95-118.

ABBREVIATIONS

GBA *Gazette des Beaux Arts*

L Frits Lugt, *Les Marques de collections de dessins et d'estampes . . .* , Amsterdam, 1921; *Supplément*, The Hague, 1956.

MD *Master Drawings*

MKIF *Mitteilungen des Kunsthistorischen Institutes in Florenz*

Index of Artists

Amand, Jacques-François, attributed to, no. 60
Anastasi, Auguste, no. 164
Baccio del Bianco, no. 15
Baccio della Porta, called Fra Bartolommeo, no. 2
Barbieri, Giovanni Francesco, called Il Guercino, nos. 12, 112
Barlach, Ernst, no. 89
Bartolommeo, Fra (Baccio della Porta), no. 2
Barye, Antoine-Louis, no. 163
Beckmann, Max, nos. 99, 100
Bella, Stefano della, nos. 16, 116
Bisschop, Jan de, no. 43
Boissieu, Jean-Jacques de, no. 65
Bol, Hans, no. 28
Bolognese, early 17th century, no. 110
Bolognese, 17th century, nos. 111, 113
Bolognese School, 17th century, no. 11
Both, Andries, no. 137
Bourguignon, Hubert-François, called Gravelot, no. 64
Bramer, Leonard (Leonaert), nos. 39, 140
Brancusi, Constantin, no. 93
Braun, Augustin, attributed to, no. 135
Brill (Bril), Paul, no. 35
Brill (Bril), Paul, attributed to, no. 126
Callot, Jacques, follower of, no. 150
Cambiaso, Luca, nos. 5, 6
Carracci, Agostino, no. 10
Cézanne, Paul, no. 83
Claude Gellée, called Le Lorrain, nos. 57, 153a, 153b
Corot, Jean-Baptiste-Camille, no. 71
Cuyp, Aelbert, no. 143
Danube School, German, early 16th century, no. 24
Daumier, Honoré, no. 73
David, Jacques-Louis, nos. 66, 160
Degas, Edgar, nos. 78, 79, 80, 81
Delacroix, Eugène, nos. 69, 70, 162a, 162b
Doudan, Ximenes, no. 165
Dutch, early 17th century, no. 127
Dutch, 17th century, no. 130
Eeckhout, Gerbrandt van den, no. 38
Emilian, late 16th century, no. 108
Everdingen, Allaert van, no. 144
Flamen, Albert, no. 133
Flaxman, John, attributed to, no. 172
Flemish, early 17th century, no. 131
Florentine School, ca. 1460-70, no. 1
Fouquier, Jacques, attributed to, no. 53
Fragonard, Jean-Honoré, no. 59
Franco, Battista, no. 4
French, 18th century, nos. 155, 157
Gandolfi, Gaetano, no. 119

Gauguin, Paul, no. 173
Genoels, Abraham II, attributed to, no. 132
German, early 16th century, no. 25
German, 16th century, no. 120
German, early 17th century, no. 122
German (?), early 17th century, no. 123
Gheyn, Jacob de, II, no. 33
Giulio Romano (Giulio Pippi), attributed to, no. 101
Goltzius, Hendrick, no. 32
Gossaert, Jan, called Mabuse, circle of, no. 23
Goyen, Jan van, nos. 40, 41a, 41b, 142
Gran, Daniel, attributed to, no. 50
Grave, Josua da, nos. 145a, 145b
Gravelot (Hubert-François Bourguignon), no. 64
Greuze, Jean-Baptiste, no. 63
Grimaldi, Giovanni Francesco, no. 18
Gris, Juan, no. 174
Guercino (Giovanni Francesco Barbieri), nos. 12, 112
Guys, Constantine, no. 166
Hackaert, Jan, no. 148
Heemskerck, Maarten van, no. 27
Hoffmann, Thomas, attributed to, no. 121
Hollar, Wenzel, no. 45
Huet, Paul, no. 167
Hugo, Victor, nos. 74a, 74b
Ingres, Jean-Auguste-Dominique, nos. 67, 68
Italian, 16th century, nos. 106, 107
Italian (Lombard School?), 16th century, no. 102
Italian, 17th century, no. 109
Jongkind, Johan-Barthold, no. 76
Kandinsky, Vasily, no. 97
Klee, Paul, no. 96
Klotz, Valentijn, no. 146
Kokoschka, Oskar, nos. 95, 175
La Fosse, Charles, circle of, no. 154
Leger, Fernand, no. 98
Lievens, Jan, no. 138
Lorrain (Claude Gellée), nos. 57, 153a, 153b
Luce, Maximilien, no. 169
Mabuse (Jan Gossaert), circle of, no. 23
Manet, Edouard, nos. 82a, 82b
Maratta, School of, no. 114
Marc, Franz, no. 88
Martinelli, Niccolò, called Il Trometta, no. 7
Master of the Blue Paper Drawings, no. 56
Master of the Story of Tobit, no. 22
Matisse, Henri, no. 94
Menzel, Adolph von, no. 171
Millet, Jean-François, no. 75
Modersohn-Becker, Paula, no. 87

Mulier, Pieter the Younger, called Cavalier Pietro Tempesta, attributed to, no. 136
Murillo, Bartolomé Estebán, no. 17
Netherlandish, first quarter of the 16th century, no. 26
Nieulandt, Williem van, attributed to, no. 34
Ostade, Adriaen van, manner of, nos. 141a, 141b
Oudry, Jean-Baptiste, follower of, no. 156
Ouvrié, Pierre Justin, no. 161
Paret y Alcázar, Luis, no. 159
Passarotti, Bartolomeo, nos. 9, 103
Pérac, Etienne du, no. 149
Piazzetta, Giovanni Battista, no. 19
Picasso, Pablo, nos. 90, 91
Pillement, Jean-Baptiste, no. 158
Pissarro, Camille, nos. 77, 168
Poussin, Nicolas, nos. 54, 55, 152
Pozzoserrato, Ludovico (Lodewiyk Toeput), no. 129
Puget, Pierre, attributed to, no. 151
Redon, Odilon, no. 85
Rembrandt van Rijn, no. 37
Reni, Guido, no. 13
Renoir, Pierre-Auguste, no. 84
Robert, Hubert, nos. 61, 62
Rodin, Auguste, no. 92
Rosa, Salvator, no. 14
Rousseau, Théodore, no. 72
Rubens, Peter Paul, no. 36
Ruisdael, Jacob van, no. 42
Saftleven, Cornelis, no. 48
Savery, Roelandt, no. 29
Scaglia, Leonardo, no. 117
Siberechts, Jan, no. 147
Silvestre, Israel, attributed to, no. 52
Spanish, 17th century, no. 115
Steinle, Edward von, no. 170
Stevens, Pieter, nos. 31, 128
Tempesta, Cavalier Pietro (Pieter Mulier the Younger), attributed to, no. 136
Tiepolo, Giovanni Battista, no. 20
Tiepolo, Giovanni Domenico, no. 21
Tintoretto, Jacopo, workshop of, no. 105
Titian, attributed to, no. 3
Toeput, Lodewiyk, called Ludovico Pozzoserrato, no. 129
Toulouse-Lautrec, Henri de, no. 86
Trometta (Niccolò Martinelli), no. 7
Uden, Lucas van, no. 46
Ulft, Jacob van der, no. 44
Ulisse Severino da Cingoli, called Messer Ulisse, nos. 8a, 8b
Utewael, Joachim, follower of, no. 124
Velde, Willem van de, the Younger, no. 49

Venetian School, 16th century (?), no. 104
Vianen, Paulus van, no. 30
Vinckboons, David, manner of, no. 125
Visscher, Claes Jansz., no. 134
Waterloo, Anthonie, no. 47
Watteau, Antoine, no. 58
With, Pieter de, no. 139
W. W. M., no. 51
Zocchi, Giuseppe, attributed to, no. 118